CEZANNE'S EARLY IMAGERY

Paul Cézanne in 1861, photograph.

CEZANNE'S EARLY IMAGERY

Mary Tompkins Lewis

UNIVERSITY OF CALIFORNIA PRESS

BERKELEY LOS ANGELES LONDON

The publishers wish to acknowledge with gratitude the
contribution provided from the Art Book Fund of the
Associates of the University of California Press, which is
supported by a major gift of the Ahmanson Foundation.

University of California Press
Berkeley and Los Angeles, California

University of California Press, Ltd.
London, England

Lewis, Mary Tompkins.
 Cézanne's early imagery / Mary Tompkins Lewis.
 p. cm.
 Bibliography: p.
 Includes index.
 ISBN 0-520-06561-1 (alk. paper)
 ISBN 0-520-06563-8 (pbk.)
 1. Cézanne, Paul, 1839–1906—Criticism and
interpretation.
I. Title.
ND553.C33L464 1989
759.4—dc19 88-27745
 CIP

Printed in the United States of America
1 2 3 4 5 6 7 8 9

For Jim and Brian

Contents

List of Illustrations

Unless otherwise noted, all works are oil on canvas. Where possible, works by Cézanne are identified by Venturi, Chappuis, or Rewald catalogue number. See Note on the Sources, p. xxi.

BLACK-AND-WHITE FIGURES

Acknowledgments

In preparing this study I have been assisted by numerous scholars, librarians, curators, and friends. But my primary debt is to Sir Lawrence Gowing, whose lectures on Cézanne I was privileged to attend at the University of Pennsylvania in the spring of 1977. The present topic evolved from a seminar paper I wrote for him that term, which was subsequently published in the *Gazette des beaux-arts*; it now constitutes the core of chapter III. My Ph.D. dissertation, "Cézanne's Religious Imagery," expanded that study to include other early works with religious or spiritual subjects. This book substantially enlarges that focus and discusses the painter's early subject matter as a whole. Throughout my study, Gowing has been a constant source of inspiration and encouragement; it was at his invitation that chapter VIII appeared in his 1988 exhibition catalogue *Cézanne: The Early Years, 1859–1872*. I hasten to add, however, that he may not agree with everything put forth in these pages.

I also offer my warmest thanks to Professor John Rewald, whose generous help in assembling the necessary photographs made this study possible, and whose meticulous editing made it a great deal more accurate. To Professor John McCoubrey my thanks are due for his many insights and suggestions. I am indebted to the Art History Department at the University of Pennsylvania for support throughout my years in graduate school, and especially for a Kress fellowship in 1978 and 1979 and a travel grant in the summer of 1980. I am also grateful for a grant from the National Endowment for the Humanities.

In Aix-en-Provence, I was graciously assisted by a number of people: the

late Louis Malbos, the conservateur honoraire du Musée Granet, whose kindness and thorough knowledge of art in Aix and also of Mistral were of inestimable value; Bernos La Dione, conservateur du Musée du Vieil Aix; Frère Pierre Desplanches, professeur de lettres honoraire, a member of the pénitents gris; and the staffs at the Bibliothèque Méjanes and Musée Paul-Arbaud.

For help in tracing iconographic and vernacular sources, I am especially indebted to M. Monestier, director of the Iconothèque at the Musée des Arts et Traditions Populaires, Paris, to Dr. Michael Evans of the Warburg Photographic Collection, and to the staff at the Princeton Iconographic Index.

At the Frick Art Reference Library and the New York Public Library I have been helped immensely by the library staffs. I should also thank my seminar students at the University of Pennsylvania, Drew, and Colgate universities for providing both a forum and stimulating criticism for my ideas.

Most recently, I am deeply grateful to Henry Millon and his extremely able staff at the Center for Advanced Studies in the Visual Arts at the National Gallery of Art, Washington, D.C. It was indeed an honor to complete this study there as a visiting Senior Fellow. Special acknowledgment is also due to Kathleen T. Mang, Curator of the Rosenwald Collection, the Library of Congress, and to MaryAnne Stevens of the Royal Academy.

It has been a consistent pleasure to work with Charlene Woodcock at the University of California Press—her faith in this project sometimes exceeded my own—and with Fronia Simpson of Wilsted & Taylor. Finally, I must thank Maggie Murray and Sara Montague, whose tireless efforts to improve this manuscript often verged on collaboration, and, above all, my husband, Jim, who has sustained me in this and in so much else.

New York City
July 1988

A Note on the Sources

Throughout the text and notes, numerical annotations and references to the following *catalogues raisonnés* are used:

V. Lionello Venturi, *Cézanne, son art—son oeuvre*. 2 vols. Paris: Rosenberg, 1936.

Ch. Adrien Chappuis, *The Drawings of Paul Cézanne: A Catalogue Raisonné*. 2 vols. Greenwich, Conn.: New York Graphic Society, 1973.

RWC John Rewald, *Paul Cézanne, The Watercolors: A Catalogue Raisonné*. Boston: Little, Brown, 1983.

INTRODUCTION

The Critical History

CEZANNE'S BIOGRAPHERS have served his early history well. The precipitous events and tumultuous emotions of his first decades—his idyllic youth in Aix and boyhood friendship with Emile Zola, his adolescent sexual longings, loneliness, and self-pity, his struggles against an obdurate, bourgeois father, his ardent commitment to painting and repeated attempts to engage and yet affront the annual spring Salon in Paris—have been recounted so often and so vividly as to need no retelling here. Equally well known is the persona that Cézanne, like Courbet, carefully cultivated for himself in Paris—a crude, brusque provincial, ill at ease with his fellow painters and the critics he met at the Café Guerbois, the hothouse of Impressionism. "I do not shake your hand," he reportedly told the sophisticated Manet; "I have not washed for a week." Such mannerisms were celebrated by Zola in the fictional character of the painter Claude Lantier, the tragic hero of his novel *L'Oeuvre* (1886), whom he based in part on his early memories of Cézanne. Ironically, however, the heroic image of the intense young romantic artist—the brash Provençal—struggling to realize his most passionate visions has long overshadowed the real paintings on which such perceptions must ultimately rest. Despite the wealth of critical literature his later painting has generated, Cézanne's first works have only recently begun to emerge from the shadow of his early history.

The first extensive and serious analysis of Cézanne's early painting was published by the English critic Roger Fry. Occasioned by his viewing of the privately held Pellerin collection, where thirty-two of its over ninety Cézanne paintings dated from the artist's early period, Fry's commentary orig-

inally appeared in the French journal *L'Amour de l'art* in 1926 as notes to the collection. It was published the following year in English as *Cézanne: A Study of His Development*. The critic's focus on the early canvases, particularly those from the 1860s, was unique in itself, and his insights into the young Cézanne's emotional preoccupations and pictorial inconsistencies were unprecedented. Yet Fry's own critical development—his establishment of the formalist approach and its subsequent influence on art criticism—served to isolate and obscure the early works, despite his evident fascination with them. Fry interpreted the young artist as an unbridled romantic whose passions were often expressed in vehement and fantastic images. At the same time Fry also recognized the role the old master paintings in the Louvre played as rigorous formal models Cézanne both revered and transformed in his early works. Fry surmised that as Cézanne's art evolved, his "passionate consciousness" came to shape the formal expression of his compositions rather than simply to determine their subjective imagery. In articulating this phenomenon, Fry strayed from a more searching critical assessment of the paintings of the first decade. Although his emphasis on the supremacy of formal values in Cézanne's later work significantly shaped the formalist interpretations of a generation of Cézanne scholars, it also focused critical attention almost exclusively on his mature painting. Thus Cézanne's early work, whose undisciplined forms and dark, elusive subjects rendered it generally inaccessible, went largely unexplored.

In 1936 Lionello Venturi published the first catalogue of Cézanne's work, *Cézanne, son art—son oeuvre*. With illustrations of over 1,600 paintings, watercolors, and drawings, it enabled a chronological appraisal of a number of early works long hidden from view in private collections. In the same year John Rewald published his first biography of the artist, *Cézanne et Zola*, and in 1937 his first edition of Cézanne's letters appeared. Together these three works provided a wealth of new critical and biographical material and thus a rich primary context in which the early works might finally be approached.

But it was not until well after World War II, when Meyer Schapiro defiantly challenged the formalist tradition in his 1952 book, *Cézanne*, that the early paintings received probing critical attention. With a new concentration on the painter's subject matter, Schapiro advanced the idea that an over-

all continuity in Cézanne's oeuvre was revealed in his subjects and their pictorial forms when viewed against the backdrop of his life. In an essay of 1968, "The Apples of Cézanne: An Essay on the Meaning of Still-life," Schapiro applied his new methodology in an iconographic study of several subject paintings, especially the work he titled *The Amorous Shepherd* or *Le Jugement de Pâris* (see fig. 87), relating their imagery and content to several still lifes by Cézanne with which they share pictorial elements. Schapiro presented the still lifes as much more than compositions for formal analyses; he perceived them as subjects filled with latent symbols of "a disturbing intensity" and highly charged with personal meaning, like the most revealing narrative works.

With Schapiro, psychoanalytic theory entered Cézanne scholarship, and the painter's early work became inseparable from a study of his oeuvre as a whole. In Schapiro's view, however, it was only after 1872, when Cézanne was formally introduced to Impressionism (which Schapiro describes as "freeing him from his too impulsive imagination"), that the artist's passionate, creative energies were constructively channeled under the tutelage of Pissarro. Despite his excellent, groundbreaking scholarship and the new focus he brought to the early works, Schapiro in the main thus sustained the prevalent interpretation of them as the turbulent outpourings of an undisciplined romantic.

Since Schapiro, the chief proponent of the psychoanalytic interpretation of Cézanne and, therefore not surprisingly, the scholar who has looked most closely at the artist's early subject paintings has been Theodore Reff. While I often argue with Reff's conclusions in this book, his various essays, especially his "Cézanne, Flaubert, St. Anthony, and the Queen of Sheba," present a model for the type of focused critical inquiry Cézanne's major early works demand. Until quite recently no one has been more instrumental than Reff in bringing Cézanne's early paintings into the forefront of twentieth-century scholarship. However, the fragmentary nature of Reff's studies to date and his emphasis on the artist's conscious and unconscious motives lose sight of the breadth and informed vision of Cézanne's early creative process. This book attempts to study Cézanne's early work—and the contexts in which it was created—as a whole, and to encourage a shift in the prevailing critical

bent that has for so long governed the scholarship on this period. In so doing, it owes something to a landmark event in the history of Cézanne scholarship and appreciation, one that will clearly be the impetus for the study of early Cézanne from numerous perspectives.

This event was the opening in April 1988 of the exhibition *Cézanne: The Early Years, 1859–1872* at the Royal Academy in London. Lawrence Gowing's introductory essay and notes in the catalogue introduce the type of radical reappraisal of the early works that this book proposes. Gowing is the first scholar to look closely and comprehensively at Cézanne's first paintings for their own sake and to argue, quite rightly, that the painter's first decade "culminated in a group of masterpieces to which opinion has still hardly allowed their deserts." Aside from providing a refreshing model for critical reassessment, Gowing has helped to assemble the tools that will make it possible. Cézanne signed and dated almost nothing; thus, questions of chronology have always been crucial to studies of any phase of his oeuvre. Gowing's inclusion in *The Early Years* of a painstaking stylistic chronology for the paintings of the 1860s allows us finally to approach and assess them with some historical clarity. Equally significant, the exhibition occasioned the first public viewing in decades of a number of paintings long held in private collections, including many formerly in the Pellerin collection.

Gowing's formative essay is principally an overview of this early period in the painter's life and work, one that emphasizes issues of style and chronology. The present study focuses instead on Cézanne's early subject pictures and views them in their cultural and artistic context. By demonstrating the major roles played by both popular and artistic tradition and literary sources in these early works, I hope to establish the first decade's paintings, and the subject pictures in particular, not only as stylistically and iconographically coherent works but also as lucid reflections of the culture in which they were created. A study of this kind, with its emphasis on internal pictorial elements and the traditions and sources they reflect, is not by nature evaluative. In some instances relatively minor works, when they are striking examples of particular choices and affinities, are discussed in detail. By the same token, a number of celebrated early works do not enter into the scope of this study. Rather than an aesthetic evaluation, then, this somewhat democratic assess-

ment seeks to redress an overall critical imbalance. Critics both before and after me have and will concern themselves with aesthetic valuation.

Seen in their full complexity, Cézanne's early studies, drawings, and paintings deepen our understanding of both the mastery he ultimately achieved and the permanence of his place in modern art. Above all, Cézanne's early works reveal the brash young painter from Aix—so anxious to play the crude provincial—as extraordinarily knowledgeable about contemporary cultural currents and powerfully capable of embracing them on his own defiant terms. Far from merely giving unschooled form to his emotions, the compelling, enigmatic imagery of these works, when finally understood, and the conviction with which that imagery is expressed compel attention, admiration—and sometimes awe.

POETIC SOIL

The Background
of Provence

I

IN ITS LOCAL HISTORY AND LEGENDS, literature and art, Aix-en-Provence has long celebrated a heritage unique to its native culture. Located in a lush and peaceful valley only thirty kilometers north of the commercial port city of Marseille, Aix has existed since ancient times in quiet contrast to the bustling pace of the world surrounding it. Founded in 123 B.C. as a Roman military outpost near famed thermal springs, the city's lore reflects its antique and Christian origins. In 102 B.C., Caius Marius slaughtered the invading Teutons at the base of a nearby mountain, and gave the mountain its name, Mont Sainte-Victoire, and, legend recounts, the foothills their blood-red earth. Only a short distance away rises the mountain of Sainte-Baume, a medieval pilgrimage site and equally central to Aixois folklore. There, in a cave, the first-century saint Mary Magdalen is said to have spent the last years of her life in prayer, repentance, and seclusion. Thus, even in its dramatic physical landscape, Aix-en-Provence speaks of its legendary past.

As a seat of culture and learning in Southern Europe, Aix has long been preeminent. Troubadour poets flourished in the medieval courts of Provence and established the city as a focus of music and literature.[1] In 1409 the founding of a university at Aix brought it additional standing as an intellectual center and made it the nucleus of successive cultural movements. Just prior to the union of Provence with the territories of the French crown in 1486, the last count of Provence, René d'Anjou (1408–1480; fig. 1), held a brilliant court at Aix and fostered a new awareness of Provençal culture throughout Europe. A generous patron of regional poets and musicians,

FIG. 1 *René d'Anjou*, engraving.

René took great pride in the literature, art, and spectacular festivals he sponsored throughout the region and in Aix in particular.[2] The extravagance of "le bon roi René," "whose large style agrees not with the leanness of his purse," was remembered by Shakespeare (*King Henry VI*, Part II, 1.1.110–12), and his court at Aix was celebrated in Sir Walter Scott's *Anne of Geierstein*. Reminders of this cultural abundance could still be found in the Aix of Cézanne's time, and evidence of it made its way into the painter's early art.

The seventeenth century witnessed another advance in the region's culture with the arrival in Provence of such gifted northern painters as Louis Finson (or Finsonius) and Jean Daret. In carrying the influence of the idiosyncratic Italian painter Caravaggio to Provence, these painters helped to inspire a local flowering of baroque painting. After the massive plague of 1720, which devastated nearby Marseille and, to a lesser extent, also affected Aix, the more elaborate and whimsical rococo movement, perhaps as a reaction to the recent horrors, spread throughout the area.[3] In Aix it was typified by the delicate fêtes-galantes that Jean-Baptiste van Loo (1684–1745) painted

for the city's *hôtels particuliers*.[4] Cézanne's later adaptations of baroque and rococo themes and pictorial elements point to his awareness of the distinctive forms these movements acquired in Provence.

In such a specific and fertile context, the nineteenth-century romantic movement was able to take a firm and lasting hold and in fact brought about a new awareness of Provence's variegated culture. Fearing that both their ancient native tongue, the harmonious *langue d'oc*, which dated from Roman Gaul, and their heritage were disappearing, regional men of letters joined together in the early nineteenth century to revive the language and legacy of their ancient and medieval past. The two major figures in the formative years of this modern renaissance, Louis d'Astros and Jean-Joseph Diouloufet, successfully established Aix as the center of the Provençal literary revival.[5] D'Astros, a physician and member of the Académie d'Aix, translated the popular fables of La Fontaine into the langue d'oc (in the usual tradition of such reclamations, he added some of his own) and later traveled throughout the region addressing the need to preserve its heritage.[6] Diouloufet, a poet and book collector in Aix, published eighteenth-century regional verses and also wrote some of his own in the neglected Provençal language.[7] Many of his poems and fables were modeled on classical pastorals or on the poetry of the troubadours; in both form and content his poems detailed and celebrated aspects of the past culture that the movement was attempting to reclaim.

In the early 1850s, several poetry festivals in Provence brought together the major literary figures (fig. 2) who would spearhead the region's cultural revival in its second generation. An association of seven Provençal poets, called *Le Félibrige*, was established in 1854.[8] Its foremost member was the writer Frédéric Mistral, later poet laureate. As a law student in Aix (1848–1851), Mistral came into close contact with d'Astros and Diouloufet, who inspired an early fervor for his regional heritage.[9] In later memoirs describing his childhood, Mistral recalled his father, who embodied the profound, mystical faith, simple life, and pride in the land that form the essence of the rustic Provençal types who inhabited his works.[10] In pastoral epics, especially his *Mireio* (1859), Mistral showed a gifted grasp of the revitalized langue d'oc, making a once-rustic vernacular tongue into a euphonious epic language and reflecting the character and traditions of Provence in a grand, romantic

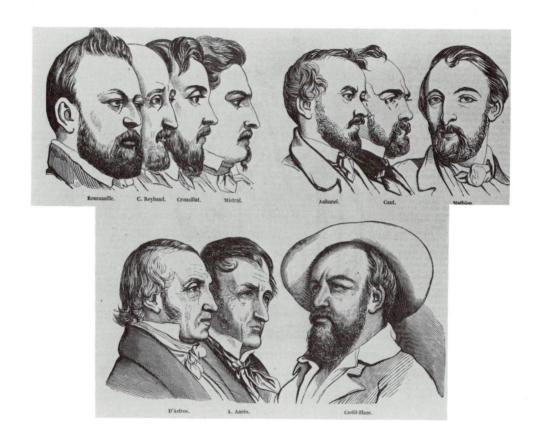

Roumanille. C. Reybaud. Crousillat. Mistral. Aubanel. Gaut. Mathieu.

D'Astros. A. Anrès. Castil-Blaze.

FIG. 2 *The Poets of Provence*, engraving.

light. His poetic evocations of the Provençal landscape, in particular, extended the influence of the Félibrige far beyond its immediate literary circles.

Growing up in Aix with Emile Zola (fig. 3) in the 1850s, Cézanne would certainly have been affected by the vital cultural resurgence taking place around him. In his memoirs, Mistral proudly noted the attendance of the young Zola, then a schoolboy at the Collège Bourbon, at the 1853 poets' festival in Aix.[11] Forty years later, in a speech at a literary banquet held by the Félibrige, Zola himself recalled the event:

I was 15 or 16, and I can see myself again, an escapee from school, in the great hall of the Hôtel de Ville at Aix attending a poetic celebration somewhat like the one I have the honor of presiding over today. Mistral was there reciting "The Reaper's Death," no doubt Roumanille and Aubanel were there, and still others, all those who were to become the Félibres several years later and who were then only troubadours.[12]

A year older than Zola, Cézanne by 1853 had already become his closest friend. Their shared love of poetry, fueled by the Provençal revival, romantic literature, and long excursions into the countryside made them (and their compatriot Baptistin Baille) inseparable. It is hardly surprising, then, to find that several of Cézanne's earliest works have among their sources the traditions and legends that members of the Félibrige, especially Mistral, had rediscovered.

A broader influence in Cézanne's formative years traceable in his early output is that of baroque painting in Provence. Along with the language and literature of its past, this remarkable period of Provençal painting, when local artists combined Caravaggio's powerful naturalism with their own rigorous piety, garnered new praise and attention in the wake of the romantic movement and growing regional chauvinism. Aaron Sheon has discussed the efforts of the painter Emile Loubon to revitalize the artistic community in mid-nineteenth-century Marseille.[13] Loubon's ambition to establish and support a truly Provençal school of art was one impetus behind his organization in 1861 of a vast exhibition in Marseille, intended in part to demonstrate the history of art in Provence. Museums, churches, and private collectors throughout the region loaned over one thousand works, and paintings

FIG. 3 Paul Cézanne, *Portrait of Emile Zola.*

by Provençal artists figured prominently. In his *Annales de la peinture* (1862), a massive study of the 1861 showing in Marseille, Etienne Parrocel made special reference to the seventeenth-century Ecole d'Aix and to Louis Finson and Jean Daret in particular. This helped to establish the popularity and disseminate the influence of the Aixois artists.[14]

For Parrocel and most later historians, the story of baroque painting in Provence began with the arrival of Louis Finson (ca. 1570–1617). Born in Bruges, Finson studied in Rome and Naples before coming to Provence. Although his tenure and activity there are largely undocumented, he left in both Aix and Marseille a number of religious canvases in which the naturalism and spirituality of Caravaggio found poignant expression.[15] One of Finson's first paintings to be hung in Aix, *La Résurrection du Christ* of 1610 (Saint-Jean-de-Malte), displayed the tenebrism and use of dramatic foreground so typical of Caravaggio. Another painting, *La Madeleine en extase* (fig. 4), is so close to Caravaggio as to have often been considered a copy of a lost work.[16] In this painting, Finson anticipated not only the sacred ecstasies of Bernini but the dramatic images of the Magdalen that later artists in Provence, including Cézanne, would so often produce.[17] Despite what were probably short stays in Aix and Marseille, Finson's influence on seventeenth-century painting there was so great as to earn him the title *Caravage provençal*. Even in the nineteenth century, the informal notion of an *école de Finson* in Aix persisted.[18] Thus the intense naturalism and somber baroque flavor of some of Cézanne's dark paintings from the 1860s (see, for example, pl. VII), always linked in the literature on the artist to the romantic fascination with Spain and with Ribera in particular, may as well reflect the firm tradition of Caravaggesque painting that existed in Provençal art.

The baroque school in Aix included another Flemish painter, Jean Daret (ca. 1613–1668). Though now largely forgotten, the story of Daret's life and the critical appraisal of his work were familiar in nineteenth-century Provence; among the critical biographers was Cézanne's friend Numa Coste, writing in 1901.[19] Daret studied in Italy before settling in Aix around 1635, where he quickly became known for his religious canvases, genre paintings, and portraits. Unfortunately, few of these works survive. But such Caravaggesque paintings as his *Portrait de l'artiste en guitariste* of ca. 1636 (fig. 5)

FIG. 4 Louis Finson,
La Madeleine en extase.

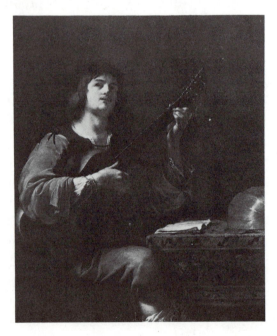

FIG. 5 Jean Daret,
Portrait de l'artiste en guitariste.

confirm that the taste in seventeenth-century Provence for this type of genre portrait continued in the generation succeeding Finson's. Daret's reputation, however, ultimately came to rest upon the large, secular, mythological decorations he did for private Aixois residences. The most famous of these was the untitled masterpiece of perspective realized in the stairwell of the Château Renard, which was as popular a tourist attraction then as it is today.[20] Another of Daret's decorations was a large panel of 1642, *Diane découvrant la grossesse de Callisto* (fig. 6).[21] Daret's cohesive composition, provocative figures, and graceful natural setting are strikingly similar to the harmonious scenes of nudes in landscapes achieved by Cézanne in his later paintings of bathers (for example, fig. 7), suggesting that Cézanne knew of Daret's mythological works as well.

The collection of the Musée Granet in Aix (formerly the Musée d'Aix) has been carefully scrutinized for possible sources of inspiration for Cézanne's painting. Theodore Reff has disproved the long-lived claim of Cézanne's indebtedness to the Le Nain brothers' *Soldats jouant aux cartes*,[22] but countless other examples of Cézanne's references to the museum's holdings, from a vast array of schools, have been proposed and will be discussed in the following chapters.[23] Although we know from his drawings of Cézanne's attachment to the work of the seventeenth-century Provençal sculptor Pierre Puget, scholarship has largely overlooked the influence of the school of baroque Provençal painting as a whole on the artist's work.[24]

Provincial art students, deprived of such sources as the Louvre, had always copied the masterworks not only in city museums but in local churches and private residences. No doubt the spate of religious images from Cézanne's first decade of painting reflects, in part, the preponderance of such subjects in Aix collections. Yet, as we have seen, the traditions and painting of Provence, and in particular of Aix, seemed to offer far more than individual prototypes from which the artist could take a motif, a brushstroke, or even a category of subject matter. The social and artistic climate in Aix was one attuned to its heritage; its brilliant evocation by artists and poets in the 1850s and 1860s could not have but touched the romantic young Cézanne, and there is evidence of his sensitivity to the past in his early sketches and paintings. His letters from Aix of 1858 to his friend Zola, then a struggling writer

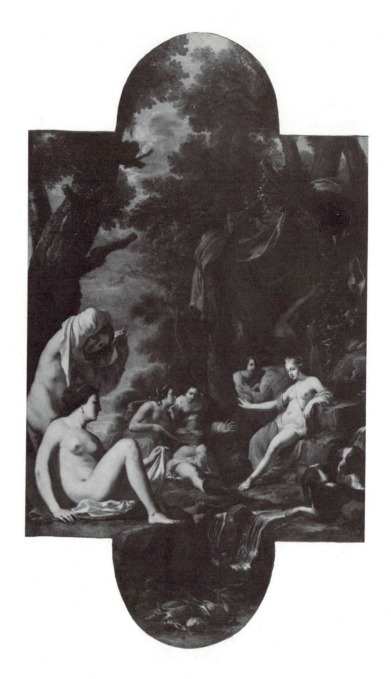

FIG. 6 Jean Daret, *Diane découvrant la grossesse de Callisto.*

FIG. 7 Paul Cézanne, *Baigneuses devant la tente*.

in Paris, also reveal his attachment to Provence when they describe the surrounding terrain with the same passion found in Mistral's landscape poems. Cézanne's later landscapes of Provence stand as equivalents in paint to Mistral's pastoral epics, reflecting in both composition and feeling the poet's sense of serene classical order and the grandeur of nature. Much of Cézanne's later oeuvre, especially the landscapes and portraits of Aixois peasants, can be seen as tributes to his native Provence and as part of the nineteenth-century Provençal revival.[25] But Cézanne's early connection to Provence was probably much more direct. Long dormant, the traditions and art of its past were newly alive in Aix in his youth and, as we shall see, figure significantly in his early imagery.

FAITH AND DEATH

Vernacular Traditions
in the Early Works

II

S O COMPLETELY HAVE CEZANNE'S LATER LANDSCAPES immortalized the terrain of his native Aix-en-Provence that the rocky bluffs and distant profile of Mont Sainte-Victoire have become familiar to even the most casual observer of modern painting. Similarly, the palette of many of Cézanne's later still lifes and portraits brings to mind the sun-drenched terra-cotta tones of his native countryside. Yet Provençal imagery figured in Cézanne's art long before he traversed its steep hills and rolling plateaus to paint *sur le motif* and even before 1861, the year in which he began to devote himself fully to painting. Many of his earliest efforts, marked by an intensity that distinguishes them from the student work of his impressionist peers, draw their vitality from the rich history and culture the city of Aix had always nourished. Such major religious paintings as Cézanne's *La Madeleine* of ca. 1867 (pl. II) establish for us the deep significance that Provençal themes had in his art, but even earlier and slighter works, such as his drawing *Moïse* (fig. 8), traceable to a popular religious festival character, reveal interesting aspects of the vivid provincial culture from which the artist emerged.

Religious imagery in nineteenth-century Aix existed on two distinct levels: in a long-established tradition of vernacular religious art and in the religious painting of Provençal baroque artists, which, as has been demonstrated, was a school revered locally in Cézanne's lifetime. Both of these forms would come to influence his early work, but the popular and vivid tradition of sacred art, which included widely circulated prints, sacred and ritual objects, and masks, puppets, and other theatrical artifacts, was the most

accessible to the young Cézanne. The nineteenth-century Provençal renaissance had fostered the revival of various vernacular rites and popular celebrations, many of which had been abandoned since ancient and medieval times. Chief among these resurrected customs were the famed religious festivals, or fêtes, around which revolved so much of Provence's folk imagery. These lively events, which were combinations of devotional and theatrical elements, offered Cézanne rich and varied visual subjects and stimulated his interest in both traditional and vernacular forms of religious expression.

Throughout Catholic Europe, from the Middle Ages on, a long tradition of religious festivals celebrating major holidays and patron saints' days had helped to perpetuate faith and piety, as well as to create enthusiasm for religious art, in the context of everyday life. In his poem *Mireio* Mistral conveyed some of the mystical fervor that underlay such enduring religious traditions in his description of the fête of St. Jean. Mistral represented the sophisticated viewers who, though experiencing demonstrations of the simple faith of country people, were still stirred by the rituals, some newly recovered, some enduring for centuries. These lively implosions of faith and popular culture usually included a devotional procession of some kind and overt theatrical elements such as puppet shows, characters in costume, and short mystery plays. Artisans and artists from many schools, especially in the provinces, contributed to the mounting of such fêtes, which intentionally displayed a kind of sacred imagery the common man could see and understand. Even Courbet, renowned for his skeptical and derisive posture in the face of most official functions, was moved by the request of his sister to contribute a processional banner of *Jésus devant un calice*, one of his rare religious works, to the annual religious festival in his small village of Ornans.[1]

The mystical fervor of the fêtes, realized in large part by common people and popular art forms, and the creativity displayed in the masks, marionettes, and vividly costumed plays were impetus for both romantic literary revivals of ancient stories and realist commentaries on rural life. Provincial religiosity had a suggestion of romantic abandon about it, and the trusting innocence of country people appealed, in this post-Rousseauean age, to romantics and realists alike. Perhaps the best-known example of this phenomenon is Gustave Flaubert's short novel, *La Tentation de Saint Antoine* (1874),

inspired in part by a puppet show at the Saint-Romain fair. Zola, too, included the festivals he had enjoyed as a youth in Aix as scenic background in some of his early novels, and in a letter to Cézanne written in 1860, he mentions seeing paintings of similar village fêtes at a café in Vitry.[2] The realist Jules Breton's paintings of devotional processions in rural northern France, such as his *Plantation d'un calvaire* (Salon of 1859), drew sympathetic attention in sophisticated artistic circles to rustic traditions and beliefs[3] and, some years later, Paul Gauguin would depict similar religious rituals in Brittany, painting with a stylized naivete that he felt mirrored their expression of primitive faith.[4] In this context, Cézanne's festival sketches, a small part of his religious work, are examples of a lingering nineteenth-century fascination with vernacular sacred art and the undercurrent of religiosity that persisted in provincial quarters, documents of both the painter and his milieu.

One of the most popular—and most extravagant—of all the festivals in European cities was the Corpus Christi, or fête-Dieu. The picturesque form it took in Aix eventually captured the attention of a variety of local artists, Cézanne among them. Introduced at Liège in 1247, the original fête-Dieu was a solemn procession of the blessed Sacrament through the city streets on the Thursday after Pentecost,[5] a radiant example of the Church triumphant.

Early artists' records of the fête tended to highlight the sacred procession, which was for some time the principal element of the celebration.[6] However, efforts to demonstrate ever more profoundly the triumph of Catholic belief over the pagan world—and to transform its folkloric remnants by absorbing them into Christian contexts—gradually altered the character and length of many fête-Dieu celebrations. Not unlike the battles of carnival on Shrove Tuesday before Lent, the elaborately staged spectacles of contests between biblical and profane characters contributed a riotous air at festivals that sometimes lasted as long as a week. In time, the dual character of the fête-Dieu and the vernacular objects it produced, which included elaborate floats, chariots, and "machinery" as well as costumes and puppets, were vivid manifestations of popular culture joined to a symbolic profession of faith.

As in the case of the Provençal cultural revival, Aix was at the heart of the region's religious traditions, and Cézanne was ideally placed to reap the ar-

tistic benefits of his city's prominence. The most renowned of the fête-Dieu celebrations was that staged each year in Aix, where it was a central event in the city's cultural life until Cézanne's twelfth year.[7] The exact date of its beginnings in Aix is not certain owing to the loss of much of the city archives in 1590 during an invasion by the duke of Savoy.[8] However, the institution of the Aix fête has traditionally been attributed to Provence's munificent René d'Anjou. At the very least, "le bon René" helped to shape the spectacular form in which the fête survived in Aix into the nineteenth century. Under his auspices, events began on Thursday, with a nocturnal parade of mythological and Old Testament figures, added to represent the pre-Christian era. This lively display was followed the next morning by the traditional sacred procession; the double processions visibly demonstrated the triumph of Catholic faith over paganism and the dark forces associated with it. Short allegorical scenes or *mystères* depicting moments of religious triumph or illumination (such as the Old Testament story of the Golden Calf) were interspersed throughout the celebrations to dramatize further the underlying theme of conquering faith. Although it is believed that René sincerely appreciated the original spiritual intent of the fête, he also took advantage of its enlarged format to display his wealth and even to parade his military officers.[9]

Not surprisingly, given these ties to royal patronage as well as such religious overtones as remained to the now rather Mardi Gras–like event, the tradition of an annual fête-Dieu in Aix was abruptly halted during the French Revolution. It was subsequently celebrated, but only sporadically, on special occasions and then on those that were regional and political, rather than religious, in nature.[10] The last fête-Dieu was held in Aix in 1851, perhaps in response to the region's revivalist temper.

One fascinated spectator at this last fête-Dieu was the poet Mistral, whose subsequent devotion to the preservation of Provençal culture was probably impelled by such glimpses of its vestiges. At the time Mistral was a law student in Aix, and he later noted his vivid impressions of the celebration:

Speaking of those games, during my stay in Aix I had the opportunity to see them come out for, I believe, the last or the second last time: the King of the Inkstand, the Abbot of Youth, the Slaughtered Innocents, the Devil, the Watch, the Queen of

Sheba, above all the Hobby Horses with their rigadoon that Bizet took for Daudet's
Arlésienne: . . . *I was deeply impressed by the revival of the Provençal past with
its naive old games of long ago.*[11]

Transforming this memory into art, Mistral included a long verse, "La Fête-
Dieu," honoring the 1851 feast in his allegorical poem *Calendau* of 1867.

Given the powerful visual elements incorporated into the fête-Dieu, it is
not surprising that artists as well as writers drew inspiration from it, and
their work formed an additional layer of subject and source material for Cé-
zanne. The earliest preserved rendering of the festival is a large painted
screen by Jean-François de Galice, dated 1760, which features a view of the
nocturnal parade as well as a glimpse of background landscape.[12] A large
1806 engraving by J. Juramy of the same scene offers a more detailed inven-
tory of the fête's many dramatic characters.[13] Among other accounts are an
engraving by an Aixois architect, M. Henri, of a chivalric contest between
costumed knights on the Cours Mirbeau from the 1851 event and several
anonymous prints that illustrate some of the mystères from the same fête.[14]
Thus, even after it had died out, the spectacle of the fête-Dieu in Aix was ac-
cessible to the populace through such images.

Even more impressive than artists' illustrations are the rare artifacts that
survive from the fête. Superb examples of folk art, they are evidence of the
fête's intricate iconography. Miniature figures of the major festival charac-
ters, costumes, ingenious mechanisms from the processions, and the ex-
traordinary *tétières*, or full-head masks, are carefully preserved today in the
Musée du Vieil Aix. But in the nineteenth century, from 1830 to 1911, they
were on permanent display in the Théâtre de Marionettes d'Aix, where Cé-
zanne may have seen them, one more indication of the central place the fête-
Dieu held in Aixois culture.[15]

The most complete account of the Aix festival, which became the standard
reference for later writers and artists, was Gaspard Grégoire's *Explication des
cérémonies de la fête-Dieu d'Aix*, published in 1777.[16] Illustrating this study are
thirteen prints of the major mystères (also referred to as *jeux*), which were
engraved by Grégoire's three sons.[17] Accounts of later fêtes often reprinted
these engravings, and several of them were adapted for François-Ambroise-

Thomas Roux-Alpheran's monumental treatise of 1846–1848, *Les Rues d'Aix*.[18] The combination of illustrations and detailed written descriptions of the fête's organization and iconography made Grégoire's study an essential guide for mounting post-Revolutionary fêtes, at a time when research was needed to recreate the interrupted tradition. The fact that Grégoire's engravings were widely reproduced and used as the basis for nineteenth-century fêtes (and even modern-day reenactments) means that his versions of figures can be used to determine whether images and subjects in paintings after 1777 are drawn from the fête tradition.

One of Grégoire's most interesting figures, and the only one that appears in more than one illustration, is his Moses, a central festival character who was featured in two of the mystères. In each of Grégoire's prints and accompanying written descriptions, Moses is in the same costume, a heavy, belted robe with deeply cuffed sleeves. In the two festival dramas in which Moses appeared (he also had a prominent position in the nocturnal and daytime processions)—the *Tirassouns* (fig. 9), a drama about the Massacre of the Innocents in which he holds up the Ten Commandments of the Old Law, and the *Juéc d'oou cat* (fig. 10), an enactment of the legend of the Golden Calf—he represented the ancient triumph of enlightened faith over idolatry. This symbolic stature was given visible structure in the Aix fête-Dieu as recorded by Grégoire: Moses is emblazoned from behind with a distinctive double group of rays of light, symbolizing divine inspiration.

Virtually a fête symbol in himself, a standard-bearer of the historical victory of faith, Moses is pictured in every tableau of the Aix festival in this precise ritual dress. The conspicuous double rays of light make the Aixois Moses an unusual depiction in vernacular French art of the ancient patriarch, who was more commonly shown with horns. Even other Provençal fête-Dieus featured the more typically horned Moses.[19] This specifically Aixois Moses is one of our keys to Cézanne's adaptation of local imagery, for it is among the festival figures sketched in his earliest known sketchbook, the *Carnet de jeunesse*.

One of Cézanne's earliest pages in this carnet (see fig. 8), dated ca. 1858, is dominated by a frontal, three-quarter-length view of Moses. Drawn in pencil and pen, the figure is identified by the two groups of rays projecting from

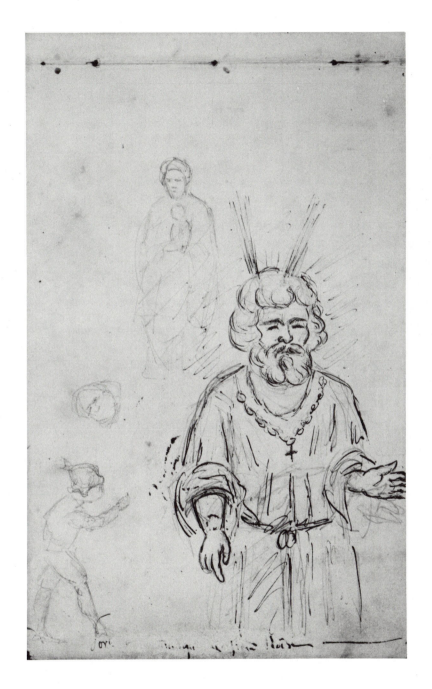

FIG. 8 Paul Cézanne, *Moïse*, pencil and pen.

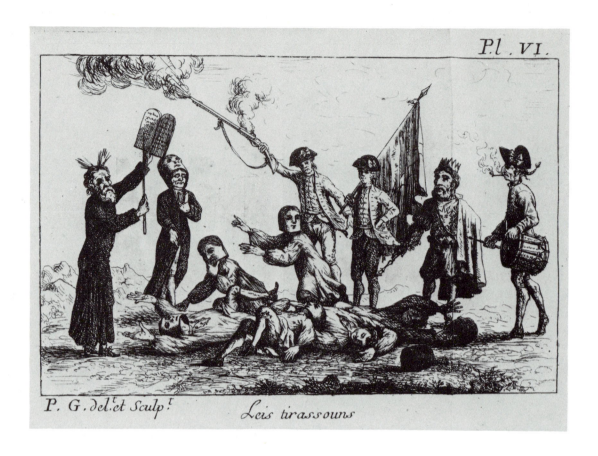

Pl. VI.

P. G. del.et Sculp.

Leis tirassouns

FIG. 9 *Leis Tirassouns*, engraving.

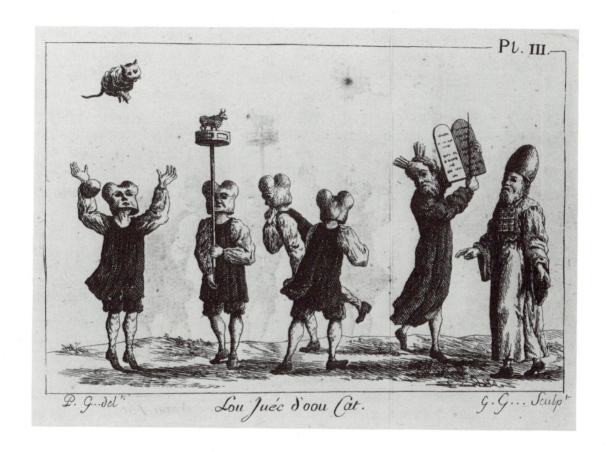

FIG. 10 *Lou Juéc d'oou cat*, engraving.

his head and the word *Moïse*, which, although partially erased, can still be read below the figure. Cézanne may have been trying to give added emphasis to the symbolic nature of the rays—a jagged, continuous penciled line circumscribes Moses' head and suggests a luminous aura. Judging by its awkward proportions, numerous pentimenti, and hesitant outlines, Cézanne's sketch is probably a rough drawing from memory of this central festival character. The figure's identical costume as well as the special double rays link Cézanne's *Moïse* to the character from the Aix fête-Dieu. The deeply cuffed sleeves, belted robe, and short beard falling in curls all conform to Grégoire's standard description of the fête-Dieu patriarch.

Another, smaller figure featured on the same page also seems to have a fête-Dieu source. In the lower left corner is a lightly penciled drawing of a young boy, singled out by Chappuis for his "curious coiffure."[20] He closely recalls a character from the festival mystère, *Lou Pichoun juéc deis diablés*, illustrated in Grégoire's plate II (fig. 11). The small boy in the center of Grégoire's engraving, reaching sidelong in a gesture that is duplicated in Cézanne's sketch and wearing the same distinctive hat (not coiffure) as Cézanne's figure, represents the *armetto*, or little soul, whose fate will be decided by the angel and devils around him.

Despite its clear affinities with traditional imagery, Cézanne's drawing of the fête-Dieu Moses was more than a remembrance of a regional festival he enjoyed as a child in Aix. Gowing has pointed out that the figure and symbolism of Moses haunted Cézanne throughout his life.[21] As a young man, when asked for a quotation he found meaningful, Cézanne cited two lines from Alfred de Vigny's poem *Moïse*:

> *Seigneur, vous m'aviez fait puissant et solitaire*
> *Laissez-moi m'endormir du sommeil de la terre.*[22]

And a few years before he died, in a period of heroic effort and output in his painting, Cézanne wrote in a letter to Vollard: "I am working doggedly, for I see the promised land before me. Shall I be like the great Hebrew leader, or shall I be allowed to enter?"[23]

Artistically and personally, the theme of Moses, as a symbol of the struggle of faith, remained with the artist. When as an old man his personal doubts

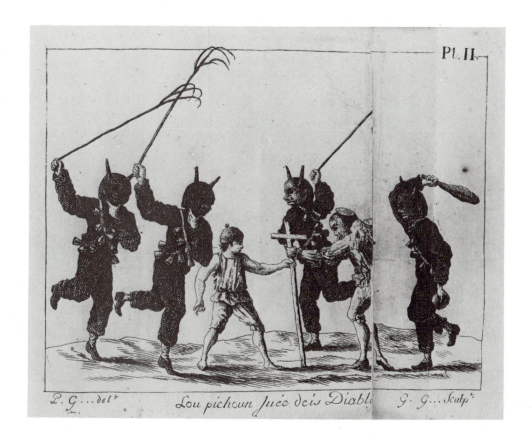

FIG. 11 *Lou Pichoun juéc deis diablés*, engraving.

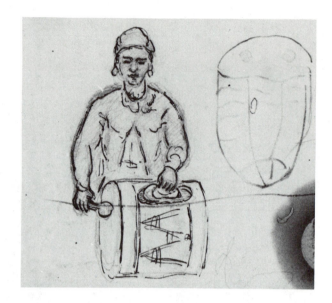

FIG. 12 Paul Cézanne. Studies, including a man beating a bass drum, pencil and pen, detail.

surfaced in his letters couched as references to Moses, they reflected not only the primacy of a Provençal symbol for Cézanne but also the aging artist's struggle to believe in himself.

Several other early Cézanne drawings also depict popular images drawn from Provençal festivals. A costumed figure found in the carnet de jeunesse and dated ca. 1858–1859 (fig. 12) is shown beating a bass drum, an instrument played in many fêtes. Another drum, lightly sketched in the same drawing, with an elongated cupular shape, is a type of tambourin, a processional instrument native to Provence.[24] It was carried by musicians mounted on horses in the Aix fête-Dieu but could have been known to Cézanne from other festivals as well. Such figures and instruments are found in Grégoire's prints and among the festival artifacts preserved in Aix, although they are not unique to the fête-Dieu. While costumed figures carrying unusual or specifically Provençal musical instruments appear in several of Cézanne's earliest drawings, they are rarely to be found in his art after this period. Their presence here may stem from his youthful involvement with religious processions in Aix. Rewald, who wrote that Zola and Cézanne played "with more enthusiasm than skill," is one of many of the artist's biographers to describe, with varying degrees of detail, his and Zola's participation as adoles-

cents in the musical club formed by their friend Marguery.[25] The band performed at major civic functions in Aix and occasionally in the city's religious parades. Whether or not Cézanne actually played in the musical portion of the fête-Dieu, he was surely familiar with that part of the ceremonial rite. It is hard to imagine that the last lavish production of 1851 would not have engaged the interest of an impressionable young boy with musical inclinations, but even after the fête ceased, its imagery remained accessible in Grégoire's study, in the artifacts and marionettes of the fête on exhibit, and in almost every handbook and nineteenth-century guide to the city. As late as 1903, Cézanne's friend, the sculptor Philippe Solari, depicted fragments of the fête-Dieu mystères and processions in a work commissioned by an Aixois patron.[26]

An understanding of the nature of the fête-Dieu with its combination of sacred and vernacular imagery and elements and the resonance of its visual components in Aixois culture reveals an aspect of Cézanne's early art that has not yet been explored. His predilection for festival elements may also inform, at least indirectly, images in his early period other than those drawn directly from the event.

For example, the prominent role given the skull in the Aix festival as a symbol of pestilence and death must have struck the romantic young artist and may have been a source of his interest in the painting of skulls. In both Cézanne's painting and early poetry, skulls appear frequently and invariably in potently symbolic contexts.

His ca. 1866 *Nature morte: Crâne et chandelier* (pl. I) stands out among Cézanne's paintings of skulls because it is clearly conceived as a traditional memento mori, a symbolic reminder of death. The book, an emblem of earthly existence, is surrounded by symbols of life's transience: the skull, wilting rose, and burnt-down candle.[27] And as Robert Ratcliffe has noted, the trowel-like application of impasto is layered over a previous painting of the same subject, visible in X-ray.[28] Skulls also figure in Cézanne's early drawings, and although they would disappear from his art for several decades, their reappearance in his painting after ca. 1895, when the aging artist began to brood on his impending death, again suggests his recognition of the skull as a traditional symbol of mortality.

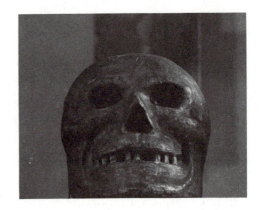

FIG. 13 Fête-Dieu têtière of *Mouért*.

Cézanne's skull imagery, however, was not confined to his still lifes and so was not solely dependent on the conventions of the memento mori. Skulls appear in Cézanne's figure compositions throughout his life, where their meanings are often direct and emotionally powerful: the *Madeleine* (pl. II) weeps over a spectral skull; two 1873 drawings after Delacroix (Ch. 325 and 326) depict Hamlet contemplating the skull of Yorick; and a late painting (ca. 1896–1898) shows a young man "seated beside a skull and books like a modern Saint Jerome."[29] The skull also figures in a grisly illustrated story about cannibalism written in Cézanne's youth and in several of his early poems.[30]

Though both the romantic movement and certain established genres in art would make the skull a compelling metaphor for a nascent painter attentive to both trends, there is no doubt that the prevalence of skulls in Cézanne's work also owes something to their prominence in Provençal tradition.

The fête-Dieu têtière, worn by the character of Death both in the festival's sacred procession and in one of its short dramas, was a realistic-looking and life-sized skull (fig. 13). Swinging a scythe at the Aixois crowds and closely following the hideous *Lepreux*, the figure of *Mouéux* was featured in what Grégoire called "the saddest, most unpleasant and most horrible of all the intermezzos" (fig. 14). This festival mask was also one of the most arresting and compelling of the vernacular artifacts on display in the Théâtre de Marionettes.

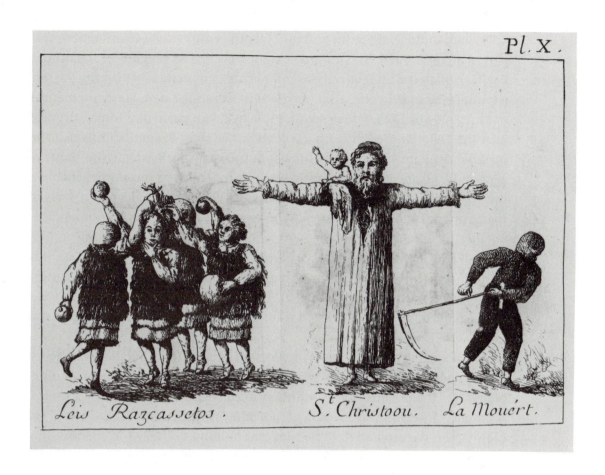

FIG. 14 *La Mouért*, engraving.

Though in the eighteenth and nineteenth centuries the Death têtière was part of a popular fête that to some extent leavened its religious associations, it still resonated with relatively recent horrors, emphatically evoking the terror of plague in Provence that persisted in Cézanne's day. Many mementos of the plague of 1720, which struck Provence with particular force, survived into the following century in contexts other than religious festivals. The massive pendant paintings of Michel Serre, realistically depicting the ravages of the plague in Marseille and hanging in that city's museum, kept alive the dread it had evoked.[31] Even more vivid were the art and ritual objects of the penitent orders of Provence, who cared for plague victims and subsequently for the poor in general. An iconographically strange painting (fig. 15) by the eighteenth-century Aixois painter Michel-François Dandré-Bardon depicts robed penitents praying before skulls, suggesting the significance of the skull to their order.[32] In Aix, the chapel of the order of the *pénitents gris* preserved a multitude of skull images, both in funerary objects and in depictions of the more popular penitent saints.[33] Occupied by the pénitents gris since 1859, the chapel's collection of devotional and death imagery would have been alluring for a young Aixois with a romantic streak of morbidity; yet it may also have informed a much later painting by Cézanne. A small, anonymous, Provençal portrait in the chapel portraying an old woman wearing a white bonnet and holding a rosary foreshadows his own profound meditation on old age and death, *La Vieille au chapelet* (1896, V. 702).

Although we have principally discussed vernacular images affecting Cézanne that were for the most part associated with or transformations of Christian religious elements, Cézanne's fascination with death imagery and skulls may also reflect historical events in nineteenth-century Aix. Artifacts identified with Aix's most ancient inhabitants were unearthed amid great excitement throughout the nineteenth century and revealed the presence of a primitive Celtic-Ligurian culture in which the *tête de mort* was venerated and thought to protect its worshipers.[34] The Oppidum of Entremont was accidentally discovered in 1810; for over a century it was the site of numerous excavations and the subject of scholarly publications issued by the Académie d'Aix.[35] Cézanne's close friend Antoine-Fortuné Marion, who became a professor

FIG. 15 Michel-François Dandré-Bardon, *L'Adoration des crânes*.

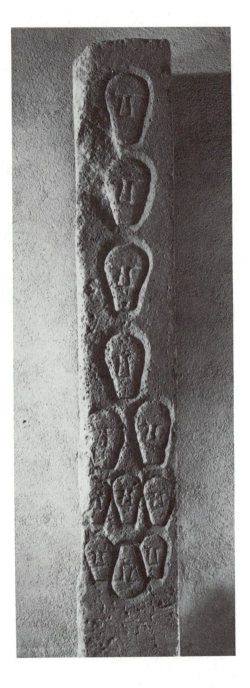

FIG. 16 Pillar from the
sanctuaire aux crânes, Entremont.

at the Faculté des Sciences, took part in the excavations in 1866.[36] Another friend, Numa Coste, also participated.[37] The archeological site, a source of considerable pride for the Aixois populace, was surveyed and described by Prosper Mérimée in 1834, by the novelist Auguste Barres, and by a number of other distinguished visitors who were fascinated with the remains of the mysterious and gruesome cult of skulls and *têtes coupées* (the decapitated remains of enemies, preserved as trophies and protective emblems).[38] Artifacts such as the pillars hewn from the Bibémus quarry and adorned with the ritual tête de mort (fig. 16) were displayed at the Musée Granet where Cézanne would have seen them,[39] and Entremont was not the region's only source of such discoveries. Not far from neighboring Marseille, the Gallic sanctuary of Roquepertuse yielded evidence of a similar ancient fascination with skulls.[40]

Thus, the motif of the skull has an ancient history in Aix, one that was enthusiastically uncovered, discussed, and extended throughout the nineteenth century. Its frequent appearance in Cézanne's early art aligns his imagery with events and traditions in Provence. As traditional, meditative emblems of mortality, a theme to which he returned in his final decade of painting, and as symbolic forms with other provocative associations in Aix, Cézanne's images of skulls also suggest the romantic spirit that the context of Provence would often rekindle in his art.

Some of Cézanne's earliest works, then, both figural and still life, can be traced to aspects of Provençal culture that previous scholarship on the artist has overlooked. Exploring these connections allows us to do more than simply identify particular images or help to explain recurring motifs, such as the skull, in his art. By securely placing such elements from the artist's early oeuvre within the vivid cultural environment of Provence, we gain a greater understanding of them. In our analyses of sources in Aix, we are forced outside the confines of the Musée Granet to consider the widest possible range of inspirations for Cézanne's developing creative imagination.

RESURRECTION AND REPENTANCE

La Madeleine et le Christ aux limbes

THE POPULAR TRADITIONS and culturally rich past of Provence, brought to light in the nineteenth-century Provençal revival, strongly influenced the imagery of Cézanne's religious works, which date almost exclusively to his first decade of painting. Yet Cézanne found in Provence more than simply vernacular precedents for his art. His rather unconventional *Visitation* of ca. 1860 (fig. 17), despite its juvenile execution and conflated religious imagery, was probably inspired, in formal terms, by a similar painting of the subject in Marseille by François Puget (1651–1707), son of the sculptor.[1] This debt is just one example of Cézanne's early interest in the seventeenth-century Provençal school. The dark, naturalistic style and predominance of religious subjects in its paintings helped to shape Cézanne's religious images and, on a broader scale, to determine the somber, baroque flavor of many of his early romantic works. The more sophisticated iconography and expressive imagery in his large painting for the salon of his father's country house, the Jas de Bouffan, *La Madeleine et le Christ aux limbes* (fig. 18)—as well as its new bold scale—reveal both a potent romanticism, which drew on a number of sources, and undertones of the artistic traditions of seventeenth-century Provence.

Scholars have usually treated the two scenes of Cézanne's large canvas of ca. 1866–1867, Christ's descent into limbo, or the harrowing of hell (fig. 19), and the lament or repentance of the Magdalen (pl. II), as intentionally distinct subjects that were merely painted by the artist on a single canvas. It has long been established that each of the two images (now separated) drew on earlier versions of the same subjects. The harrowing or limbo scene is based

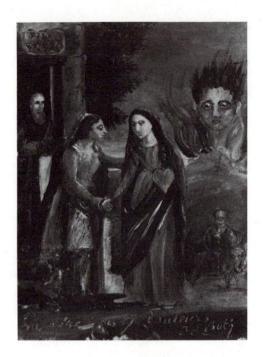

FIG. 17 Paul Cézanne, *La Visitation*.

on a painting by Sebastiano del Piombo. The original is in the Prado, but Cézanne knew the work from Charles Blanc's illustration of it in his *Histoire des peintres de toutes les écoles, Ecole espagnole* (fig. 20). (Published in 1869, Blanc's Spanish volume has traditionally been used to date Cézanne's painting, but Gowing has recently demonstrated that its prior publication, in periodical form, was known to Honoré Daumier, who also imitated the engraving after del Piombo as early as 1867. Gowing's assumption that Cézanne, too, knew the earlier source accounts for the redating.)[2]

The once-adjacent Magdalen may have been derived from several sources, the most significant of which was the baroque painter Domenico Feti's *La Mélancolie* in the Louvre (fig. 21). It was probably Cézanne's juxtaposition of these two common subjects, without any adjustment of the discrepant scale between them, that led to critical misunderstanding of the whole and the eventual division of the canvas into two halves.[3]

However, the relationship between the two figure groups suggests that Cézanne must have intended a visual and iconographic continuity in the

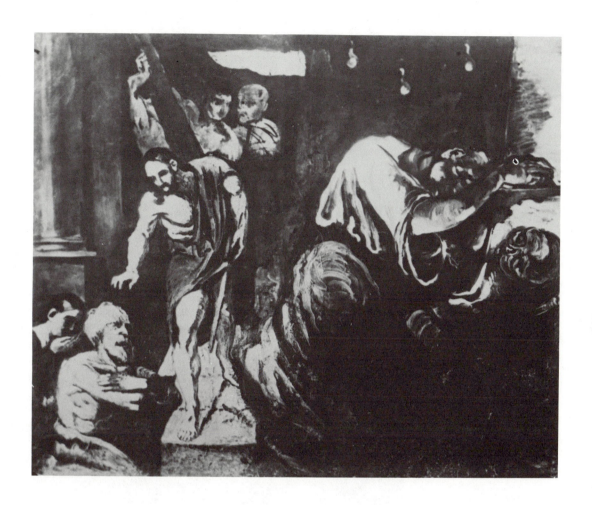

FIG. 18 Paul Cézanne, *La Madeleine et le Christ aux limbes*.

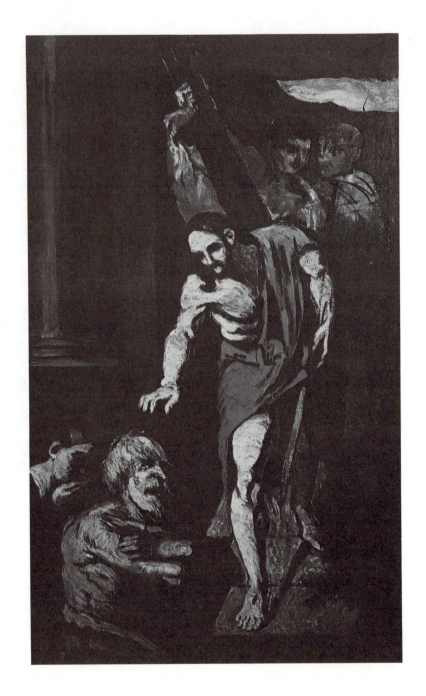

FIG. 19 Paul Cézanne, *Le Christ aux limbes*.

FIG. 20　Engraving after Sebastiano del Piombo's *Le Christ aux limbes*.

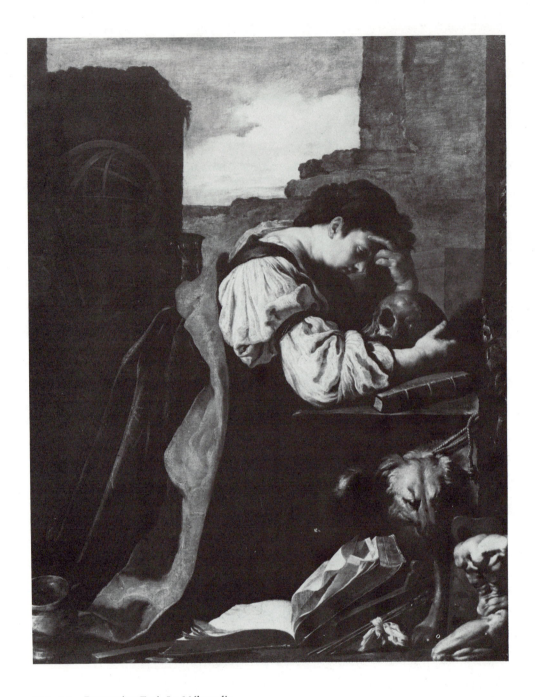

FIG. 21 Domenico Feti, *La Mélancolie*.

painting's original, undivided state. Unlike his earlier, more simplistic religious painting, Cézanne here recognized the full significance of his subjects and their motifs and must have painted them together intentionally. The artist rarely combined unrelated images in a single work for simply practical reasons, and the prominent place Cézanne gave this large picture in the salon of the Jas de Bouffan suggests that it was a deliberate and poignant statement. His treatment of the Magdalen, in particular, implies a convincing relationship with the adjoining scene. Her robe falls in front of Christ's left foot and also casts a shadow on the ramp on which he walks. The shaft of light over Christ's head is paralleled by three small flames that appear in the uppermost portion of Mary Magdalen's space; both light and flame serve similar symbolic functions and may derive from literary descriptions. In addition (though it is difficult to see in reproductions), both halves share a dim layer of bitter blue underpainting that binds them together visually. Moreover, the strange discrepancy in scale between the two figure groups becomes understandable when we recognize that two distinct spheres of reality, the underworld and the temporal world, are represented. Christ's descent into limbo and the lament of the Magdalen, both of which are related in the Easter narrative, are often referred to in popular literature as simultaneous events signifying faith and enlightenment.[4]

Here again, a specific aspect of Provençal history and culture lends weight to the argument that Cézanne's conception rests on an intimate knowledge of the subject and iconography of the Magdalen. She was not merely a religious figure in a pantheon of possible subjects but the patron saint and protectress of Provence, one whose legend had become interwoven with both the folk and high art of the region. The cultlike devotion to the Magdalen in Aix had evolved from medieval legends of her preaching mission and later hermitage in Provence. Only a few miles from Mont Sainte-Victoire are the sacred hill and caves of Sainte-Baume, recalled in the paintings of the sixteenth-century Flemish painter Joachim Patinir, where she was believed to have spent the last years of her life in seclusion, and where pilgrimages in her honor traveled throughout the nineteenth century.[5] Mary Magdalen also figures prominently in popular Provençal literature; her story is poignantly retold within Mistral's epic poem of 1859, *Mireio*.[6] The baroque

painters of Provence had also produced many images of the patroness, a number of which were exhibited at the huge exhibition in Marseille in 1861. And a recent account has shown that in 1860 the city of Aix was bequeathed an important collection belonging to the Bourguignon family that included at least fourteen paintings of the Magdalen, three of which showed her in repentance.[7] Cézanne saw the collection in a temporary gallery in October 1866 and mentioned the fact in a letter to Zola.[8] In a different context, the renowned Dominican preacher and writer Lacordaire (1802–1861), whose sermons at Notre-Dame in Paris in the 1840s became the literary and social sensation of their day, brought new interest to the saint's legendary mission in Provence in his biography *Sainte Marie-Madeleine* (1860). Lacordaire's influential book and his efforts to reanimate the traditional pilgrimage to Sainte-Baume in the saint's honor added to the debate surrounding the authenticity of the Magdalen legend in the later nineteenth century.[9] Cézanne's painting of the Magdalen, so steeped in local tradition and with so many probable local models, thus acquires special meaning in his hands.

Aside from her specifically religious connotations, the repentant Magdalen was receiving renewed attention—and a new role—in nineteenth-century France. During the Bourbon Restoration (1814–1830) she became a symbol of a despondent nation repenting the martyrdom of its king.[10] The elements of sexuality and transcendence in her history accorded with the romantic tension between the flesh and the spirit and made her a popular romantic heroine as well. Antonio Canova's sculpture of the weeping Magdalen was a sensation at the Salon of 1808 and was described by Stendhal as the greatest work of modern times.[11] Similarly, in Delacroix's painting of the penitent saint, *La Madeleine et un ange* (ca. 1843–1845), the dual aspects of the saint's life are combined in a powerful image of sensuality and remorse.[12] And after the Revolution of 1848, the Provençal painter Daumier, though profoundly anticlerical and usually at odds with the Church, produced an intensely mystical religious painting, *Madeleine pénitente*.[13] This work, too, owed something to the political context into which the image of the Magdalen was being drawn, as Daumier did it at the request of the new republican government, which wanted a symbol of its greater political and religious tolerance in comparison to that of Louis-Philippe.[14] Clearly, Cézanne's por-

trayal of the Magdalen in repentance was dependent on romantic as well as Provençal traditions.

Though it was rarely treated by nineteenth-century artists, the other portion of this contentious dual painting, the *Christ aux limbes*, also has numerous antecedents, even if Cézanne's picture can be traced to a single source. The legend of Christ's harrowing of hell can be traced to the *Gospel of Nicodemus*, an anonymous early medieval work written to document the major tenets of faith espoused in the Apostles' Creed. In the thirteenth century, Vincent of Beauvais and Jacobus de Voragine recounted the event in the popular *Golden Legend*; a French edition of the 1840s brought this famous collection of saints' tales new and wider recognition. In the *Golden Legend*, the story of the scene in limbo is told by two people, Leucius and Karinus, the two sons of Simeon, who were among those resurrected by Christ; these may, in fact, be the three figures whom both Sebastiano and Cézanne have included in the background, facing the viewer. In the foreground, Christ meets Adam and Eve.

Although there is no firm biblical basis for the legend, the New Testament does make references to the salvation of the ancient dead and to Christ's victory over death, hell, and the powers of darkness.[15] In both the *Gospel of Nicodemus* and the *Golden Legend*, emphasis is placed on the conflict between light and darkness—with Christ representing light and victorious faith and Satan sin and vanquished darkness. The shafts of light that break into the deep chiaroscuro of the works by Sebastiano and Cézanne and that radiate from Christ may represent each artist's awareness of the symbolic meaning of illumination in this context, even if they do not conform to the standard artistic depictions of the legend.

As mentioned earlier, the concomitant relation of the harrowing and Magdalen scenes was not at all unusual in narrative and theatrical literature. The influence of the *Gospel of Nicodemus* in general, and the story of the harrowing of hell in particular, on medieval art and literature was extensive.[16] Almost every Easter cycle of miracle plays included a version of this vivid confrontation. By the late Middle Ages, the dramatic role of Mary Magdalen, expressing intense grief in eloquently lyrical laments, had also become a principal element in the Easter plays.[17] In the liturgical drama *Ordo paschalis*,

produced in Klosterneuburg, the two events were joined into a single episode, suggesting corresponding themes of faith and salvation.[18] In some surviving plays from this period the Easter drama was divided into episodes that occupied specific areas of the stage, which was regarded as a symbolic and mutable world, and through this configuration permitted dialogue between the participants in the different events. The harrowing of hell and the lament at the tomb may, in fact, have been placed physically close to one another in some dialogued versions of the Easter story, allowing for just such an interchange.[19]

Aix was among the many areas where a passion play was produced each Easter, performed by the *Sociétés des jeunesses*, youth groups that took part in civic and religious functions.[20] These plays were still being performed during Cézanne's youth, and the dramatic role of the Magdalen would have been considerable in this city of which she was the honored patroness. Unfortunately, no texts for these plays have survived, so they cannot be studied specifically. However, it is evident from what we do know that Cézanne's juxtaposition of the themes of the harrowing of hell and the penitent Magdalen is by no means unique. It seems to reflect, if indirectly, a similar tradition in popular liturgical theater.

In addition to literary and dramatic sources, Cézanne might also have drawn on artistic traditions that regularly combined the two images. For example, the weeping Magdalen is often pictured next to the newly risen, triumphant Christ in traditional symbolic images of the penitent saints.[21] Rubens's *Christ and the Penitent Saints* is perhaps the best known of such *repenti* images,[22] but closer to Cézanne's conception is the painting by Caspar de Crayer (1584–1669) of the same subject (fig. 22). Visually and iconographically related to the traditional image of Christ in limbo, the motif of Christ and the penitent saints presents a more timeless—in that it is purely symbolic—enactment of the theme of repentance, faith, and salvation than that of the harrowing of hell from which it evolved. It is also one in which the weeping Magdalen, an arresting, tragic figure, has a central role. Cézanne's juxtaposition of the two scenes suggests his familiarity with this tradition.

Cézanne's knowledge of broad religious, historical, literary, and artistic traditions relating to the limbo and Magdalen images, both separately and in

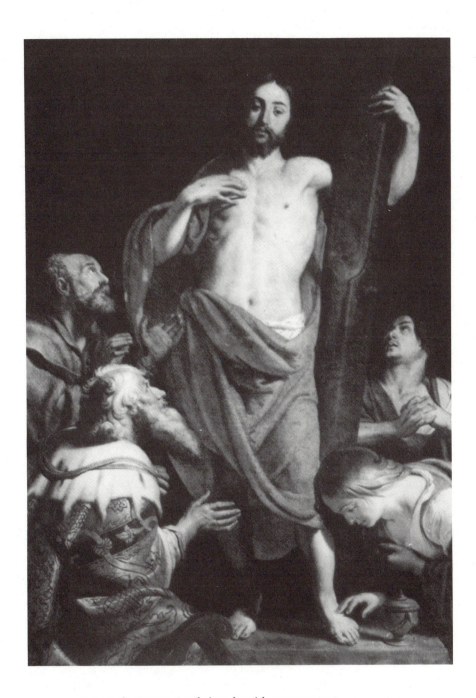

FIG. 22 Caspar de Crayer, *Le Christ et les pécheurs repentants*.

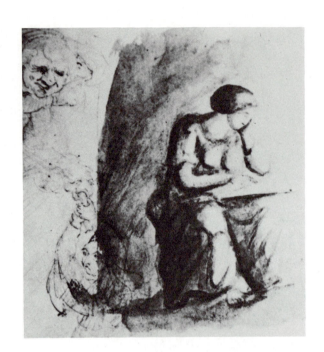

FIG. 23
Paul Cézanne,
Woman Reading
pencil and wash.

FIG. 24
Paul Cézanne,
*Woman Reading
Outdoors*, pencil.

FIG. 25
Paul Cézanne,
studies of a
mourning
woman, pencil
and watercolor.

conjunction, is a rich area for speculation, but his work suggests that he was well versed in the complex imagery of the Magdalen in particular. An early wash drawing of ca. 1860–1865 (fig. 23) depicts the familiar Magdalen motif of a melancholic figure reading in a darkened cavelike space. It is reminiscent in form and mood of several versions of the penitent Magdalen by Georges de La Tour.[23] In a later study, probably based on a painting of the Magdalen then attributed to Correggio, Cézanne depicts her as a sensuous nude in a landscape (fig. 24).[24] And in a recently discovered drawing (fig. 25), Cézanne sketched a figure in mourning, which may well depict the Magdalen and derive from a larger crucifixion scene.[25] But his painting for the Jas de Bouffan is by far the most elaborate of his Magdalen images, combining a number of different motifs. In the *Golden Legend*, she is called "'light-giver' because therein she drank avidly that which afterward she poured out in abundance; therein she received the light with which afterward she enlightened others." As Cézanne's Magdalen grieves over the death of her savior, the Pentecost-like flames over her head symbolize the enlightened faith and salvation that will come to her in the moment of the Resurrection, which is anticipated in the adjoining scene.[26]

In his depiction of this redeemed fallen woman, Cézanne could also have drawn on a literary commonplace: descriptions of her in which her pearls and rubies are transformed into burning tears and tongues of fire, symbols of both her lament and conversion. A sonnet by P. Le Moyne, inspired by a painting of Guido Reni and dedicated to "La Madeleine nouvellement convertie," provides an explicit picture of this twofold image:

> Ici d'un repentir célèbre et glorieux
> Madeleine à soi-même indulgente et cruelle
> Guérit de son péché la blessure mortelle
> Et par ses larmes tire un nouveau feu des Cieux.
>
> Son luxe converti devient religieux:
> L'esprit de ces parfums se fait dévot comme elle
> Ces rubis sont ardents de sa flamme nouvelle
> Et ces perles en pleurs se changent à ses yeux.
>
> Beaux yeux, sacrés canaux d'un précieux déluge,
> Innocents corrupteurs de votre amoureux juge,
> Ne serez-vous jamais sans flammes ni sans dards?
>
> Au moins pour un moment faites cesser vos charmes
> La terre fume encor du feu de vos regards
> Et déjà vous brûlez le ciel avec vos larmes.[27]

The vivid imagery of the converted Magdalen's tears illuminating the sky seems to have attracted the romantic young Cézanne; the tears on the face of his Magdalen (pl. II) are, in fact, bright red and find their echo in the pendulous flames above.

Symbolic allusions to the Magdalen's new faith may also have suggested a conflated image to the artist. The two events depicted in his large painting coincide in traditions in which the Magdalen is equated with the allegorical figure of Synagogue, a personification of the Old Testament Hebrews' disbelief in the New Testament Christ. Among others in the cluster of allusions that surround this eloquent figure, St. John's detailed account of the role of Mary Magdalen in the Easter story stimulated its introduction into the

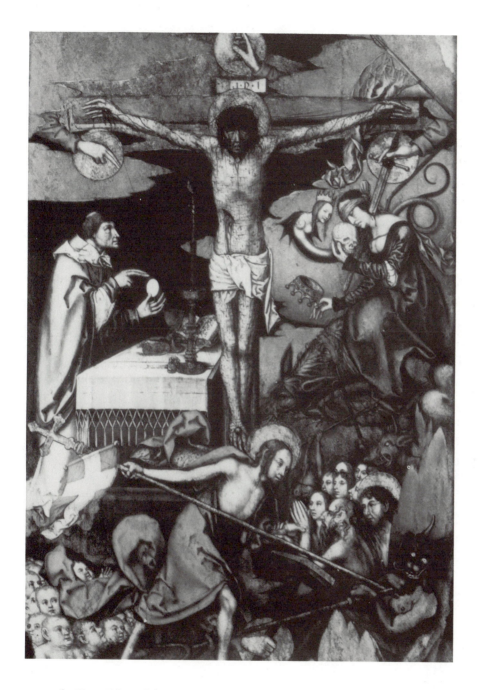

FIG. 26 Hans Fries, *Living Cross*.

Easter plays and suggested to commentators this identification. In St. Gregory's twenty-fifth homily, read on Thursday of Easter Week, Mary Magdalen is interpreted as a symbol of the penitent who tearfully seeks Christ and is finally rewarded, an image that Cézanne has incorporated. More significantly, Cézanne's juxtaposition of the weeping Magdalen contemplating a skull with Christ's harrowing of hell recalls an artistic tradition of Resurrection symbolism. The closest example is seen in Hans Fries's ca. 1510 *Living Cross* (fig. 26), in which a very similar figure of Synagogue is paralleled by the same Descent. Both a general and specific thematic equation of the two figures of Mary Magdalen and Synagogue can be found in Gregory's twenty-second homily, read on Low Saturday, the Saturday of Easter Week: "The Church of the Gentiles hath run in a parallel road with the Synagogue. . . . The Synagogue came first to the Sepulchre [as did the Magdalen], but she hath not yet entered in; for . . . she will not believe in him who died for her."

Cézanne, then, intended his original work to be much more than the simple juxtaposition of two known motifs. There were dramatic, liturgical, artistic, and literary traditions for him to draw upon to create a unified work. Along with his religious awareness, a coherent theme of doubt, enlightened faith, and spiritual reward draws together his conception of the whole. One of his most eloquent tributes to his native Aix, his painting of *La Madeleine et le Christ aux limbes* reaffirms, on another level, the informed vision and wealth of tradition that Cézanne's religious imagery encompasses.

PATRIARCHS AND PROTAGONISTS

Biblical Images and the
Context of Romanticism

IV

CEZANNE'S CHOICE OF BIBLICAL SUBJECTS ranged beyond those given special meaning by their Provençal context. His rudimentary drawing of Moses and his painting of the Magdalen become more intelligible when viewed in light of local custom and tradition. However, his early renderings of two other biblical figures, Job and Lot, exemplify the expressive treatment such subjects were often given by romantic artists and the traditional sources behind the transformed elements.

Although few in number, these biblical works from the 1860s are an important part of Cézanne's early development and are essential to a study of his first decade. They further document Cézanne's familiarity with the standard artistic conventions for such religious subjects, even when those conventions are willfully subverted, and thus the biblical works underscore the major role tradition played in the creation of his early work. Yet the significance of these scenes is really twofold. His *Job et ses amis* and the provocative *Loth et ses filles* reveal the haunting, expressive power with which Cézanne endowed traditional motifs, making them into potent—and personal—romantic statements. They firmly link his early work not only to previous traditions but also to the larger, contemporary romantic movement.

Cézanne's early brush drawing of *Job et ses amis* (fig. 27), dated ca. 1864–1867, is one of his most finished and exquisite. In this moving version of the biblical episode, the tormented patriarch is sitting humbly on the ground with bare legs extended, while bending over Job are three friends who deride him.[1] One of the three is barely visible in the upper right corner.[2] The composition is consistent with a long-established tradition in representations of

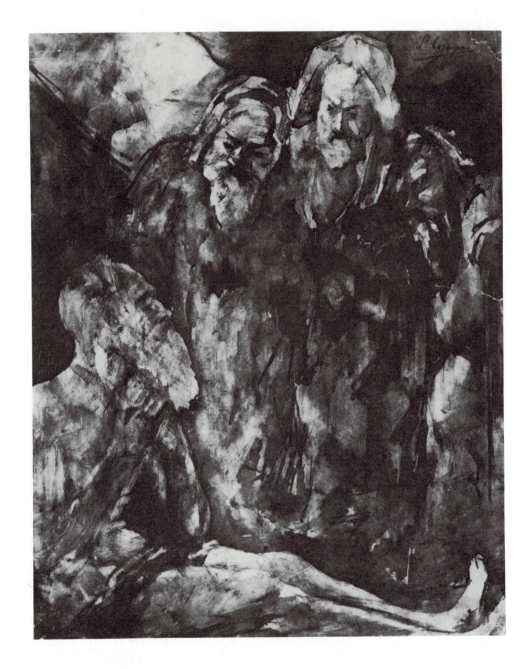

FIG. 27 Paul Cézanne, *Job et ses amis*, pencil and brush with brown wash.

FIG. 28 Spanish School, 17th century, *Job*.

Job and makes evident Cézanne's knowledge of such conventions. A starkly profiled, two-dimensional figure of Job, seated on the ground with his bare legs extended, can be traced in French sculpture at least as far back as reliefs on the north transept at Chartres or the slightly later tympanum from the Calixtus portal at Rheims (ca. 1220);[3] this horizontal orientation for the subject remained popular in French art through the late baroque period. In the nineteenth century, both an engraving by Gustave Doré and the painting *Job et ses amis* by Ingres's student Claudius Lavergne testify to the survival of the motif.[4] It also commonly figured in the mise-en-scène for this episode in nineteenth-century dramatic versions of the biblical story.[5] More generally, the theme of long and patient suffering helps to relate the motif to well-known classical and neoclassical antecedents, such as antique depictions of defeated heroes and the works of Poussin and David. David's *Seneca*, like many impervious neoclassical sufferers, is portrayed in this poignant, seated position.[6] So similar, in fact, were such depictions of classical and biblical suffering that a famous painting of Job, then attributed to Velázquez, and until 1848 on view in Louis-Philippe's Musée Espagnol (fig. 28), had been

misinterpreted, ironically, as a Dying Seneca.[7] In Cézanne's own work, as in artistic and biblical typology in general, the drawing of Job anticipates his later images of the dead Christ.

Chappuis has suggested Cézanne's ca. 1866–1869 study (see fig. 59) after Fra Bartolommeo della Porta's drawing of an *Entombment of Christ* in the Louvre (see fig. 60) as a basis for the Job composition.[8] But it is more likely that the relationship between the two works is reversed. The wash drawing of Job is clearly part of an established tradition; its inherent pathos may have stimulated Cézanne's interest in Bartolommeo's visually and iconographically related image of Christ. Whatever the connection, the emotive power of the image of embodied suffering seems to have impressed Cézanne deeply, and he returned to it in several other works. He copied Delacroix's *Agar dans le désert* which featured another tormented biblical figure in a pose similar to Job's,[9] and reinterpreted the same basic motif in more dramatic and contemporary terms in his ca. 1868 painting *La Toilette funéraire* (pl. VII), to be discussed in chapter VI.

As with his other works based on literary images, Cézanne's choice of subject was stimulated by thematic as well as visual considerations. Job's acute self-doubts and miseries certainly found resonance in the young and impressionable artist; in fact, Job's plaints are echoed in several of Cézanne's gloomy early poems.[10] Moreover, Job, like Mary Magdalen, was an immensely popular subject in Cézanne's time; the biblical account of his dramatic and causeless adversities made him a favorite figure in romantic art and literature, which indulged its fascination with doomed and embattled protagonists. In addition to the personal meaning the story of Job may have held for Cézanne and his response to the poignant formal elements in the tradition as a whole, his choice of subject reflects the painter's absorption of the general aesthetic currents of his time.

To the romantic imagination, Job represented the fervid individualist who refuses to cease rebelling against mundane life and the empty rituals that sustain it.[11] Moreover, like Socrates, Jesus, and Torquato Tasso, Job exemplified a type of hero very much in the romantic mode—a victim of an irrational fate whose story provided visually spectacular or poetically arresting images. William Blake's elaborate cycle of illustrations of Job's story epito-

mized the depth of self-involvement the romantics could display in the plight of the Old Testament patriarch.[12] And Flaubert's densely pictorial tale of Saint Anthony—which Cézanne would later depict (pl. XII)—was analogous to the drama of Job, and the two must have appealed to the painter for some of the same reasons. While engaged in handling a traditional biblical image such as that of Job, an artist could confront both personal doubts about faith and self-determination and the nature of human suffering, issues that engrossed many nineteenth-century romantics.

A mid-century revival in France of religious art and sentiment also helped to foster a new appreciation of the Job narrative, though from an appreciably more philosophical standpoint than that of the romantic movement. For example, the nineteenth-century French historian and philosopher Ernest Renan advanced profound questions about divine justice and the reason for human suffering in his *Histoire générale et système comparé des langues sémitiques* (1864), a philological work that included a controversial interpretation of the Job story. A more traditional interpretation could be found in *Job, drame en cinq actes* (1866), a play by the philosopher and social reformer Pierre Leroux, which accepted the idea of a benign God but nonetheless concentrated on the theme of inexplicable human suffering.[13] Social tracts somewhat parallel in tone to these literary works include Eugène Buret's *De la misère des classes laborieuses en Angleterre et en France* (1840) and l'Abbé Mullois's *La Charité et la misère à Paris* (1856). The interest of these writers in social injustice was far from either the romantic absorption in individual anguish or from the philosophical issues raised by Renan and Leroux, but they expressed doubts similar to those voiced by their contemporaries.

Such skepticism was perhaps best known to Cézanne through the work of Alfred de Vigny, who was one of his favorite poets. De Vigny's recounting of the tragic biblical story of Jephthah in his poem of 1820, *La Fille de Jephté*, celebrated the travails of a hero very much like Job.[14] De Vigny's God was often capricious or inexplicably ruthless, as revealed in the poet's *La Prison* (1821) where the dying man piteously declares: "Take a good look at me and then say that a God defends the cause of the innocent. . . . Alone, always alone, overcome by age and suffering, I die full of years, and have not yet lived."[15] Cézanne parallels this sense of irony and despair in his treatment of

FIG. 29 Paul Cézanne, copy after Dubufe's *Le Prisonnier de Chillon*.

a directly romantic subject, Lord Byron's tragic hero Bonivard from the *Prisoner of Chillon*, in a painting of the same name dating from the early 1860s (fig. 29). Although closely copied from a painting in the Musée Granet by Edouard-Louis Dubufe (1820–1883), Cézanne emphasized in his version the shadowy chill of the dungeon-cum-tomb and the black melancholy of the hero.[16] Establishing again the relation between biblical subjects and the romantic environment, the work is similar to both the *Job* painting and *La Toilette funéraire*, with the hero's dead companion posed like the exhausted prophet of the former, and the anonymous cadaver of the latter, work. When we consider the complex network of influences surrounding it, Cézanne's *Job et ses amis*, despite its historical theme and motif, becomes a uniquely expressive and personal statement by the young artist.

In striking contrast to his somber wash drawing of Job is Cézanne's small, lustrous painting on the biblical theme of Lot and his daughters (pl. III). The previously unknown painting, which has been dated ca. 1861, has only recently come to light in a private collection formerly in Aix.[17] The canvas depicts explicit lovemaking between Lot and his eldest daughter, identifiable

by her closely knotted hair, while the younger daughter, with flowing hair—both established visual motifs—looks on.[18] The shadowy setting of the scene is the cavern outside Zoar described in Genesis 19:30–38; the burning light in the distance denotes the fiery destruction of the cities of Sodom and Gomorrah. Silhouetted against the background glow is a large, ornate wine jug—a standard element in treatments of this subject—alluding to Lot's drunken state at the time his daughters seduced him. Fearing that they alone had escaped a universal holocaust, the two conspired, as the Bible records, to "make our father drink wine" and then to "lie with him, that we might preserve the seed of our father."

In the aspects of the story he chose to emphasize and in the painting's mood and execution, Cézanne's canvas recalls the early romantic work of Delacroix, especially his *Mort de Sardanapale* (fig. 30), which was inspired by Byron's play on the same subject. Studies that Cézanne made of the *Sardanapale* have been dated ca. 1866–1867, but his Lot suggests an even earlier attraction.[19] The palette of his *Loth et ses filles*, a dark background enlivened with brilliant reds and golds, comes strikingly close to the coloring of the *Sardanapale*. Similarities of feature such as the flowing red draperies, lustrous nudes, ornate jugs, and distant fires also link the two paintings. Compositionally, Cézanne's diagonally arranged figure group, offset by the glowing fire in the upper right corner, subtly mirrors Delacroix's more elaborate pictorial scheme. And his vehement brushwork, evident especially in Lot's boldly executed cloak, overtly displays his debt to Delacroix's style and technique. The relation of *Loth et ses filles* to Delacroix's work establishes yet again that Cézanne's treatment of biblical subjects owes as much to his growing understanding of the romantic attitude as to his comprehensive awareness of traditional precedents.

Although it recalls the style of Delacroix's *Sardanapale*, the Lot composition departs radically from most previous treatments of this biblical episode. Nowhere else, in fact, does Cézanne so fiercely affront tradition or the sensibilities of his viewers. Italian and Northern European mannerist and baroque painters favored a side-by-side arrangement for the three figures.[20] This gave the composition a formal symmetry and the subject an ambivalent context, with only the slightest hint of sexual interplay. Even Courbet chose

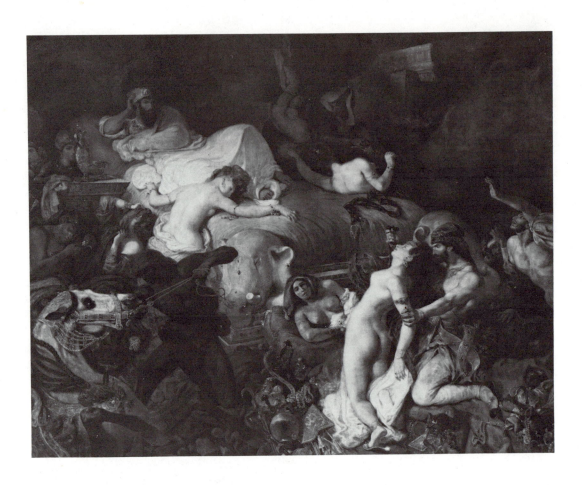

FIG. 30 Eugène Delacroix, *La Mort de Sardanapale*.

FIG. 31 Agostino Carracci, *Loth et ses filles*, engraving.

this more symmetrical organization for his rather conventional painting of ca. 1840 (although preparatory drawings suggest that an earlier version, now lost, may have been more erotic).[21] In Cézanne's more complex composition, the three figures are interlocked in a tight, dynamic triangle of extended limbs and swirling drapery. One of the daughters, with a *profil perdu*, is seen from behind. This type of arrangement had precedents but only in the most explicit representations of the story, which existed principally in engravings. In his extensive study of the Lot theme, Joshua Kind notes that an engraving of ca. 1530 by Georg Pencz was one of the first to depict the elder daughter from this intimate viewpoint, close to the viewer and unmistakable in her posture.[22] In Agostino Carracci's erotic engraving of the subject (fig. 31), from his widely circulated *Lascivie* series, the elder daughter is shown in profile but is twisted to reveal more of her nudity. The scene as a whole has bacchic rather than biblical overtones. A work somewhat closer to Cézanne's general conception (though his boldness is without any real precedent) is Jan Müller's widely circulated engraving, which was possibly based on a painting by Bartholomäus Spranger.[23] In it the massive figure of the elder

daughter, facing backward, reaches out for the diminished figure of Lot. In so doing, she draws the viewer into the erotic scene she dominates. Cézanne's painting, however, is even more erotically charged. The elder daughter is also seen from behind but in the act of forcefully grasping her visibly aged, drunken father. Her gesture adds to the sexual tension of the scene, already evident in Lot's taut limbs and wildly disheveled cloak. The viewer's sense of sharing this intimate scene is reinforced by the proximity of the third figure, the younger daughter who faces the viewer and is shown with one breast bared. She invites us, as do similar figures in ribald seventeenth-century Dutch genre scenes, to witness the lewd spectacle being played out before us.

Depictions of Lot and his daughters had rarely appeared in medieval texts but had become commonplace by the sixteenth century, especially in Northern Europe. The image entered the visual arts in general at a relatively late date, because of obvious problems associated with handling the story's incestuous subject.[24] While the theme of incest was long accepted in mythological painting, and other salacious Old Testament themes remained popular, it was the "confluence of the biblical with the incestuous" that seemed to give the subject of Lot "a uniquely prohibitive aspect."[25] Only when any hint of moralizing was absent, as in Cézanne's version, did it become a common theme in painting.

The drunken Lot emerged as a popular subject in Northern art early in the sixteenth century and continued in the seventeenth, but the idea of love-play was rarely even suggested. Lot's drunkenness provided a pretext for pastoral scenes of feasting and elaborate still lifes as seen in Gabriel Metsu's painting in Aix (fig. 32). Often the daughters appeared as bystanders or in the company of other guests. A love of conflagrative effects and vast panoramas encouraged a very different sort of treatment elsewhere in Northern painting, where the emphasis switched from the figures to large dramatic landscapes lit by explosive fires.[26] In still other versions from this school, the wide disparity in age between Lot and his offspring made for links with such popular genre motifs as the mismatched couple or the ill-assorted lovers.[27] Rembrandt's numerous drawings of the Lot theme suggest another interpretation of the subject, one to which Cézanne was clearly also sensitive. The drunken Lot became a poignant image of self-revelation, and Rembrandt's

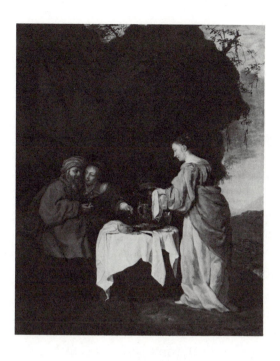

FIG. 32 Attributed to
Gabriel Metsu, *Loth et ses filles*.

images from the 1650s of a weary, aged Lot are telling reminders of the art-
ist's own advancing age.[28]

Much as Rembrandt's Lot drawings reveal the dark dimension of advanc-
ing mortality, Cézanne's painting suggests, beneath its boisterous surface, a
mood of dark terror that has explicit roots in both the romantic conjunction
of sexuality and violence and aspects of the painter's own, sometimes tor-
tured, sensibility. Undoubtedly, Cézanne was attracted to the story of Lot be-
cause it allowed, as had Byron's drama *Sardanapalus*, occasion for expression
of an illicit but potent sensuality, one he simultaneously explored in his
erotic early poetry. The theme also suggested a number of visual possibilities
that were already emerging as subjects and motifs in this first, most experi-
mental decade of Cézanne's career. The combination of drunkenness and
love-play made for strong orgiastic overtones explored in *Le Festin*, painted
late in this period. And the wine vessel in the Lot painting—a requisite nar-
rative element—became both symbol and still-life object in such erotic fig-
ure compositions as *L'Après-midi à Naples* (V. 224).[29] But principally it is the
mood of dread and force that links Cézanne's small canvas with so many of

his other early images of sensuality. The dark mountain cave and the distant glow of the conflagration are an appropriate backdrop to a scene of lovemaking that is rife with conflict and demonstrates the depth of the artist's personal involvement with the imagery of his early fantasy paintings. Likewise, the vehemence of the brushwork in *Loth et ses filles* suggests the artist's violent attitude toward that sexual image as much as it does his appreciation of Delacroix's style.

The association of sensual and destructive elements, the union of love and death, such as the Lot story offers, are themes Cézanne explored often in his early work.[30] Moreover, the prohibitive subject of the Lot theme links Cézanne's canvas to a general romantic fascination on the part of both writers and artists with illicit love and incest in particular. Horace Walpole, Percy Bysshe Shelley, René Chateaubriand, and Byron all explored this dark phenomenon in their work and drew dramatic inspiration from the tragic emotions it could evoke.[31] Flaubert also flirted with the taboo subject.[32] And, in a list of projects to paint in the early 1820s, Delacroix had included Ovid's Myrrha, less notorious than the concubine of Byron's *Sardanapalus* but the central figure in the incestuous story told in book 10 of the *Metamorphoses*.[33]

Cézanne's fascination with the Lot story, which finds its most dramatic expression in *Loth et ses filles*, is manifested elsewhere in his early period. On a sketchbook sheet dated by Chappuis ca. 1866–1869 (fig. 33), Cézanne copied the figure of Lot's younger daughter from Veronese's large painting in the Louvre, *L'Incendie de Sodome* (fig. 34). In his study of the Venetian painting, he carefully reproduced the play of light on the figure and her diaphanous drapery as well as her dramatic and sensual pose.

In light of the background of both the subject and the various gestural and visual motifs used to convey it, it becomes possible to identify another Lot image among the early works, one that is less explicit. This drawing, dated ca. 1860–1865 (fig. 35), is believed by Reff to be a study for Cézanne's painting *Le Jugement de Pâris* (V. 16), though this suggestion has met with some resistance.[34] The drawing can now be read convincingly as a more conventional version of the biblical story of Lot, and one with less emphatic romantic overtones.

The abandoned slung-leg position of the figures in Cézanne's drawing is a

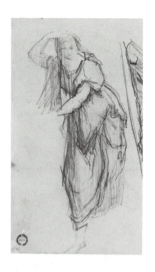

FIG. 33 Paul Cézanne,
copy after Veronese's
L'Incendie de Sodome,
one of Lot's daughters,
pencil, detail.

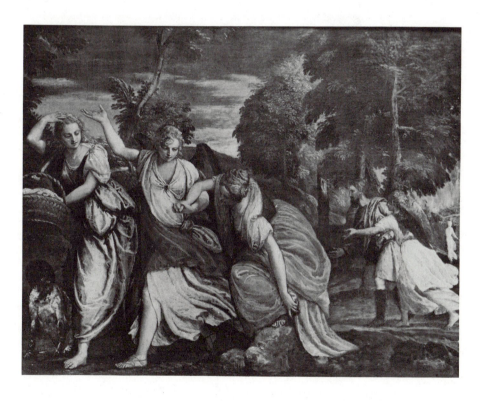

FIG. 34 Paolo Veronese, *L'Incendie de Sodome*.

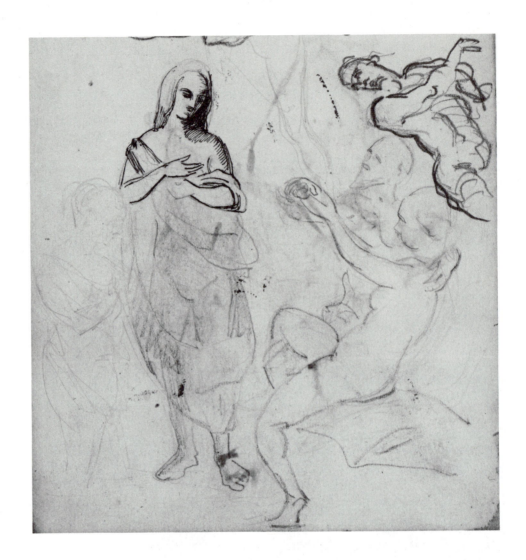

FIG. 35 Paul Cézanne, page of figure studies, pencil and pen, detail.

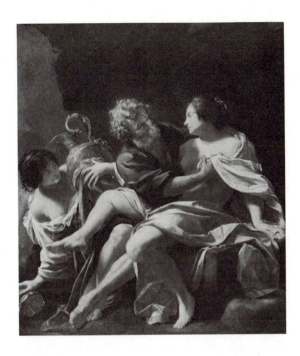

FIG. 36 Simon Vouet,
Loth et ses filles.

coded representation of the lovemaking he would depict more openly in his
painting.[35] It was a favorite device of Netherlandish painters in their treat-
ment of the theme of Lot,[36] and Simon Vouet's sensual painting of 1633 (fig.
36), which was frequently copied, centers around this symbolic gesture, one
that other French painters of the Lot subject would adopt.[37] A common sign
in earlier art of sexual union, it helped to remove from this biblical subject
any sense of moralizing content by emphasizing its purely erotic character.

In both Cézanne's drawing and painting, the figure of Lot is shown from a
three-quarter view and with a pronounced beard. In the drawing as in the
painting, the elder daughter is featured with the traditional plaited hair; yet
at the lower right of the sheet she is embraced by Lot. This gesture is another
respect in which the drawing is a more traditional treatment of the subject
than the later painting. Despite the account in Genesis, when sexual play is
intimated in paintings of Lot's story, he is more often portrayed as a lecher-
ous aggressor—as Vouet pictured him—than as a pathetic recipient of his
daughter's advances.[38]

On the lower left in Cézanne's drawing, the younger daughter is shown

with flowing locks and one breast bared as in the paintings. Her transparent drapery negates her chaste pose and alludes to her role as an accomplice in the unfolding narrative. Unlike the darker painting and in keeping with many of the lighter depictions of the story, any hint of violence is gone, and the scene takes on the air of a bacchic pastoral.

A close analysis of his early drawing reveals that the symbols and metaphors traditionally used to make the biblical story of Lot more presentable in visual terms were well known to Cézanne. The motifs find only a fragmentary role, however, in his painting of the same subject. Despite certain general parallels that may be drawn between his canvas of *Loth et ses filles* and prototypes that would have been available to him, Cézanne's painting clearly stands apart. The level of sexual explicitness aligns it more closely to the most frankly erotic treatments of mythological themes, such as Leda and the swan, than to any earlier works inspired, however remotely, by the biblical patriarch.

Filled with a potent suggestion of his own troubled, youthful sexuality, which is elsewhere stated this emphatically only in some of the early poems, Cézanne's painting of *Loth et ses filles*, as Gowing notes, would have verged in its day on pure pornography.[39] As forcefully as any of his later and more masterful fantasy paintings, this small canvas all but overpowers the viewer with its heated and intensely private inner vision. Yet it was much more than his viewers' polite sensibilities that Cézanne was striving to affront. While individual elements in his painting—the daughters' distinguishing hairstyles, the distant fire, the wine vessel, and the cavelike setting—point to his obvious awareness of the biblical story's conventional depictions, Cézanne's conception as a whole is a deliberate travesty of that pictorial tradition. His painting reveals, at the very start of his working life, the artist's occasional need to subvert such norms in images that were intentionally and dramatically beyond the pale.

Although it shares with his delicate wash drawing of Job a personal expressiveness and larger romantic affinities, Cézanne's Lot shows an artist learning to shape tradition to his own ends.

OUTCAST
AT THE FEAST

*Cézanne's Picnics and the
Art of the Fête-Galante*

CEZANNE'S AFFINITY with the romantic movement, like his early efforts in the realist style, was evident in a number of ways. As both style and sensibility, it was as multifaceted as the movement itself, reflecting romanticism's many sources and moods. Some of his early romantic works, imbued with the spirit of the early eighteenth century, offer lighter, less impassioned alternatives to his intense, uneasy fantasy paintings. While evidently part of a larger rococo tradition of non-narrative images that included elegant fêtes and fantasies, a genre that persisted even in the work of the impressionists, especially that of Renoir, they also bring to light an important undercurrent in the Provençal romantic school. More extensively than any of his contemporaries in either Paris or Provence, Cézanne probed the meaning and possibilities of eighteenth-century painting and sought to validate its currency in his own day.

Neoclassicists, both artists and critics, had condemned the rococo period for its sensual themes and emphasis on technical virtuosity; there also was general criticism of its alleged corruptive influence on society.[1] Yet the art of the rococo—especially amorous and erotic themes and scenes of fashionable urban life—continued to thrive in the early nineteenth century. Such subjects found a substantial audience in private collectors and became the forte of *petits maîtres* like Carle Vernet.[2] They were even more fashionable in the less exclusive and less expensive realm of popular prints.[3] But with the intensification of the French romantic movement, artists and critics alike became newly aware of eighteenth-century painterly sensibilities and light poetic conceits, and a different view of the rococo tradition evolved. More

appealing to romantics than intimate boudoir subjects (which would, however, be copiously recreated by minor followers of the style) or scenes of aristocratic splendor was the eighteenth-century image of a delicately perfect nature. Rococo paintings of quiet, elegant figures in harmony with sunlit, idealized natural settings were recalled in countless ways by romantic painters and reflected upon by their critics.

Founded in 1831, the popular journal *L'Artiste* was at the heart of the nineteenth-century rococo revival.[4] With its many studies and frequent reproductions of rococo works, it kept before an eager public, who had come to treasure the style, visions of a past golden age. Like the nineteenth-century perspective on baroque Holland (see chapter VI), the era responsible for such idyllic scenes came to be seen as one with an enviably stable society. The rococo school itself became the subject of nationalist pride as the first truly French art style to develop since the medieval Gothic.[5]

Of all the newly celebrated masters, Antoine Watteau most excited the romantic imagination. In his *Histoire de l'art français au dix-huitième siècle* of 1860, the poet Arsène Houssaye described Watteau as both a great painter and a great poet.[6] Houssaye saw in Watteau's colorism and imagery refreshing antidotes to the decadent academic tradition. Equally charmed, Théophile Gautier took special delight in Watteau's view of nature that blended sensuality and fantasy.[7] Gautier and Houssaye were two of the founders of the *cénacle*, a group of romantic artists and writers that revered rococo and other antiacademic painting.[8] Even the influential critic Théophile Thoré, initially repulsed by the eighteenth-century school and its contemporary adherents, in time fell under the spell of "l'art coquet et parfumé" of Watteau.[9] Charles Baudelaire, a close friend of Gautier's, extolled Watteau's idyllic scenes of figures in nature in several of his early poems.[10] But it was the de Goncourt brothers in their *L'Art au dix-huitième siècle* of 1860 who grasped most fully the significance Watteau and the rococo as a whole had for painters of their time, including Cézanne. In their understanding of Watteau's fusion of a sensual brushstroke with an equally sensual pose or figure and his imaginative use of light and color to enhance the sense of fantasy, the de Goncourts suggested a depth and poetry in rococo painting few others had seen.[11] To them, Watteau's art represented not only a pinnacle of elegance

and artifice but a school of painting where freedom of style and fantastical idealization of subject were uniquely one. Cézanne had the same understanding of Watteau's work, and his investigations of rococo painting demonstrate his use of technique not as cosmetic manipulation but as a thoughtful consideration of subject and treatment.

Even before critical reclamation of the style, the rococo had lingered in Provence and seems to have influenced Cézanne at an early date. The tradition had been well established in Aix in the previous century in the paintings of Jean-Baptiste van Loo and in the work of such minor regional masters as J. S. Duplessis and Henry d'Arles.[12] In the nineteenth century it was first manifested in the painting of Camille Roqueplan, a friend of Houssaye and Gautier from Marseille, and something of a dandy. Gautier drew early critical attention to Roqueplan and praised him for matching the grace of Watteau in such delicate works as his painted fans.[13] In later works, such as his 1849 watercolor *Deux Femmes cueillent des cerises*, Roqueplan's broader handling of the paint, darkened palette, and monumentality of form signaled a debt to Courbet that anticipates Cézanne's early works in a more realist vein.[14]

Before establishing himself as a master painter of the Provençal landscape, Emile Loubon also had painted pastiches of eighteenth-century art. As a young man, Loubon studied with Roqueplan and, like him, intermingled genteel rococo imagery with realist touches of light and color.[15] Later, as curator of the Marseille museum, Loubon organized several large exhibitions that included the rococo-inspired works of his Parisian friends, and the 1861 annual exhibition, the impact of which was felt throughout the region, featured a number of Watteau fêtes.[16]

Loubon's follower Prosper Grésy (1804–1874) further deepened Provençal interest in eighteenth-century art and thought, especially its notion of an ideal nature. He first studied in Arles with the rococo revival painter Eugène Devéria and then in Aix with Joseph Gibert, but in the late 1820s came under the influence of Loubon in Marseille, as his *Mont Sainte-Victoire* of ca. 1840 (Musée Granet) makes evident.[17] Yet such later works as his *Baigneuses* of 1854 (fig. 37) convey what one critic has called "une certaine sentimentalité impalpable" quite distinct from his regional colleagues.[18] While still

FIG. 37 Prosper Grésy, *Baigneuses*.

reminiscent of Loubon's works in their brushwork and almost tactile surfaces, Grésy's ideal natural settings in such pieces had little reference to Provence. His flickering light and delicate, nymphlike figures seem closer to eighteenth-century mythological landscapes than to any realist scenes of bathers in the hot Midi sun. Moreover, his proposed affinity between the figures and their surroundings restated in romantic terms an eighteenth-century harmony that Cézanne's bathers would ultimately redefine.

Of all the Provençal artists caught up in the rococo revival, by far the most involved was Adolphe Monticelli (1824–1886), called the *Watteau provençal* by his friends.[19] Influenced initially by Narcisse Diaz de la Peña (1807/8–1876) and his numerous pastiches of rococo art, Monticelli became a prolific painter of fashionable fêtes-galantes and eighteenth-century-style mythological scenes. His debt to the rococo was deliberately acknowledged in works like the *Gilles séducteur* or *Fête à Saint-Cloud*, which even in their titles evoke the Watteau and Fragonard examples from which they are drawn.[20] Monticelli's active role and frequent exhibitions in Marseille salons helped to sustain the city's interest in the art of the eighteenth century and its romantic legacy.[21] Although Cézanne did not meet Monticelli until the late 1860s, he certainly knew the older artist's work from regional exhibitions and shared his deep attachment to eighteenth-century painting. By the 1880s, as John Rewald has documented, the two were close friends, often painting together in the area around Marseille.[22]

The special attachment of certain Provençal artists to the rococo movement was mirrored in the work of Provençal poets and writers. Michel de Truchet was one of the first poets to reveal a strong connection to the rococo tradition. In such pieces as *Cansouns prouvençales* (1827) he displayed a grasp of the classical amorous conceits so beloved by the eighteenth century.[23] In the first volume of regional works issued by the Provençal movement, *Lou Banquet prouvençau vo leis troubadours revioudas* (1823), Truchet brought together forgotten eighteenth-century writers from Provence who had inspired his own work. Théodore Aubanel's *La Miougrano entre-duberto* (1860), a collection of sentimental and melancholy poems filled with such characteristic rococo details as intimate conversations, fêtes, and food, showed the continuing dominance of this revived style in Provence's literary circles into

the second half of the century.[24] Even Zola's first book, a collection of love stories entitled *Contes à Ninon*, published in 1864, was described as being heavily doused with the "perfume" of the eighteenth century.[25]

Not surprisingly, given his own love of nature, his romantic impulses, and an environment in which a mock rococo style was burgeoning, the young Cézanne's interest in the rococo was consuming. In many of his early works he explored a full range of standard rococo themes, including that of nature as an idealized, genteel world. Not only his subjects but also his brushstroke and palette at times derived from eighteenth-century models.

Cézanne painted several of his earliest rococo-inspired works with the aim of providing fashionable wall decorations for his father's country house, the Jas de Bouffan, which Louis-Auguste Cézanne had purchased in 1859. Many Second Empire bourgeoisie revived eighteenth-century styles and decor to grace their hôtels particuliers.[26] Among the works that decorated the walls of the Jas de Bouffan was Cézanne's ca. 1860–1862 copy (V. 14) after an engraving of Lancret's rococo canvas *Le Jeu de cache-cache*, and his first known painting, a large folding screen (probably decorated with Zola's help between 1859 and 1862), is also imbued with rococo spirit. Ratcliffe and Reff have demonstrated how often Cézanne included details from this essential early work in later paintings.[27]

The screen's large size (13 ft. 2¼ in. × 8 ft. 2½ in.) and the vertical orientation and motif repetition on the panels of the verso have clear rococo precedents.[28] The recto (fig. 38) resembles a mounted eighteenth-century tapestry and depicts two pastoral fêtes with figures in eighteenth-century dress. Reff believes that the right-hand group derives from an engraving after a Lancret design.[29] A dense cluster of naively executed but rather graceful trees frames each panel of the screen as they frequently do in rococo screens. On the right Cézanne has included a rocky bluff. This background effect is similar to that of his *Le Baigneur au rocher* (V. 83, ca. 1860–1862), which was painted on a wall at the Jas de Bouffan, and the details may have been taken from the Aix landscape.[30] The screen's air of fantasy seems appropriate for what may be Cézanne's first painted image of Provence, since both the eighteenth century and his native region would stimulate the artist's dreams of a pastoral paradise.

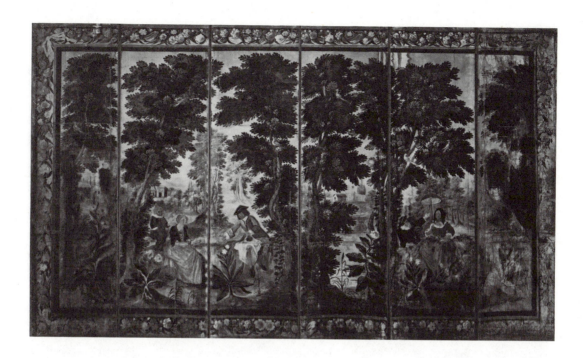

FIG. 38 Paul Cézanne, *Feuillage et scènes champêtres*, painted screen.

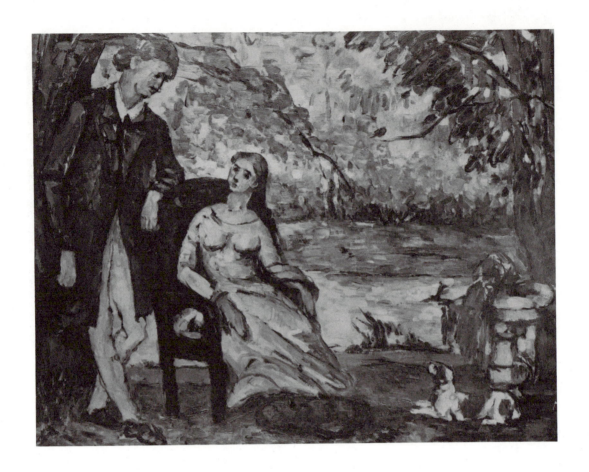

FIG. 39 Paul Cézanne, *La Conversation*.

For a time Cézanne abandoned his imitations of the rococo, but in the early 1870s he began a spate of more mature works that provide us with what amounts to a virtual lexicon of stock rococo motifs. Undoubtedly, Cézanne's growing friendship with Monticelli during the intervening years helped to rekindle his interest in the movement. Aaron Sheon has even tied Cézanne's parallel brushstroke style of the mid-seventies to Monticelli's roughly similar one from the same period, but the much greater structural implications of this method in Cézanne's art make such a connection somewhat tenuous.[31] Moreover, Cézanne's relationship to eighteenth-century art is much more complex than Monticelli's, and his problematic paintings are far removed from the well-bred pastiches the older artist turned out in vast numbers. Almost all of Cézanne's amorous outdoor scenes and small fêtes date from ca. 1872–1875, when the artist was immersed in the experiments that led to what came to be called Impressionism, and the works bear the marks of that investigation. But the imaginative confluence of styles is not the only way in which Cézanne's painting breaks with that of Monticelli and other models. His enigmatic subjects demand our attention as well.

Such paintings as Cézanne's *Conversation* of ca. 1872–1873 (fig. 39), for example, despite its broken brushstroke and brightened palette, convey more of the spirit of a rococo courteous flirtation than of an impersonal impressionist plein-air study. In his several versions of *La Partie de campagne* of ca. 1873–1875 (for example, fig. 40) it is details of costume that signal the modern approach; Cézanne recasts the familiar characters of eighteenth-century fêtes in simultaneously updated and more rustic roles. The performing singer recalls Watteau's *La Perspective* (fig. 41) or his *Récréation italienne* (Charlottenburg Palace, Berlin), and the amorous couple in the lower right corner, the standing woman viewed from behind, and the framing of the group by graceful trees all follow Watteau as well. Unlike the figure-in-landscape paintings of his impressionist peers, the arrangements of Cézanne's figures suggest threads of dramatic interaction, and so reveal a lingering attachment to a treatment of subject matter reminiscent of eighteenth-century art. Cézanne's debt to the rococo fête-galante tradition and his understanding of its thematic intricacies are most apparent in his many variations on the picnic theme.

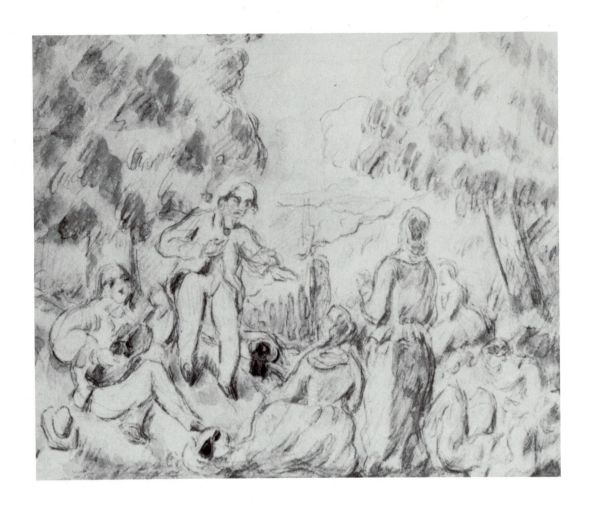

FIG. 40 Paul Cézanne, *La Partie de campagne*, pencil and watercolor.

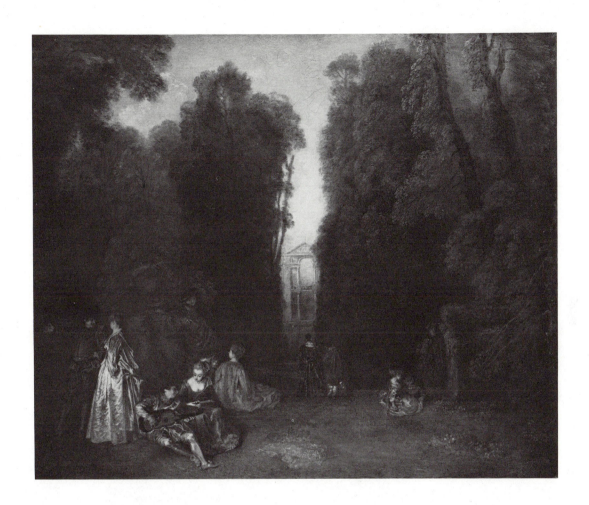

FIG. 41 Antoine Watteau, *La Perspective*.

Watteau's supposed invention of the fête-galante centers around his 1717 admission piece to the French academy, *L'Embarquement pour Cythère*.[32] It was the most famous of many works he created in this non-narrative genre that idealized elegant society. Fête-galante paintings are generally characterized by well-dressed figures in garden or woodlike settings in which themes of romance or courtship replace dramatic action.[33] Donald Posner has argued convincingly that the formal and subjective relationships enjoyed by Watteau's figures convey specific psychological meanings, which are amplified by symbols and theatrical devices.[34] Cézanne's picnics were often dependent on the same implicit modes. Yet more important for Cézanne than inferred relationships was the potent mood of the eighteenth-century fête-galante, which allowed the figures a new freedom and amorous license when placed within the context of nature.

In Watteau's fête paintings that succeeded the *Cythère*, certain pictorial elements became virtually constant and established standards for the form, and Cézanne would draw on a number of them. Watteau's *L'Assemblée dans un parc* (fig. 42) introduced the promenade, or strolling couple (here on the left), who serve as thematic and pictorial foils to the more demonstrably romantic couple seated opposite them. Watteau's involvement with French theater has suggested to some critics that these contrasting pairs represent alter egos of the same two lovers. Rodin even suggested a similar motif for the *Cythère*, advancing the idea that the three couples in the right half of the painting are meant to depict the reluctant action of a single pair of lovers as they gradually move from a seated to a walking position.[35] Whatever its meaning at its first appearance, the promenade became a romantic ritual in fête-galante paintings and their nineteenth-century descendants.

As foils to the paintings' figures, both music and food were introduced into such eighteenth-century scenes to nurture love's light-hearted existence in perfect natural surroundings. Watteau's *La Gamme d'amour* (fig. 43) implies that music is the food of love in a general, atmospheric way, but the presence of real food, as in Boucher's later veritable sex tease *Pense-t-il aux raisins?* (fig. 44), refers quite explicitly to a direct passionate exchange. Even Boucher's rhetorical title ("Is He Thinking about the Grapes?") indicates that the sharing of food between lovers in such pastoral settings infers a like

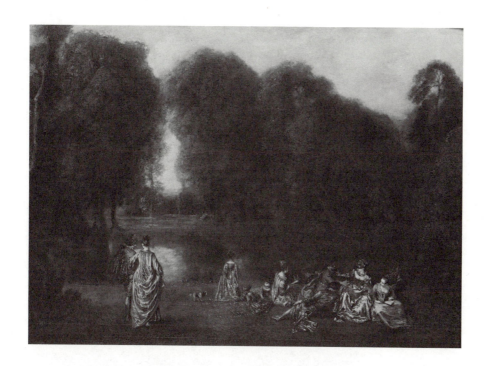

FIG. 42 Antoine Watteau, *L'Assemblée dans un parc.*

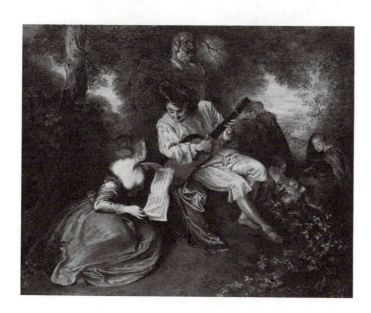

FIG. 43
Antoine Watteau,
La Gamme d'amour.

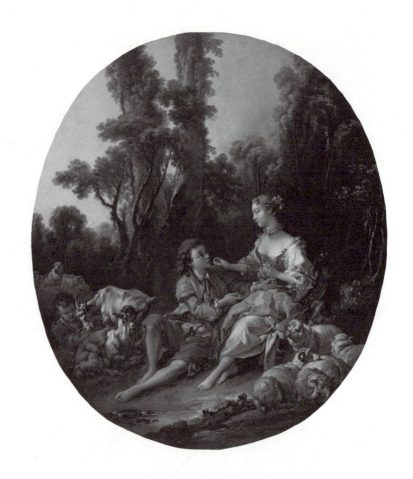

FIG. 44 François Boucher,
Pense-t-il aux raisins?

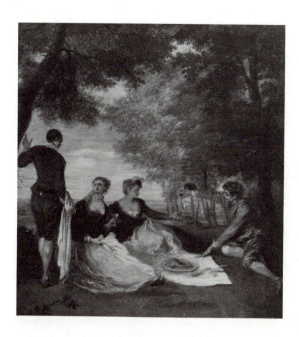

FIG. 45 Antoine Watteau,
La Collation.

offering of amorous favors. In more subtle ways, rococo paintings of *colla-tions*, such as Watteau's *La Collation* (fig. 45), play on the same symbolic equations and would be recalled in Cézanne's picnic paintings—another way in which these early works drew on the eighteenth-century admixture of formal and amorous elements.

Later adaptations of Watteau's fête-galante form expanded the genre's pictorial possibilities with new formal pretexts and locations and gradually broadened its range of subject matter. In the nineteenth century the advent of pleinairism found many artists combining the spontaneity of Watteau's figures with a style of equal freedom. As Linda Nochlin has demonstrated, the fête-galante evolved into a casual picnic.[36] Early impressionists like Bazille and Monet delighted in combining figures, still-life elements, and landscapes without a narrative context. In such versions of the theme as Monet's *Déjeuner sur l'herbe* (Pushkin Museum of Fine Arts, Moscow) or Bazille's *Réunion de famille sur la terrasse de Méric* (fig. 46) of 1867, which Cézanne must have known, the artists downplayed the amorous mood with inclusions, in light-filled settings, of less intimate figures seemingly caught unawares in their relaxed, spontaneous poses.[37]

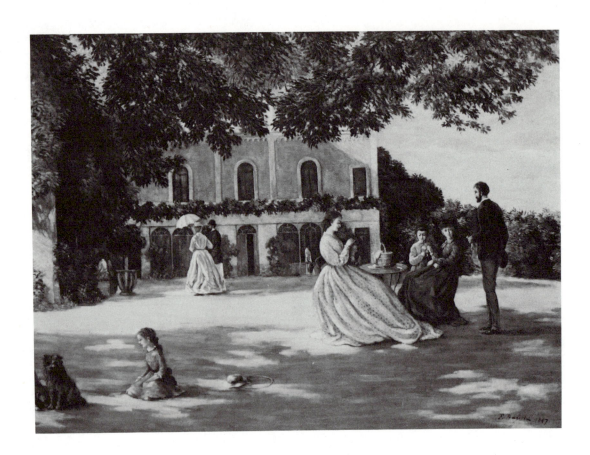

FIG. 46 Frédéric Bazille, *Réunion de famille sur la terrasse de Méric.*

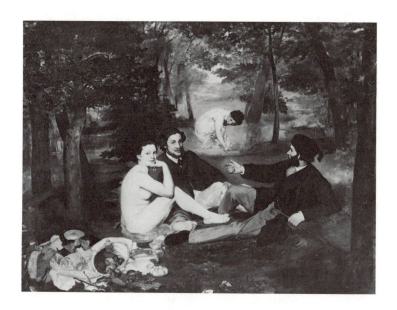

FIG. 47 Edouard Manet, *Le Déjeuner sur l'herbe*.

Even with these variations, the picnic theme as explored by the realists and impressionists still evoked memories of Watteau's flirtatious couples in exquisite landscapes. For all its scandalous novelty, Manet's *Déjeuner sur l'herbe* (fig. 47) blatantly restated Watteau's equation of idyllic nature with license and love. The reams of critical discussion this painting has recently generated do not need recounting here, but an examination of later picnic paintings supports Anne Coffin Hanson's contention that "the presence of even fully clothed couples sprawled on the grass in such undignified poses" as those of Manet's figures implies freedoms beyond those of ordinary bourgeois society.[38] In Tissot's langorous painting entitled *Holyday* or *Picnic* of 1876 (fig. 48), one of many versions that Manet's scene would inspire and similar to Cézanne's *Déjeuner sur l'herbe* (pl. v) from the mid-seventies, the popular French painter revived the amorous spirit of earlier fêtes with similarly provocative poses.[39] And by including the telling gesture through which food and (symbolically) love are shared, Tissot underlined his debt to rococo art and to such paintings as Watteau's *La Collation* in particular. Certainly the subject and its implications had remained current enough.

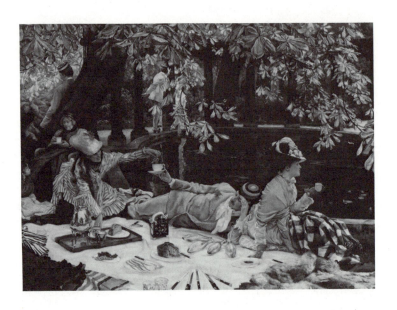

FIG. 48 James Tissot, *Holyday*.

As in so many of his early works, Cézanne drew on various manifestations of an established pictorial tradition to create new—and in some cases, disturbing—works. The first and most enigmatic of his many picnic paintings, *Le Déjeuner sur l'herbe* of ca. 1869–1870 (fig. 49) is unique in its narrative emphasis. Set in a turbulent landscape with a haunting atmosphere of gloom and mystery, it has an explicit dramatic content that Cézanne's later picnics would only suggest. Several elements within the painting clearly recall the tradition of the fête-galante. On the left, the strolling couple from the rococo promenade serves as a foil to the reclining group on the right, the poignant offering of food recalls the love feast or collation, and the enclosed wooded setting further establishes the painting's eighteenth-century character. But the somber, even threatening, mood of Cézanne's painting is quite foreign to both eighteenth- and other nineteenth-century depictions of picnics and gives the familiar subject a bizarre new twist.

For his subject Cézanne turned to contemporary literature.[40] The outdoor picnic, with its overtones of the pastoral, was a common scene in the fiction of the day. Like their counterparts in paintings, literary picnickers were

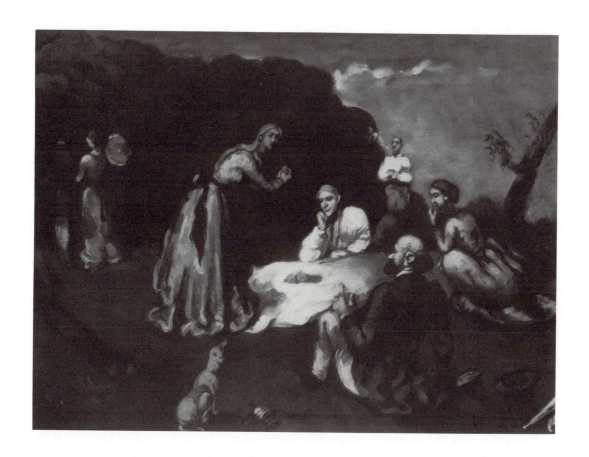

FIG. 49 Paul Cézanne, *Le Déjeuner sur l'herbe*.

refreshed by such excursions into the country and on these jaunts felt free to pursue amorous goals. In Flaubert's *Madame Bovary* Emma spends long and lovely afternoons in shady retreats with her illicit lover Léon, idylls she fondly recalls in later bouts of melancholy. In the novelist's *L'Education sentimentale*, the innocent Mademoiselle Louise makes bold advances toward the hero Frédéric when the two find themselves alone in Monsieur Roque's garden.

Even Zola's very worldly Nana would invite her Parisian friends to the country house of her lover to enjoy a picnic lunch and a weekend of flirtatious fun. Yet Zola also succeeded in turning the rose-tinted world of the pastoral picnic inside out, and it is such dark inversion that we sense in Cézanne's work. In Zola's novel *Thérèse Racquin* (1867), the heroine, her lover, Laurent, and her husband, Camille, spend an uncomfortable afternoon together in the grassy park at Saint-Ouen. The picnic ends in violence when Laurent invites the unfortunate Camille on a boat ride and succeeds in drowning him. In *Madeleine Férat* the gloomy specter of Madeleine's first lover, Jacques, hovers over her romantic sojourns into the country with the amiable Guillaume.

Although *Thérèse Racquin* is the more prominent of the two novels and has done more than *Madeleine Férat* to enhance Zola's reputation as a zealous realist, it is the lesser work that has established links to Cézanne's picnic paintings. *Madeleine Férat* was originally written in 1866 as a play and was published first in serial form in the popular journal *L'Evénement* and then, in 1868, as a novel. In it the early excursions of the heroine and her lover, Guillaume, into the richly wooded countryside about five miles from the southern ramparts of Paris convey a beautiful picture of lush green landscape and the corresponding burgeoning of young love.[41] Zola's lavish descriptions derived from his own trips into the area in the early 1860s, trips on which Cézanne often accompanied him. The two spent numerous Sunday afternoons together, hiking through this countryside, respectively noting and sketching its beauties.[42] In a letter of 1863, Zola described their favorite picnic spot, of which Cézanne prepared a sketch, as a place "where the trees receded like wings of a theatre, draping the curtains of their branches as in a chapel." It soon became the destination of all their Sunday travels: "We camped there,

we lunched, we dined, and only the twilight chased us away."[43] This visual idyll is specifically recalled in *Madeleine Férat*; Zola describes the lovers' favorite picnic spot in terms that clearly paraphrase his letter—"framed by trees which shape an amphitheatre" and "enclose this clearing with an impenetrable wall."[44]

Yet, despite this idyllic element, many of Zola's descriptions of the landscape in *Madeleine Férat* hint at a less-than-benevolent nature and so set the stage for the fateful romance played out within it. Early in the novel the lovers rendezvous in a clearing outside Paris where, "in the far distance, the Verrière Woods formed a black band, as if the sky were in mourning." As Madeleine caught sight of the "menacing storm clouds, she seemed to sink into memories that hurt."[45] Like the dark, enclosed wooded setting and threatening sky, which defy the promise of nature to replicate paradise, Zola's tragic love story subverts the enchanted image of the picnic. A comparison of Zola's text with Cézanne's painting makes clear that the painter drew not only on the memories of the countryside he shared with his friend but went directly to the novel for his setting and mood. Zola carefully delineates both characters as they set out for their first picnic:

Madeleine was nearly twenty. She was wearing a very simple grey woolen frock trimmed with blue . . . [and had] a magnificent shock of auburn hair. . . . She was a fine-looking young woman, tall, her lissom, powerful body revealing unusual vigor. . . .

Guillaume was five years Madeleine's senior. He was a tall, thin young man of aristocratic air. With its fine-honed features, his elongated face would have been ugly if not for the clarity of skin and loftiness of forehead. . . . He was slightly stooping and spoke with cautious gestures.[46]

And Zola describes the picnic ritual itself in some detail when the lovers later rekindle their romance:

They would continue their sentimental stroll, finding new enchantment in the silence and coolness. . . . Madeleine always brought fruit with her, and, emerging at last from her reverie, would plunge her lovely teeth into the juicy flesh and hold a peach or pear to her lover's lips, for him too to bite. Guillaume was filled with wonder at the sight of her. Every day she seemed more dazzlingly beautiful to him.[47]

The details of Cézanne's painting are clearly drawn from Zola's text: the standing figure of Madeleine is tall, young, and dressed in a simple gray frock trimmed with light blue. She has a cascade of auburn-tinted hair. Seated next to her and looking at the viewer is a figure answering Zola's description of Guillaume: slightly stooped, thin, with finely honed features, and an elongated face. His melancholic pose encapsulates his role as betrayed lover. The moment Cézanne has chosen to represent, Madeleine's offering of a peach or pear to Guillaume, is a poignant one in both the painting and the story. It revives the association between offers of food and love such scenes had long portrayed. The strolling couple in the left background are Madeleine and Guillaume as well, a reminder of the theatrical device of duplication initiated by Watteau and then embedded in the fête-galante convention. Further strengthening the painting's specific derivation from the novel is the elegant parasol in the lower right corner. In Zola's text Madeleine carries and then disposes of the parasol at the picnic ("Under her sunshade, Madeleine's face was adorable").[48]

And who are the other characters in Cézanne's morbid cast? One, at least, is also obviously drawn from *Madeleine Férat*. Overshadowing Madeleine and Guillaume's first excursions into the country, as Zola took great pains to emphasize, was Madeleine's guilt-ridden memory of her former lover, Jacques. It was with Jacques that Madeleine had first discovered both the hidden retreat and the amorous pleasures she would later introduce to Guillaume. Sometimes, Zola writes, "The moment his shadow had been evoked, this lover, whose ineffaceable living memory [Guillaume] found in every gesture, every word of the girl's, seemed to rise between them."[49] In one of the ironic coincidences that punctuate Zola's novels, Madeleine soon discovers that Jacques had been a childhood friend of Guillaume. She comes to this horrifying realization when she finds among Guillaume's belongings a photograph of Jacques, puffing on the clay pipe she remembers so well and smiling eerily out at her. It is this figure who looms, strangely threatening, in the background of Cézanne's painting.[50] Zola's narrative pivots around this menacing character from the past, and in the painting, though distant from the foursome around the picnic cloth, he is clearly part of the depicted drama. With arms aggressively crossed, he glares at the exchange of favors

between the lovers in the foreground as he puffs on a clay pipe. As in the novel, he "wraps [the lovers] in a lugubrious gloom" and breathes "a sort of icy breath" into their midst.[51]

Less clear in terms of Zola's novel are the roles of the other two figures with Madeleine and Guillaume in the center of the canvas. The female figure on the far right, although eating, as if engaged in the action of the picnic, seems to serve formal rather than narrative purposes.[52] The line of her body extends the diagonal of the distant woods and reverses the angle of the right-most tree; more important, she fills an empty area in the composition where the space recedes rather awkwardly. The male figure is recognizable as the artist himself, as a comparison with his *Portrait de l'artiste* of ca. 1872 (pl. VI) demonstrates. The manner and pose he strikes in the *Déjeuner sur l'herbe* are also similar to those he would later assume in his second version of *Une Moderne Olympia* (fig. 50). In both pictures his role is that of the detached observer: with his back to the viewer, and so assuming our point of view, he quietly watches a ritual of love in which he has no part. (In the former, his role may further reflect the painting's relation to Zola's novel, with Cézanne taking the place of the writer/narrator who watches the action unfold and symbolically comments on the two artists' shared past.) Likewise, in his enigmatic *Idylle* (see chapter VIII, pl. XIV), Cézanne positions himself in a gloomy landscape filled with symbolic images of love and then retreats from them in melancholy.

More than Degas, Renoir, or any of the other artists who were drawn to Zola's texts, Cézanne appreciated the potent darkness of Zola's landscapes and the hopelessness of the love pursued within them. Given his own stormy liaisons and futile romantic longings, which his friend would document in the novel *L'Oeuvre*, the fate of Madeleine Férat must have struck a profoundly personal note. In his painting *Déjeuner sur l'herbe*, Cézanne takes his place in a verdant landscape well known to him, witness to a seemingly romantic moment, but once there he gives shape only to the gloom that pervaded such fantasies of love both in his own early work and in Zola's.

The dark, impassioned style of Cézanne's first picnic painting relates it to his other romantic images of the 1860s, yet despite its brooding imagery his *Déjeuner sur l'herbe* still drew on the traditions of the fête-galante. His later

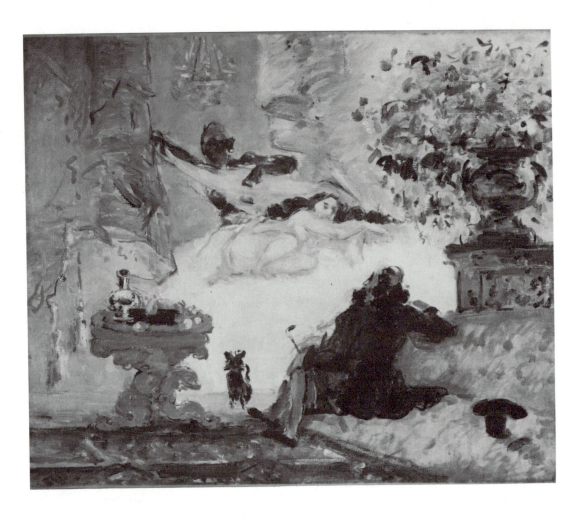

FIG. 50 Paul Cézanne, *Une Moderne Olympia*.

picnics, in which many levels of meaning are expressed in a markedly different form from that of the first, would be much closer to the spirit of their eighteenth-century models.

A picture unknown to Venturi and until recently out of public view in private collections, Cézanne's *Picnic on a River* sheds new light on the artist's receptivity to the rococo (pl. IV A).[53] Probably contemporary with the artist's *La Partie de pêche* of ca. 1873–1874 (V. 230), it features a seated couple and other figures on the banks of a river in a simple landscape framed by trees. The tree on the left anticipates the taut vertical trees often seen in Cézanne's bather compositions of the mid-seventies (for example, V. 276). Playing a similar compositional role, it balances the strong horizontals of the landscape, echoes the vertical shape of the standing figure, and offsets the diagonal thrusts of the fishing pole and parasol. Yet within the painting's tight construction many elements of the intimate and freer fête-galante form are realized. Even the costume of Cézanne's female figure harks back to the rococo, establishing stylistic links and accentuating the enigmatic mood of the work.

Although it is one of Cézanne's simplest versions of the picnic theme and displays some affinity with the fête-galante form, the *Picnic* also suggests that Cézanne had moved beyond the fête as a purely formal device to a deeper understanding of rococo art. The painting's palette of warm rococo pastels is similar to that of Watteau's *Le Dénicheur de moineaux* (pl. IV B), while the soft brushstroke, especially in the woman's skirt, echoes the gentle touches of Watteau's brush extolled by the de Goncourt brothers. Quite far from the local color, granular surfaces, and broken brushwork of paintings contemporary with it, such as his *La Maison du pendu* (pl. XIV), the Yale *Picnic* suggests an alternate path in tradition Cézanne pursued while he was also discovering the more optically oriented art of the impressionists. Ultimately, his art would build upon the dual loyalties such paintings of the early 1870s expose.

Cézanne's small *Déjeuner* of ca. 1873–1874 (pl. V) also recalls in some aspects the tradition of the fête-galante, and the very complete watercolor study for it that exists (fig. 51), a rarity in Cézanne's work, allows detailed analyses of his development at this stage. The two are confidently painted in a strong, harmonious palette, and each demonstrates an almost equal

FIG. 51 Paul Cézanne, study for *Le Déjeuner sur l'herbe*, pencil and watercolor.

concentration on subject and style that marks a point of transition in Cézanne's art. His treatment of the foliage, especially, characterizes the parallel brushstroke method of his landscape and bather paintings from the mid-seventies. And the painting's range of color and shadings has a sunlit intensity influenced by Cézanne's studies of the plein-air style. But vestiges of the pastoral fête persist. The standing male figure who offers a basket of red apples to the woman in the foreground reappears in a later fantasy painting (see fig. 87), which Meyer Schapiro has shown to represent the amorous shepherd from an elegy of Propertius.[54] In each, the offering of apples serves as a token of love. The motif of pouring wine in this small picnic, so close to Watteau's *La Collation* (see fig. 45) and again symbolic of shared love, may also link Cézanne's painting to such famous mythological feasts as Titian's *Bacchanal of the Andrians*.[55] But in this case Cézanne favors that larger tradition of outdoor feasts as it was transformed into the delectable forms of rococo art. The work does not have the friezelike composition often seen in his mythological scenes (see chapter VII, figs. 94 and 96), but the semicircle created by his figures instead recalls the graceful lines of the more elegant school. Like many of Watteau's demure females, the figures closest to the viewer turn away. And, as in the Yale *Picnic*, the antiquated costume of the woman in the center facing the viewer points to the rococo era as well.

Most of Cézanne's later variations on the picnic theme and the pastoral interlude suggest the increasing emphasis he placed on matters of pure form and the motifs he found in nature. *L'Etang* of ca. 1875 (fig. 52) falls into this more objective category. Here, Cézanne has turned his attention away from the possible narrative implications of his subject matter to capture the essence of a strong summer sun; his figures answer scenic rather than dramatic, explicative needs.

Yet, although Cézanne's paintings after the early 1870s show him moving into the form-oriented style for which he is best known, some of the later paintings have reversionary elements, glimpses of narrative and natural elements conjoined. The *Lutte d'amour* of ca. 1880 (pl. XVIII) is Cézanne's own version of a bacchanal and one in which an idealized theme—a mythological picnic of sorts—is boldly transformed. In a landscape that is itself wild and capricious, Cézanne's figures fight and wrestle in a scene of violent love

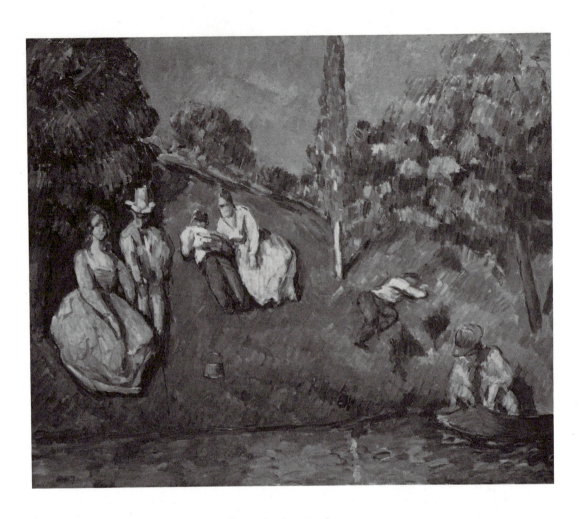

FIG. 52 Paul Cézanne, *L'Etang* (*Couples Resting by a Pond*).

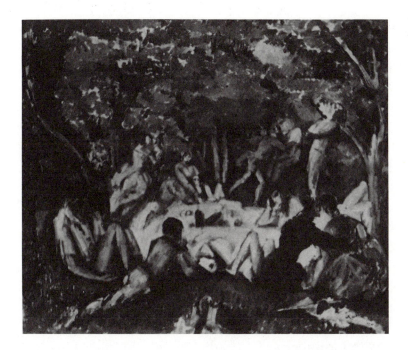

FIG. 53
Paul Cézanne,
*Le Déjeuner
sur l'herbe.*

whose structure derives only from its harmonious forms and even brush-strokes. The composition centers around the rapacious attack on a nude, young female. And when Cézanne returns directly to the theme of the picnic as he does in the *Déjeuner sur l'herbe* that Venturi dates ca. 1877–1882 (fig. 53), the same struggling figures reappear.

This later picnic appears innocent enough at first glance. An allover flick-ering light and patterned brushstroke align it more closely with Cézanne's bather paintings of the late seventies than with any of his mordant fantasies. In addition, the sheer number of figures and sharp distinctions in scale dem-onstrate a concentration on formal issues: the artist is grappling with the problems of figure-space relationships. Nonetheless, here, as in the earliest picnics, the theme seems to have awakened in Cézanne a feeling for narra-tive subject matter. The embracing couple in the lower right corner draws us into the world of the amorous pastoral fête, while the struggling pair in the background—though the assailant's bestial form, a fantasy element, is transformed by elegant coattails, and the woman is clothed as well—still im-

parts an air of muted violence, a suggestive background narrative inserted into a scene whose concerns are chiefly formal.

Such pictures are odd intrusions into Cézanne's mature work, curious reflections of an earlier stage in his artistic development. Often, internal structural dissonances obscure the iconographic and formal traditions on which these later works depend. Yet an explanation can be sought in their earlier counterparts. A study of Cézanne's picnic paintings as a group reveals much more than his debt to the fête-galante and the rococo revival in Provence. As we move from his earliest *Déjeuner sur l'herbe*, so clearly based on a specific narrative, to his later picnics, where many shades of meaning are possible, the depth of his understanding of eighteenth-century art emerges. By giving life to the full meaning of the subject and the wealth of traditions behind it, Cézanne's picnic paintings look far beyond the example of Manet. At a point in his career in which he produced some of the most radical artistic innovations of his time, these later pictures also demonstrate his profound attachment to the past. It has long seemed too simple to suggest that in the 1870s Cézanne's concern with form replaced an earlier interest in subject matter. His picnic paintings reveal that, quite often, that form continued to have a wealth of meaning.

THE IDEAL
OF THE REAL

Early Essays in Genre

VI

ALTHOUGH CAUGHT UP IN THE SPIRIT of the Provençal revival and attracted to aspects of the romantic movement, Cézanne strove at the same time to join forces with the realists. After a brief infatuation with academic art sparked by the Salon of 1861, the first he had ever seen (this at the time Zola was extolling the sentimental paintings by the popular artist Ary Scheffer), he sought to embrace wholeheartedly the art of Courbet and Manet as well as the general cause of realism in Paris.[1] At the Académie Suisse he formed a friendship with the young Puerto Rican artist Francisco Oller, a quasi-landsman of Pissarro and disciple of Courbet; Cézanne himself would emulate Courbet's technique in several early portraits and landscapes.[2] His participation in the Salon des Refusés of 1863 and his visits to the Café Guerbois, though infrequent, also brought him into contact with Manet, Fantin-Latour, Bazille, and other realist painters in Paris. Yet throughout much of the 1860s, Cézanne was still too deeply concerned with the private meanings or pictorial drama in his painting to approach nineteenth-century realism on its own, more objective terms. Venturi has described Cézanne's early realism as being "at bottom formless, and never more than a romantic transformation of reality."[3]

Despite their internal conflicts and the acknowledged weaknesses of some of them, Cézanne's early attempts in the realist mode, especially his genre scenes, reward further study. They illuminate his formative sources and influences and further establish his close connection to the contemporary revival of interest in earlier art and in genre in particular. Steadfast in his commitment to tradition, Cézanne's genre scenes also help us to define the

singular qualities and poignant motifs characteristic of his realist work as a whole.

Cézanne's first efforts in this style are often colored with personal reflections. Yet the tensions apparent in his early genre paintings most clearly reflect the opposing artistic tendencies he sought to reconcile during the 1860s—a romantic strain wrestling with the more straightforward attitudes of the realist school—exactly the contradictions and mixture of traditions that the art of the decade as a whole embraced.

Long dismissed as a foreign, northern-based style, despite the work of the brothers Le Nain, Chardin, and Greuze, genre painting gradually rose to a position of prominence in mid-nineteenth-century France.[4] Its intentionally ordinary subject matter and easily appreciated forms could be manipulated to please a wide range of needs and viewers; once established, genre painting quickly became synonymous with the taste of the bourgeoisie. Napoléon III's purchase of Jean-Louis-Ernest Meissonier's *Rixe* for 25,000 francs from the Salon of 1855 greatly helped to elevate genre to a more exalted status.[5] It would soon rival all other official categories of French art in popularity and prominence. At the Salon of 1857, with Ingres and Delacroix absent, the majority of exhibited works, as the contemporary critic Jules Castagnary noted, were genre pictures.[6] It was at this point also that critical acceptance of genre drew abreast with its popular appeal. Along with other critics at that Salon, Castagnary saw the future of genre affirmed "by the power of numbers and authority of talent" it attracted.[7]

A decade later, with both Ingres and Delacroix dead, the continued hegemony of genre in French painting could no longer be rationalized as a temporary or class-based phenomenon, as it had been by conservative critics. By the Salon of 1868, the obvious triumph of humbler genre over history painting, with its elevated classical, biblical, or moralized subject matter, was broadly acknowledged in all quarters. Thoré saw it as a modern shift in preference toward northern art and its predilection for scenes of everyday life, as opposed to France's more traditional alignment with the mythological and religious art of southern Europe.[8] In fact, the new popularity of genre reshaped the contemporary French outlook on the realist issues explored by baroque painters. In addition, despite arguments of critics like Paul Mantz

and Maxime DuCamp and the international acclaim accorded the Barbizon school, genre had clearly superseded landscape painting as well.[9] The persistent diatribes of some diehard critics (Théodore Duret called it vulgar and mediocre and Ernest Chesneau's condemnation—"insignificant size, insignificant subjects, insignificant painting"—has become infamous) did little to diminish its widespread acceptance.[10] Instead, the emergence in genre painting of a number of subcategories—historical genre, religious genre, exotic or Orientalist genre—connoted its expanding appeal and assured it of a major role in later nineteenth-century French art. Cézanne's genre paintings, a large number of which date from the 1860s, thus reflect not only his personal commitment to baroque realist traditions but the special tastes of the period in which he began his work as an artist.

One of Cézanne's earliest known paintings, *Jeune Fille en méditation* of ca. 1860 (fig. 54), can be classified as religious genre.[11] Although the image is awkward, it is one of simple piety devoid of any traditional narrative religious theme, and it must be considered in terms of the widespread interest in genre in the 1860s and its broad vernacular appeal. Linda Nochlin's discussion of religious genre painting provides a helpful context for assessing Cézanne's several efforts in this vein: "They betray no direct religious feeling at all but rather, within the context of a more or less objective description, a yearning sympathy with the archaic faith of these touchingly simple beings . . . expressed in appropriately rustic, and sometimes primitivizing, pictorial language."[12]

Jeune Fille en méditation depicts a young woman leaning against a chair, presumably praying before a crucifix; a vase of flowers and a mirror are shown behind her. The painting has been seen as a portrait of the artist's older sister, Marie, but the figure's features and age do not correspond to other portraits Cézanne did of her.[13] A related drawing (Ch. 66) also belies any connection with known portraits. However, the painting's mood of rustic sentimentality is clearly defined, which allies it in both mood and style to religious genre.

With its clumsy foreshortening of space and simplistic rendering of the figure (especially in the woman's stylized gesture), Cézanne's painting can rightly be called naive. It is but a step removed from the ex-voto scenes so

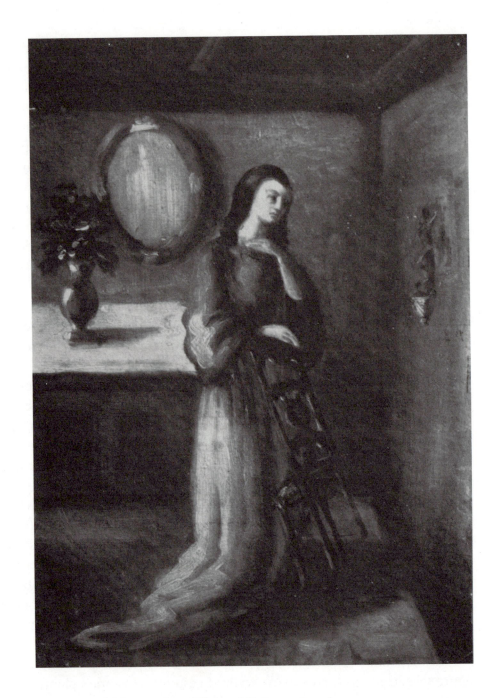

FIG. 54 Paul Cézanne, *Jeune Fille en méditation*, on board.

common in vernacular religious art, a type of votive popular imagery on which realist artists drew and which Cézanne may have seen in Aix.[14] Lawrence Gowing has noted a similar quality in a fragmentary image of praying figures (fig. 55), just visible in the underpainting of Cézanne's *Tête de vieillard* of ca. 1865.[15] A detail from an earlier, unfinished canvas, it represents a procession of penitents. Some of the participants are garbed in white penitential robes, and this too links Cézanne's image to the vernacular religious practices of the pious cults in his own city, whose costumes are still preserved in the Musée du Vieil Aix (fig. 56). To reinforce the genre character of the *Jeune Fille* painting Cézanne includes a *bénitier*, the holy water font with crucifix that was a common devotional object in households of the time.[16] Like the sacramental *clochettes* or small bells kept in provincial homes to ward off evil spirits, the bénitier was a ritual object believed to protect the health and well-being of the inhabitants. Its presence in the home attests to the same simple faith that is the subject of Cézanne's canvas, which prefigures Gauguin's later scenes of praying Bretons.[17] Yet whereas Gauguin's archaic style would suggest a self-conscious primitivism, Cézanne's is more revealing of the rudimentary hand of the artist at this early stage of his career and of the appearance in his work of relatively undigested vernacular precedents.

One of Cézanne's first religious paintings therefore lacks traditional religious imagery and falls more correctly into the realm of genre. The new mode of religious genre allowed him here a kind of "spectator Christianity," a freedom to "distance himself from the religious experience by assimilating it to the primitive fervor" of his sitter.[18] Close to Cézanne's conception in both date and sentimental mood are the religious works of such important genre painters of the time as Théodule Ribot and Alphonse Legros. The young girls in Ribot's *Les Deux Novices* of 1861 (fig. 57) effectively convey a mood of simple spirituality and become almost votive objects in themselves.[19] Similarly, Legros's *Ex-Voto* of 1860 (Musée des Beaux-Arts, Dijon) was described by Baudelaire as capturing "the burning naïveté of the Primitives."[20] Like Ribot and Legros, Cézanne used the techniques of genre in his *Jeune Fille en méditation* for uncomplicated but expressive ends.

If the religious environment was the first one in which he tested his

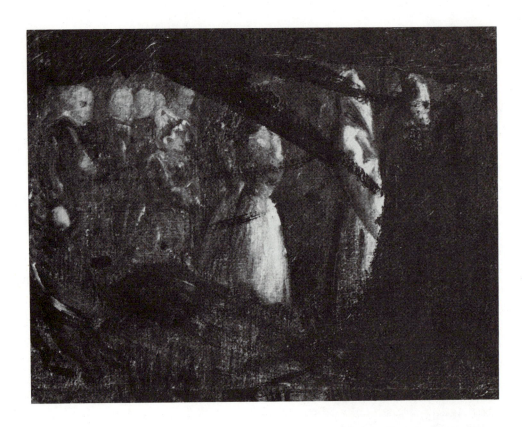

FIG. 55
Paul Cézanne,
Tête de vieillard, detail.

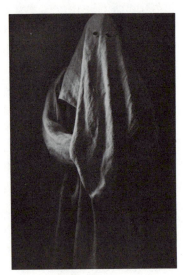

FIG. 56
Robe of a penitential
order, Aix.

FIG. 57
Théodule-Augustin Ribot,
Les Deux Novices.

growing interest in genre, Cézanne, like many of his realist contemporaries, also gravitated to scenes of death. One of the most brutal of his early genre works, *La Toilette funéraire* of ca. 1868 (pl. VII) has often been called *L'Autopsie*, a title that would link it to the strikingly realist subject of paintings such as François Feyen-Perrin's *Une Leçon d'anatomie de Dr. Velpeau*, exhibited at the Salon of 1864 (Ecole National de Médecine, Tours), or his related drawing *Leçon avant l'autopsie* and etching *Avant l'autopsie*.[21] Daumier also pictured the realist theme of the autopsy; his parody of Feyen-Perrin's composition, published in *Le Charivari* 21 August 1869, helped to establish the subject's currency.[22] But where Feyen-Perrin's scene revives a motif from Rembrandt's realistic group portraits in a tribute to modern science and a famous surgeon, Cézanne's *Toilette* has quite a different character. The theme of Cézanne's painting is not the power of science but the finality of death as evidenced by the physical disintegration of the body. Its model is closer to Flaubert's overtly physical description of the dead Danbreuse in *L'Education sentimentale* or to Zola's gruesome account of Camille's corpse in *Thérèse Racquin*.

Mary Louise Krumrine has recently pointed out a striking parallel be-

tween the bald, bearded figure in Cézanne's painting, reminiscent of the artist himself, and the painter Laurent in Zola's novel, who, like Lantier in *L'Oeuvre*, was partly modeled on Cézanne. Krumrine suggests that the sepulchral scene in which Laurent haunts the morgue to search for the murdered Camille and discovers him "stretched on his back, head elevated, eyes half-opened" may well have inspired Cézanne's dire image.[23] Such an intimate literary reference would help to explain the painting's intensely felt morbidity, but Cézanne's sources extend far beyond the literary. With its thickly painted strokes, intense palette, deep shadows, and intimate focus on the corpse itself, Cézanne's painting also suggests the influence of a more general tradition in historical painting—that of depicting, in various contexts, the preparation for funeral rites and burial.

While Roger Fry popularized the identification of this painting as an autopsy scene, many other early scholars of Cézanne's oeuvre have referred to the painting as *La Toilette funéraire*, and a study of its imagery and sources reveals this to be the painting's true subject.[24] Perhaps the extreme bleakness of Cézanne's canvas led to the misunderstanding of its subject. It is also true that burial preparation scenes were uncommon in nineteenth-century art; Courbet's analogous *La Toilette de la morte* suffered a similar fate and was mistitled for over half a century.[25] Nonetheless, aside from its grim atmosphere and the undeniable presence of a cadavre, there is little in Cézanne's painting to suggest that it depicts an autopsy. There is the distinct omission of any scientific apparatus or even the requisite scalpel; Cézanne shows only a small bowl of water, the corpse, and two attendant figures. The morbid atmosphere of the scene, which Fry called macabre, becomes more comprehensible in light of historical depictions of the dead Christ, a common source for this motif. Despite the declining interest in traditional religious subjects, this specific one continued to fascinate painters throughout the nineteenth century and was particularly important to Cézanne in the mid-1860s, just when he was experimenting with genre.

Théodore Géricault's *Pietà* after Tiarini (ca. 1816–1817, fig. 58) epitomizes nineteenth-century harsh and realistic treatments of the death of Christ. Although copying an earlier picture, Géricault succeeded in rendering death in a ruthlessly graphic manner. The body of Christ is visibly and vividly suc-

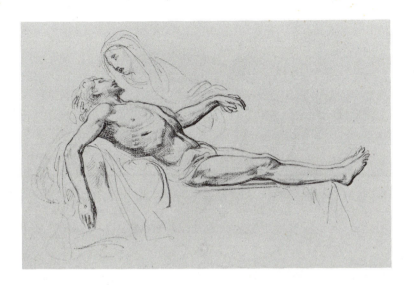

FIG. 58 Théodore Géricault, study after Tiarini's *Pietà*, black chalk.

cumbing to death: his legs have become inert and rigid, while his upper torso falls softly into his mother's lap.[26] Cézanne's study (ca. 1866–1869, fig. 59) after Fra Bartolommeo della Porta's *Christ au tombeau* (fig. 60) is an even harsher treatment of the sacred figure in death. The unidealized face, angular arms, and exaggerated tautness of the legs throw into sharp relief its Renaissance prototype. In copying Delacroix's *mise-au-tombeau* at St. Denis-du-Saint-Sacrement (fig. 61) from an engraving, at about the same time he was working on the study, Cézanne dispels much of its romantic pathos. Delacroix's Christ is profoundly and humanly tragic with his pained expression and a body made heavy and burdensome by suffering; in contrast, Cézanne's almost featureless Christ simply crumbles in death (ca. 1866–1867, fig. 62). In his own work, however, Cézanne rarely practiced the detached realism he exhibited in these copies after earlier masters, probably because he could not at this time distance himself completely from the emotional implications of his subjects. Thus, while his *Toilette funéraire* projects a baroque character in its rendering of the pure physicality of death, one that is almost palpable on the surface of the canvas, its effect is to make the subject even more humanly powerful and tragic. As do many of his other early genre paintings, it dem-

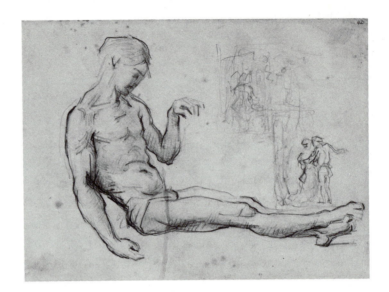

FIG. 59
Paul Cézanne,
study after
Fra Bartolommeo
della Porta's
Christ au tombeau,
pencil.

onstrates how traditional themes and motifs, such as those of death and suffering, could be translated into more modern and directly accessible terms.

The composition of *La Toilette funéraire* further establishes the baroque influence on Cézanne's painting and its effect on his developing realism. The unclothed body in horizontal profile attended by onlookers recalls his earlier depiction of Job (who both in pose and as symbol can be seen as a type of Christ) and his entombment study, reaffirming the poignancy of this motif in his early work. However, as early as 1865, Marius Roux had described Cézanne as a "great admirer of Ribera and Zurbarán," and *La Toilette funéraire* was probably inspired by studies the artist made after several Ribera entombments.[27]

Among the scholars who have made this connection, Alfred Barnes has compared the patterned chiaroscuro of *La Toilette funéraire* with a number of Ribera paintings, including a *Christ au tombeau* (fig. 63), which was given to the Louvre in the 1860s.[28] Robert Ratcliffe has suggested that Cézanne may also have known of a second Ribera version, which was acquired for the Louvre by the superintendent of fine arts during a visit to Spain in 1868; Ratcliffe takes this fact into account in dating the Cézanne painting to the fol-

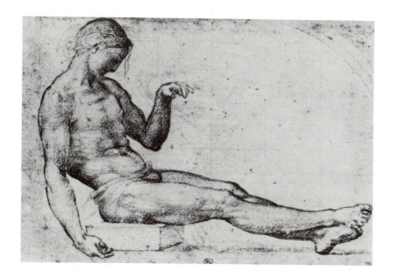

lowing year.[29] The close similarity of the head of Ribera's and Cézanne's figures makes plausible the idea of the earlier work's influence. However, a third *Christ au tombeau* attributed to Ribera, now lost but known through copies (for example, fig. 64), may also have influenced Cézanne's conception, making the chronology less fixed in relation to Ribera's works.[30] The older woman on the right-hand side in the Cézanne painting, sharply profiled with her back to the viewer, corresponds to a figure in this Ribera composition, and both function as framing elements. Moreover, Cézanne's treatment of the corpse's upper body—a curving line formed by the chest in profile—most closely echoes this third Ribera version. The thick, unbending line of Cézanne's paint stroke, stretched along the figure's stiffened legs, renders even more palpably than did Ribera the rigidity of death. The stark lighting in all three Ribera paintings, which projects the figures into a planar composition against a dark background, is evident in Cézanne's canvas as well.

Though certain aspects of composition and execution were clearly influenced by Ribera, the central figure in Cézanne's work, bent intently over the corpse he is about to wash, has no counterparts in any of the Spanish

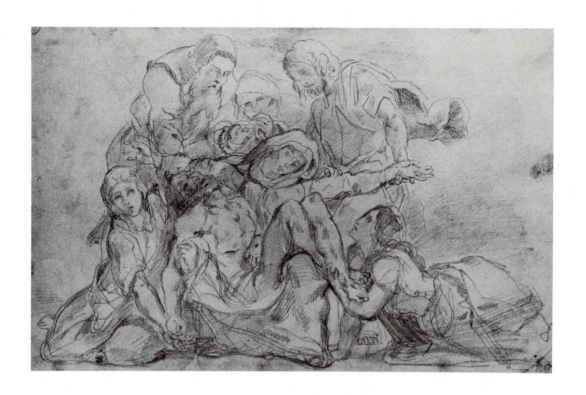

FIG. 61 Eugène Delacroix, study for a *mise-au-tombeau*.

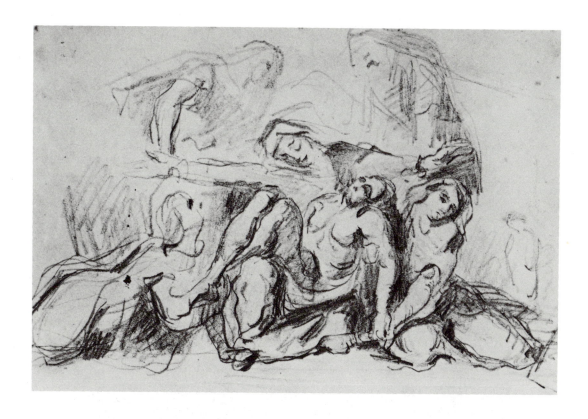

FIG. 62 Paul Cézanne, study after Delacroix's *mise-au-tombeau*
at St. Denis-du-Saint-Sacrement, soft pencil.

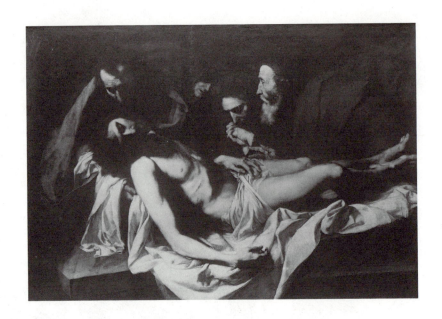

FIG. 63 Jusepe de Ribera, *Le Christ au tombeau.*

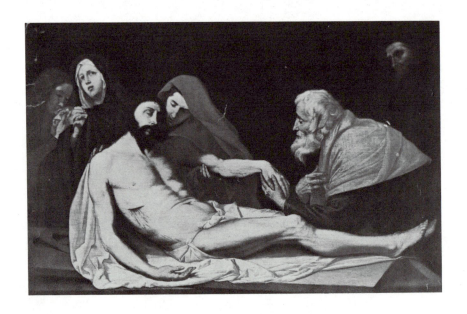

FIG. 64 Copy after Jusepe de Ribera, *Le Christ au tombeau.*

entombments. Zola's possible literary influence has been noted, and Gowing has also linked this figure's bearded, wrinkled head, reflecting an eerie light, to the series of bald heads in Caravaggio's *Mort de la Vierge* in the Louvre.[31] Given the strong Caravaggesque flavor of the baroque paintings Cézanne had studied in Provence and Ribera's own debt to Caravaggio, such a relationship seems likely. Certainly Cézanne, immersed in realism and its graphic precedents, would have been drawn to the naturalism of this famous seventeenth-century painting with its denial of the supernatural. The bowl of water in Cézanne's painting, illusionistically so close to the canvas surface, is a baroque device as well and one he could have borrowed from either Caravaggio or Ribera.

Cézanne's *Toilette funéraire* can thus be seen as both a tribute to these earlier masters of realism and a secularized mise-au-tombeau. The radically secular tone of Renan's popular *La Vie de Jésus* (1863) encouraged expressions of this type; some of the most successful death images of the decade were paintings that combined traditionally reverent motifs with aspects of the mundane. Carolus-Duran's *L'Assassiné*, which was awarded a medal at the Salon of 1866, recalled an actual assassination the artist had witnessed in Italy; in format, however, it was a thinly disguised and updated version of a religious lamentation.[32] The following year, Ribot exhibited *Le Supplice d'Alonso Cano*, which depicted the unjust torture of a seventeenth-century Spanish artist in an essentially religious composition only slightly revised from Ribot's own *Saint Sébastien*. To demonstrate further the link between the genre painters of the day and baroque masters, this famous painting, shown at the Salon of 1864, was itself inspired by Ribot's study of Ribera.[33] Cézanne's predilection for this type of theme must have influenced his initial choice of Ribera's entombment series as prototypes for his own work, and in this he was clearly aligned with some of his contemporaries. Few nineteenth-century painters, however, were as successful as Cézanne was in capturing the raw intensity of baroque death imagery. In *La Toilette funéraire* he preserved the emotive power of the painting of that era by using its own models and devices and in so doing produced an image whose spirit and sense of realism belong to the past.

While Cézanne's brooding temperament may have drawn him to Ribera,

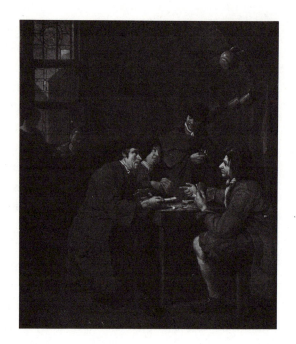

FIG. 65
Jan Horemans,
Les Joueurs de cartes.

and perhaps even to Caravaggio, his painter's instinct and eye would attract him to the more objective art of Flanders and Holland.[34] Like many of his realist contemporaries, he amassed considerable knowledge of Dutch painting in particular. Throughout the 1860s he was exposed to the art of the Dutch and Flemish masters in the Musée Granet and in the Louvre. The La Caze bequest of 1869, which consisted primarily of seventeenth-century Dutch and eighteenth-century French paintings, substantially enhanced the Louvre's Dutch holdings. In addition, numerous engravings in Charles Blanc's *Ecole hollandaise* (1861) and frequent reproductions of Dutch art in popular journals made northern painting quite accessible to the public.[35] The interest of critics also helped to arouse enthusiasm; Thoré's reviews and writings on seventeenth-century Dutch art were especially influential. Thoré saw in this school a reflection of the egalitarian nature of seventeenth-century Dutch society and espoused it as a model for his own social and political ideals.[36] Finally, the prevailing taste for bourgeois scenes was given new impetus in the 1860s. The rustic peasant scenes that had become so popular after the Revolution of 1848 were being replaced by bourgeois sub-

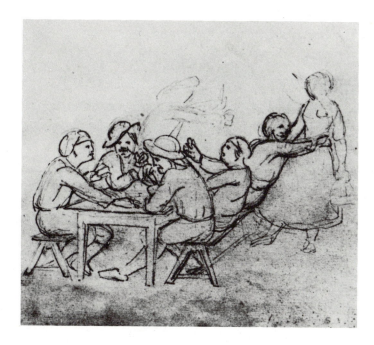

FIG. 66
Paul Cézanne,
Les Joueurs de cartes,
pencil.

jects—often with a more urban flavor—such as Manet's *Le Déjeuner dans l'atelier* of 1868 (Neue Pinakothek, Munich), reminiscent of Vermeer's interiors—and this sparked a renewed appreciation of Dutch genre painting, and its interior scenes in particular.[37]

Several of Cézanne's early drawings show that his attraction to the northern baroque dates from the very beginning of his career and that he probably drew on a number of different paintings from this school as sources. In 1860 the Musée Granet acquired Jan Horemans's *Les Joueurs de cartes* (fig. 65), and Bruno Ely has proposed this work as a possible inspiration for Cézanne's later paintings of cardplayers.[38] While a distant connection to Cézanne's later canvases might be argued, it seems that he knew the seventeenth-century Flemish painting well before his late work. In depicting both gaming and amorous advances, his small drawing of cardplayers of ca. 1860 (fig. 66) recalls the rustic spirit of Flemish tavern scenes. This early drawing features the same coarse wooden table, slouched poses, and sharply tilted perspective found in Horemans's canvas. And, as Reff has noted, the similar work of David Teniers the Younger or Adriaan Brouwer may also have provided Cé-

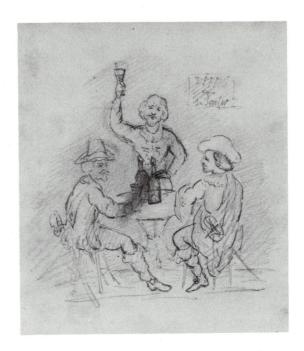

FIG. 67
Paul Cézanne,
Scène dans un cabaret,
pencil, detail.

zanne with models for his drawing.[39] The sketchlike quality of Cézanne's small drawing allows for more than a single source. He seems to be experimenting loosely with a theme that would figure prominently in his later work. Quite likely he was originally introduced to the motif through Horemans's painting, and through him, to Teniers, to whom Horemans's art was clearly indebted.

Cézanne's drawing of three soldiers in a cabaret (fig. 67), another early work with distinctly northern characteristics, also suggests multiple sources. Its subject may have been inspired in a general way by an anonymous northern genre painting, *Intérieur d'un corps de garde*, acquired by the Musée Granet in 1858. Although originally dated ca. 1856–1858 by Chappuis, Cézanne's *Cabaret* drawing has been correctly redated to ca. 1860–1862 by Ratcliffe; it shows both a more sophisticated composition and a better understanding of the northern genre images than the earlier drawing of card-players. Among other sources proposed for the work, Reff has linked it to Michael Sweerts's *Intérieur d'un corps de garde* in the Louvre;[40] it could as well have been inspired by Teniers's *Saint Pierre renie Jésus*, also in the Louvre.[41]

FIG. 68
Jean-Louis-Ernest Meissonier,
Les Joueurs de cartes.

Cézanne's inspiration may also have been secondhand. The jocular subject had already been revived by Meissonier in his many guardsman scenes, among them his *Les Joueurs de cartes* (fig. 68).[42] However, Meissonier emphasized the anecdotal to a greater degree than either Cézanne or other later realists inspired by northern genre.[43]

In two other genre paintings, *La Femme au perroquet* of ca. 1864–1868 (fig. 69) and the related *Fillette à la perruche* of ca. 1888 (fig. 70), Cézanne revived another favorite motif of the seventeenth-century Dutch school: a girl with a pet parrot or bird. Both paintings are small, as befits their genre subject matter, and employ the popular Dutch framing device of a window or ledge. In the former version the girl is shown feeding a bird perched in her hand; in the latter the girl reaches her hand toward her caged parrot. Courbet and Manet would each treat this traditional theme in 1866 and exploit its sensual possibilities in quite modern terms.[44] Although equally aware of the amorous connotations commonly acknowledged in relation to this theme, Cézanne more studiously followed the forms of its Dutch prototypes.

In seventeenth-century Dutch painting, baroque emblem books, and the

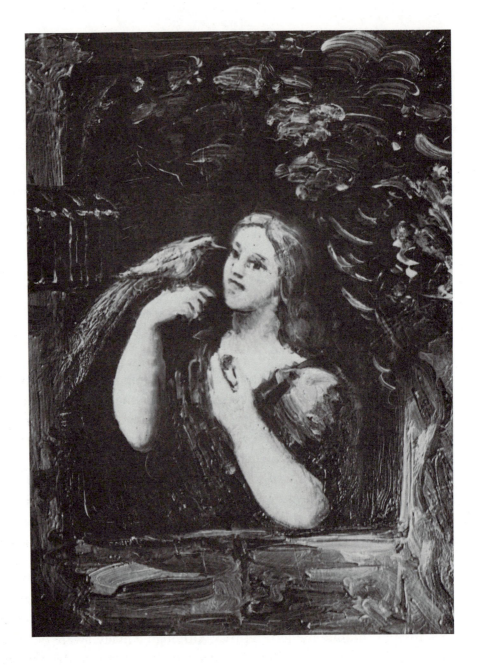

FIG. 69 Paul Cézanne, *La Femme au perroquet*.

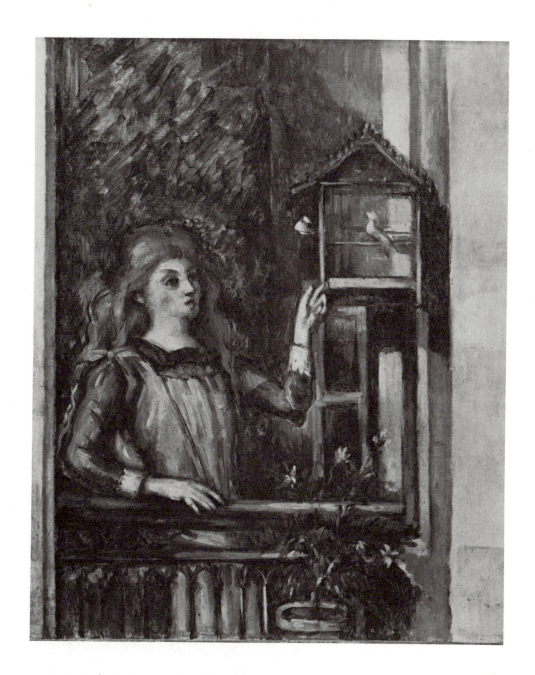

FIG. 70 Paul Cézanne, *Fillette à la perruche*.

FIG. 71
Engraving after
Gaspard Netscher,
La Femme au perroquet.

FIG. 72
Engraving after
Gerard Dou,
La Ménagère.

work of later rococo artists, an intimate and sometimes erotic relationship is frequently projected between a woman and her pet bird, often a parrot, but only a few versions invite explicit symbolic interpretations. As Mona Hadler has pointed out in her article on Manet's *Femme au perroquet*, the parrot could serve as both confidant and substitute lover.[45] A girl reaching toward a parrot, as in Jan Steen's *The Parrot Cage* (Mauritshuis, The Hague), might symbolize the girl reaching for dreams of love; while a woman feeding her parrot, as in Van Mieris's painting of the subject (National Gallery, London), could represent a woman nurturing dreams of romance.[46] The caged or tethered bird was also a traditional symbol of virginity or sometimes of love enslaved, while the bird that escapes its cage might represent lost virginity.[47] The theme continued and evolved in many eighteenth-century versions, of which those by Boucher are particularly familiar. As both the woman and her pet acquired new elegance in this period, overt moral commentary disappeared from the subject, but its symbolic amorous connotations survived, as is demonstrated by Boucher's *Marchande d'oiseaux* or Jean Raoux's two pendants, *Jeune Fille tenant un oiseau* and *Jeune Fille nourrissant un oiseau*.[48]

Cézanne's two paintings, which can themselves almost be thought of as pendants, continue the genre tradition but underscore its Dutch baroque origins. Bruno Ely has suggested two works in the Musée Granet as potential sources: Martin Drolling's *Jeune Paysanne à sa fenêtre* and *Portrait de la femme d'un ambassadeur* by a later, anonymous Dutch painter.[49] On the one hand, while Drolling's work is typical of eighteenth-century versions of the subject and merits notice as a source for Cézanne's composition (for example, his use of a ledge and placement of the cage), his treatment of the theme is quite different from Cézanne's. On the other hand, the anonymous Dutch portrait, which is thematically similar, is quite different in composition. Alternative and more likely sources for both Cézanne's subject and his renderings were provided in Blanc's *Ecole hollandaise* of 1861, which reproduced engravings after Gaspard Netscher's and Gerard Dou's versions, which place the figure in a niche (figs. 71 and 72). Viewed as simple, light-hearted pendants, devoid of instructive moral content but still reflecting a sustained tradition, Cézanne's two works are appropriate and informed renderings of his subject.

Whether or not they depict one or both of his sisters, as has been suggested, or allude to the pretty young girl he and the young Zola serenaded, "who owned as her sole fortune a green parrot," Cézanne's two paintings manifestly tie his genre work to the renewed interest in Dutch art apparent throughout the 1860s.[50]

The Dutch painter most championed by Thoré was Vermeer, whom he "rediscovered" in his pioneering articles of 1866 in the *Gazette des beaux-arts*, which focused new attention on the art of the Delft school.[51] Yet the paintings of Pieter de Hooch, a Delft contemporary of Vermeer, had been inspiration for nineteenth-century realist interiors—including those of Cézanne that fit this definition—long before Thoré's critical reappraisal of Vermeer appeared. Two decades earlier, in his *Femme lisant*, a copy of a painting then attributed to de Hooch, François Bonvin had introduced realists to the serenity and pristine formal organization found in painting from Delft.[52] Jean-François Millet's domestic interiors of the 1850s also recall de Hooch's in formal terms, while in mood they reflect the more humble peasant scenes of Adrien van Ostade and Nicolaes Maes.[53] Cézanne's earliest painting of this sort, his *Scène d'intérieur* of ca. 1859–1860, recalls the de Hooch he knew best, *Intérieur d'une maison*, in the Musée Granet.[54]

Even more typical of a realist canvas painted in the Dutch spirit is Cézanne's portrait of Zola and Paul Alexis, *La Lecture de Paul Alexis chez Zola* of ca. 1867–1869 (pl. VIII), which Fry noted was also reminiscent of de Hooch.[55] Wayne Andersen's careful study of three preparatory drawings for this work (Ch. 220, 222, and 221) outlines the evolution of Cézanne's composition, which follows traditional Dutch prototypes.[56] The earliest sketch (fig. 73) places both figures in a close space and tight-fitting frame with little regard for contrasts of tone. The second (fig. 74) has a more coherent figure-space relationship and utilizes the curtain to unify space and mass. In the third study (fig. 75), the structure of the painting is finally determined. Against a backdrop of horizontals and verticals, echoed in the lines of the table, the diagonal relationship between the two figures is projected into an upward-tilting space where both the curtain and strong contrasts of light and dark reinforce major compositional lines. A similar painting, *Paul Alexis lisant à Emile Zola* (V. 117), probably completed slightly later, displays

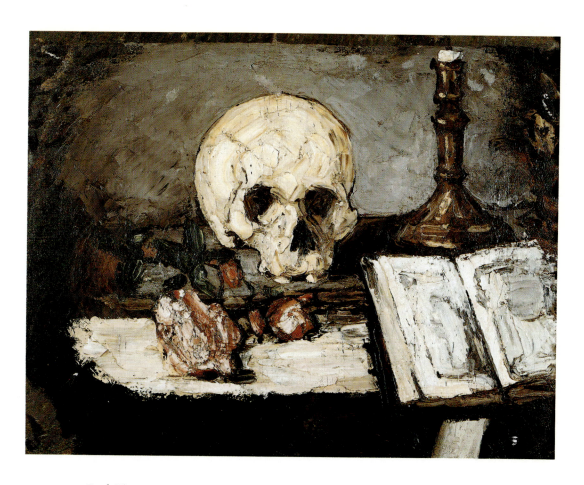

PLATE I Paul Cézanne, *Nature morte: Crâne et chandelier.*

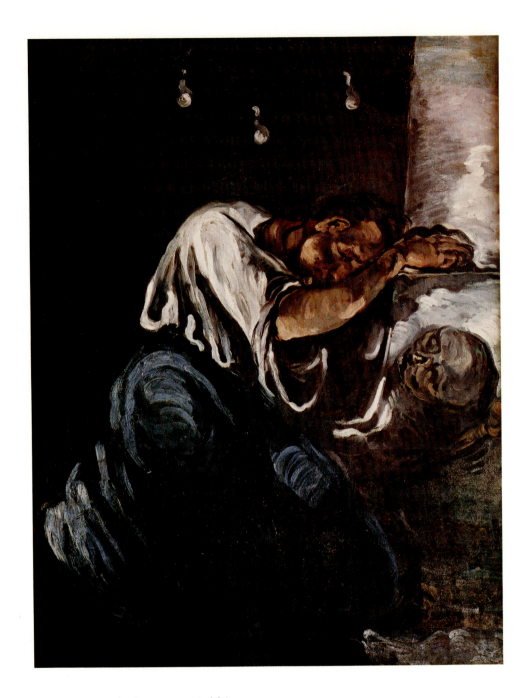

PLATE II Paul Cézanne, *La Madeleine*.

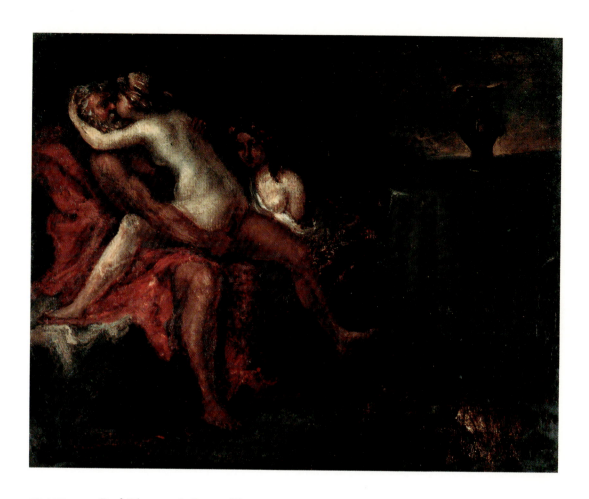

PLATE III Paul Cézanne, *Loth et ses filles*.

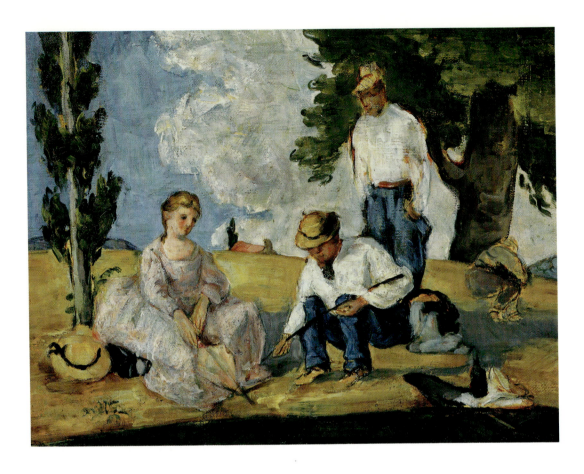

PLATE IV A. Paul Cézanne, *Picnic on a River*.
 B. Antoine Watteau, *Le Dénicheur de moineaux*.

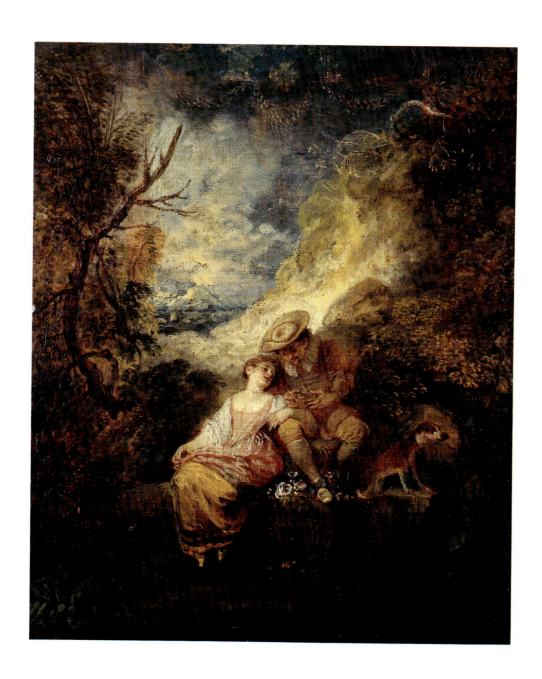

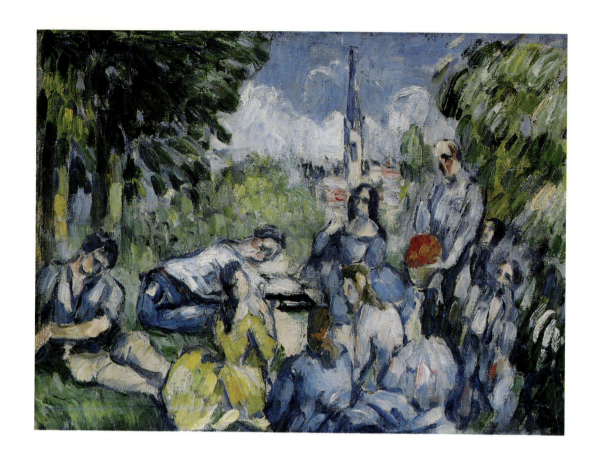

PLATE V Paul Cézanne, *Le Déjeuner sur l'herbe*.

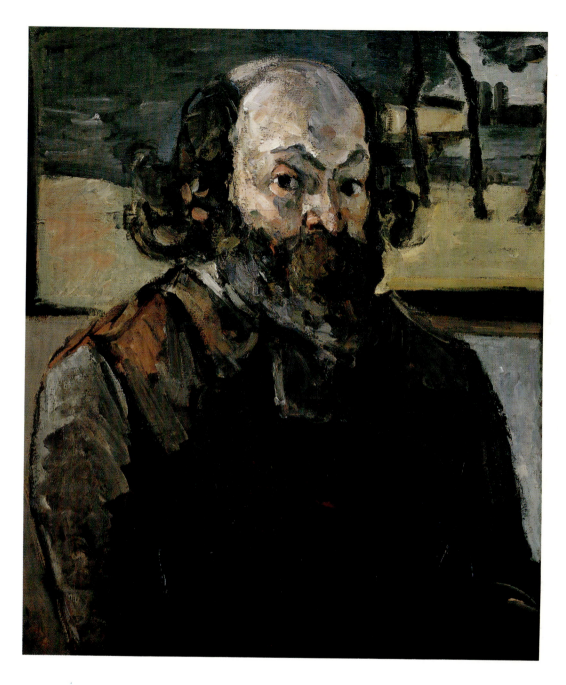

PLATE VI Paul Cézanne, *Portrait de l'artiste*.

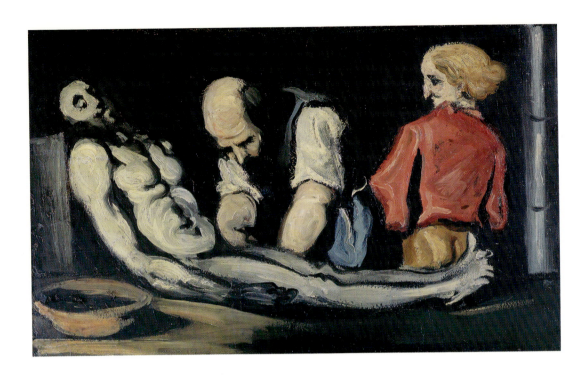

PLATE VII Paul Cézanne, *La Toilette funéraire*.

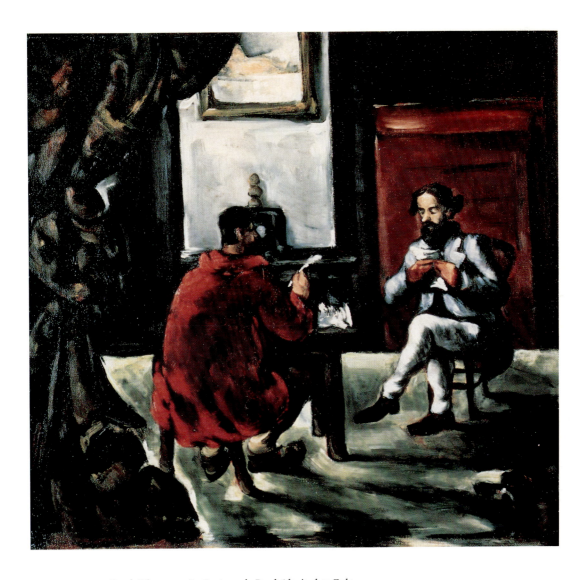

PLATE VIII Paul Cézanne, *La Lecture de Paul Alexis chez Zola.*

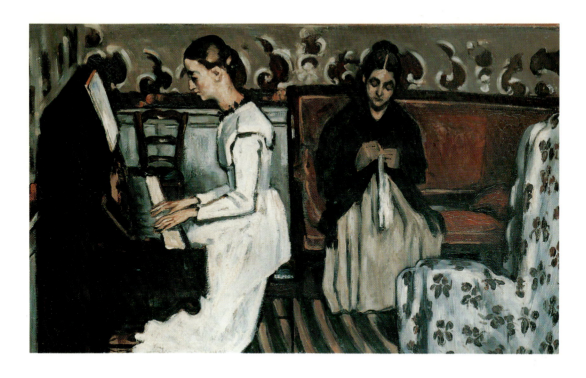

PLATE IX Paul Cézanne, *Jeune Fille au piano: L'Ouverture du "Tannhäuser."*

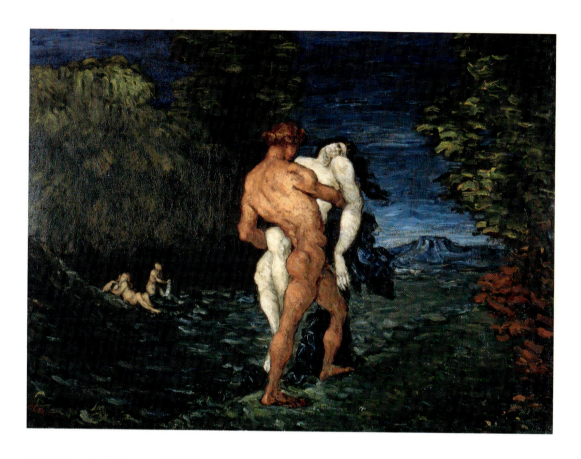

PLATE X Paul Cézanne, *L'Enlèvement*.

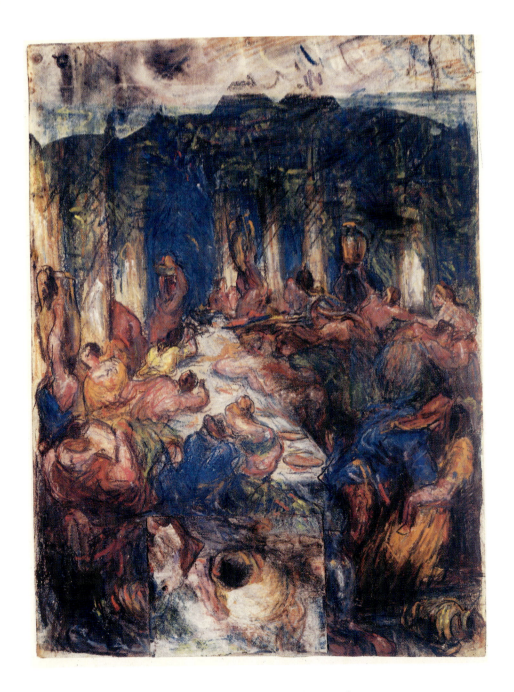

PLATE XI Paul Cézanne, study for *Le Festin* (*L'Orgie*), pencil, crayon, pastel, and gouache.

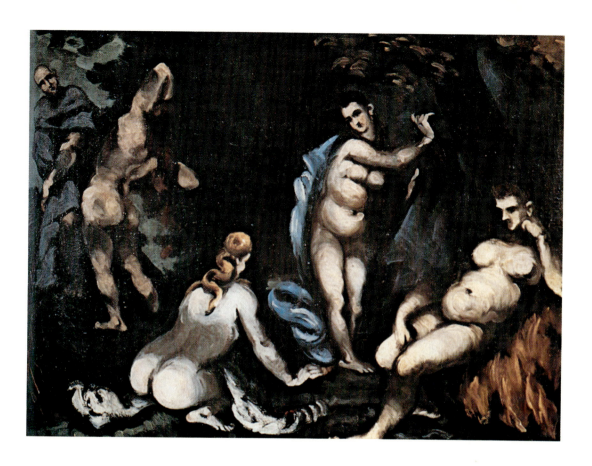

PLATE XII Paul Cézanne, *La Tentation de Saint Antoine*.

PLATE XIII Paul Cézanne, *Les Baigneuses*.

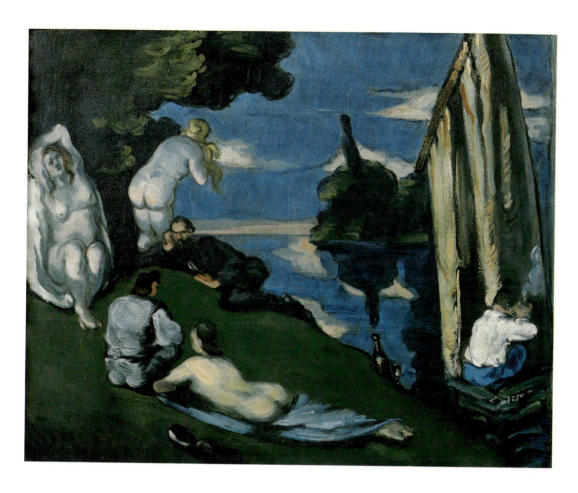

PLATE XIV Paul Cézanne, *L'Idylle* (*Pastorale*).

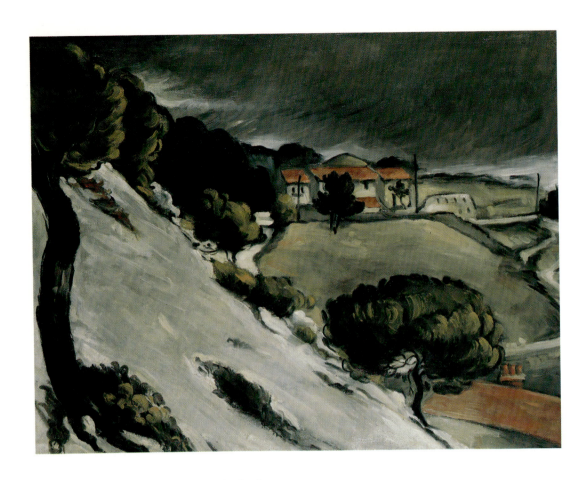

PLATE XV Paul Cézanne, *La Neige fondue à L'Estaque.*

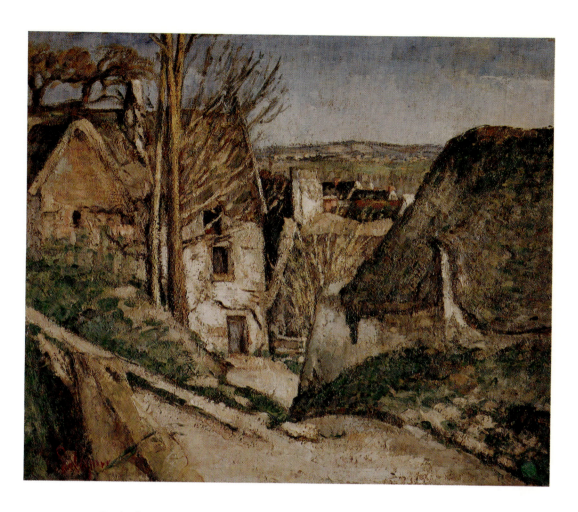

PLATE XVI Paul Cézanne, *La Maison du pendu*.

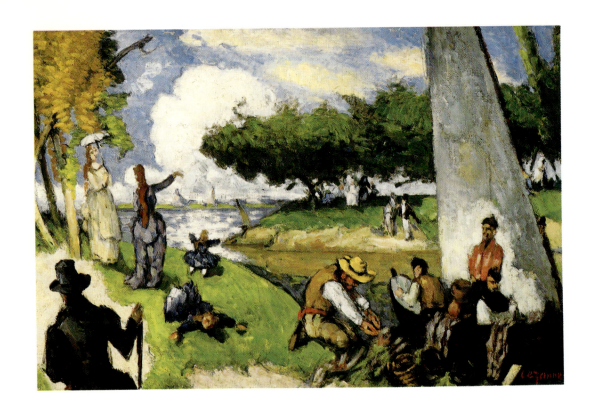

PLATE XVII Paul Cézanne, *Scène fantastique*.

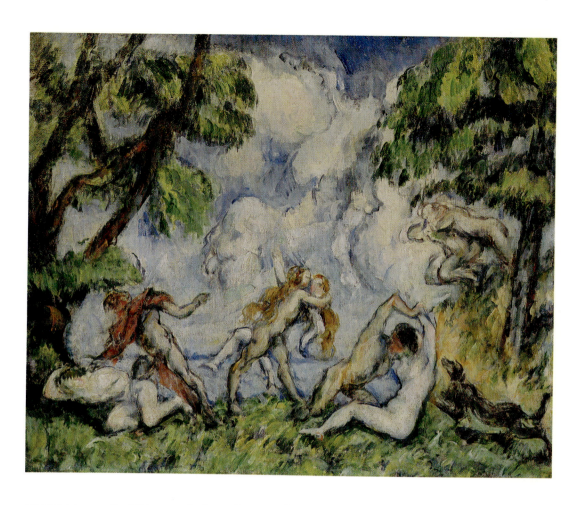

PLATE XVIII Paul Cézanne, *La Lutte d'amour* (*The Battle of Love*).

a radically different composition and style; significantly, as Andersen points out, it is posed out-of-doors, an environment not characteristic of these Dutch-derived genre works.[57] Cézanne's choice in the earlier *Lecture* of the quiet interior scene (typical of the Delft school), the slightly elevated view into a bright, unpretentious room, and the formal organization of the far wall into a gridlike pattern formed by the door jamb, moldings, and small rectangular painting is characteristic of Dutch interiors, especially of de Hooch's. Its predominantly black, white, and red color scheme may also derive from such paintings.[58] Even the trompe-l'oeil drapery in the earlier work, not a common feature of nineteenth-century interiors, may derive from Dutch examples, possibly, as Gowing suggests, from Dou's *Femme hydropique* in the Louvre, which Cézanne admired.[59] By using the drapery to frame the left half of the painting and to accentuate the contrast of light and dark, Cézanne anticipates the attraction impressionists would later find in the Delft school's sensitivity to natural light.

Cézanne's *Jeune Fille au piano* (pl. IX) of ca. 1869–1870 is also indebted to Dutch genre painting. The work depicts a young girl at the piano and an older woman sewing in the background of a salon. This type of quiet, intimate family scene is often found in paintings of Dutch interiors. Cézanne's first two versions of the subject are now lost and are known only from letters written by Cézanne's friend Fortuné Marion to the young German musician Heinrich Morstatt.[60] Noting that both were intended as tributes to Wagner and were entitled *L'Ouverture du "Tannhäuser,"* Marion also described the importance of these two paintings to an understanding of Cézanne's early development, observing that, while the more crowded version of 1866 was "wild [and] overpoweringly strong," the second was "most carefully finished" and in some parts "magnificently true."[61] Cézanne's final version, probably an offering to Wagner like its predecessors, suggests that the content and organization of the work had evolved along with his growing interest in realism and Dutch genre. In addition to its simplified format, the empty chair in the foreground corner, the floor tilted upwards, the rectilinear organization of the far wall, and the attitudes of his figures—one playing an instrument and the other quietly working—were all standard features in Dutch domestic scenes.[62]

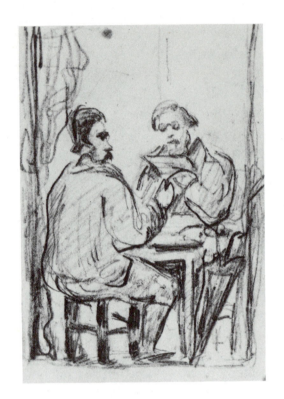

FIG. 73 Paul Cézanne, study for
La Lecture de Paul Alexis chez Zola,
pencil. Private collection.

FIG. 74
Paul
Cézanne,
study for
*La Lecture
de Paul
Alexis chez
Zola*,
pencil.

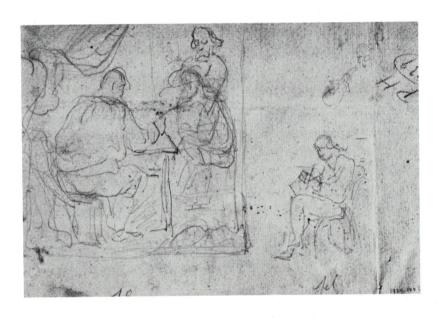

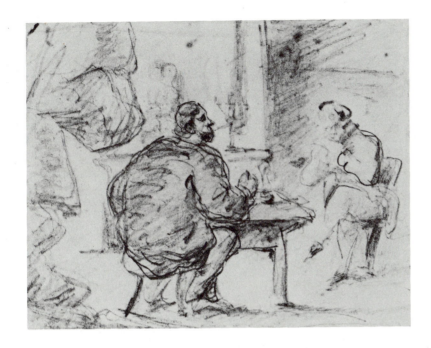

Cézanne would have been familiar with a number of important baroque Dutch works that might have influenced his choice of subject and composition. Jan Steen's *La Leçon de clavecin* (fig. 76), wrongly attributed by Thoré to Vermeer, was well known through an engraving of 1804 by J. S. Marcus.[63] *Dame debout jouant de l'épinette*, which Thoré correctly assigned to Vermeer and reproduced in his article of 1866, was equally familiar to nineteenth-century viewers.[64] Metsu's *Hollandaise au clavecin* (fig. 77) was reproduced in Blanc's widely distributed *Ecole hollandaise* and was also partly responsible for the subject's frequent reappearance in the 1860s. As was often the case, another factor was popular taste. This type of bourgeois scene, with its nice blend of materialism and sentiment, often appeared in the popular paintings of interiors that delighted Second Empire and later bourgeois patrons.[65]

While he would certainly have had these models in mind, Cézanne's interest in this aspect of Dutch genre may also have been inspired by the work of his peers. Among likely candidates are Fantin-Latour's *Deux Filles* of 1859 (The St. Louis Art Museum) or his 1864 etching *A Piece from Schumann*, one of his tributes to a modern composer. More thoroughly indebted to

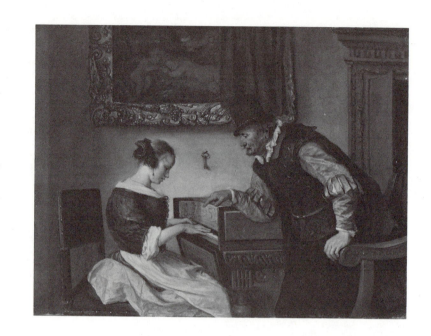

FIG. 76
Jan Steen,
*La Leçon
de clavecin.*

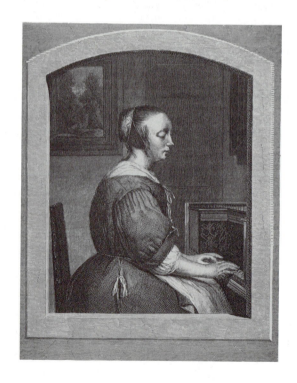

FIG. 77
Engraving after
Gabriel Metsu,
Hollandaise au clavecin.

FIG. 78
James
A. McNeill
Whistler,
Au piano.

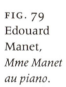
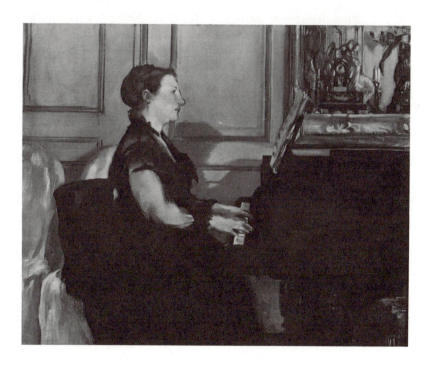

FIG. 79
Edouard
Manet,
*Mme Manet
au piano*.

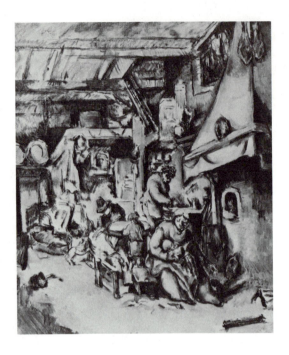

Netherlandish art was James McNeill Whistler's painting of 1859, *Au piano* (fig. 78), which was finally accepted at the Salon in 1867.[66] Its contemplative mood, geometric composition, and subdued palette set forth the Dutch features that were so attractive to realist painters and critics. (At one point, Thoré even considered buying Whistler's work because it would have fit in so well with his own seventeenth-century Dutch collection.)[67] And in his painting of 1868, *Mme Manet au piano* (fig. 79), so clearly linked to Metsu's engraving, Manet established this northern genre theme and its seemingly obligatory geometric composition as a hallmark of the realist Dutch revival.[68] Cézanne's *Jeune Fille au piano* thus revives both the general form and spirit of a popular theme representative of the renewed interest of realists in Dutch art.

The simplicity and geometric order of the depicted interior and the quiet absorption of the two sitters, rare qualities in Cézanne's early subject pictures, point to the continued hold that Dutch painting had on his imagination. Only the vibrant, organic design of the wallpaper that breaks into the stillness of his *Jeune Fille*—perhaps emblematic of Wagner's controversial

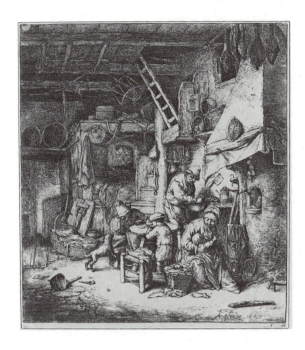

new music itself—suggests a more contemporary and personal element in his version of this popular subject. With thick black outlines and broad strokes of paint, Cézanne emphatically freezes in place both pattern and figures, anticipating his subsequent shift in focus from iconographic to more formal issues by emphasizing here formal values rather than symbolic allusions.

Cézanne remained fascinated by the poignant naturalism and style of the baroque Netherlandish school, and it continued to inform his art after his first decade. In a small drawing of ca. 1870–1873 (Ch. 211), he studiously copied the humble contours of a cart horse from Paulus Potter's *Les Chevaux à l'auge* in the Louvre, which he knew from an engraving in Blanc's Dutch volume. Cézanne's heavy shadows and strong black outlines exaggerated the contrasts found in the original and underscore the artist's attention in the early 1870s to the effects of natural light on form. Similarly, his ca. 1880 oil sketch (fig. 80) after Adrien van Ostade's 1647 etching *La Famille* (fig. 81), which had appeared in the *Magasin pittoresque*, reveals Cézanne's growing interest in creating a cohesive pictorial structure for his paintings.[69] Emile

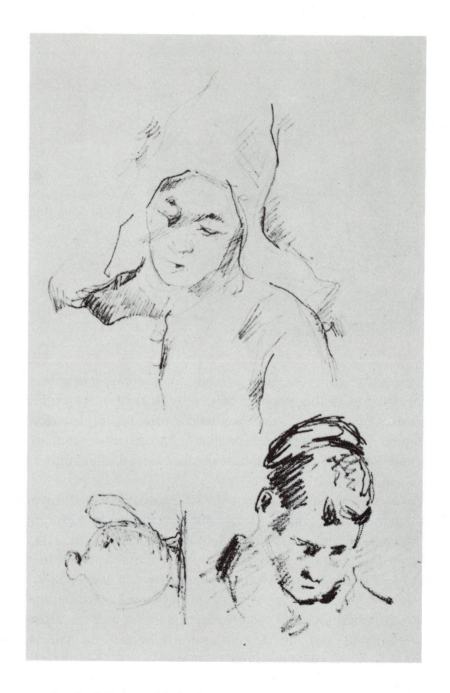

FIG. 82 Paul Cézanne, sketch of a peasant woman, pencil.

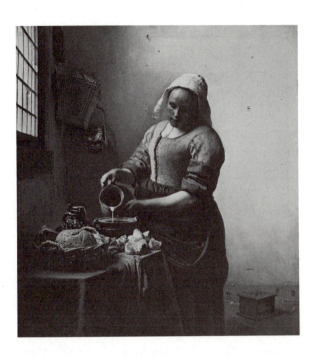

FIG. 83
Jan Vermeer,
Maidservant Pouring Milk.

Bernard recounts how Cézanne once remarked that van Ostade was for him "l'idéal des désirs."[70] Cézanne's version of the etching reveals his admiration of van Ostade's gifted sense of composition. Executed in oils and with little note taken of its rustic genre theme, Cézanne's copy translates and restructures the intricate composition of van Ostade's print in rich blues, ochres, and shades of white. Cézanne attempted a similar chromatic structure in such works as his *Compotier, verre, et pommes* (V. 341) of the same period.

The example of Dutch art would assume more than a formal role in Cézanne's painting after the 1860s. His small sketch of a peasant woman of ca. 1874–1877 (fig. 82), while possibly reflecting the influence of Camille Pissarro's drawings of such subjects, has also been linked to Vermeer's *Maidservant Pouring Milk* (fig. 83).[71] In a recent article, Bob Kirsch discussed Vermeer's influence, but in a different context, suggesting that it might be seen in a general way in the poses and attitudes of Cézanne's portraits of women from the later 1870s.[72] Kirsch points to a Vermeer-like bearing and degree of concentration in the sitter's attitude in such depictions as *Madame Cézanne cousant* (V. 291) of ca. 1877, which is itself related to the figure of the older

woman in the earlier *Jeune Fille au piano*. Yet far more significant than specific poses or compositional traits is the larger context of dignity and serene order in which Cézanne's genre figures appear. It is this sense of order that reflects most clearly Cézanne's understanding of the Dutch baroque school, of which Vermeer is perhaps the most resonant example. Given the larger historical framework they so cogently inhabit, Cézanne's later paintings of ennobled figures in their everyday surroundings, whether peasant or bourgeois, never fall into the realm of ordinary genre, where Ribot's and Bonvin's paintings remain.

More than his early still lifes or landscapes, Cézanne's first genre paintings underscore the complexity of his early realist work by revealing its broad roots in several older pictorial traditions. In 1857 Castagnary had called genre painting the ideal artistic form because it emphasized "the human side of art";[73] Cézanne's study both of Ribera's compelling subjects and motifs and of quiet Dutch interiors helped to define the romantic/realist parameters of the human subject in his early painting. Many nineteenth-century critics, such as Gabriel Laviron and Thoré, advocated the study of past masters of realism whose painting could serve as models for contemporary artists. But few apprenticeships of that time yielded conclusions as original and moving as Cézanne's. Although his genre paintings place him squarely within the context of nineteenth-century revivals and help to document his own artistic evolution in the 1860s, they also serve to separate the artist from his peers. Cézanne's knowledge of the tradition of realism and his historical approach to its visual properties honed his feeling for the greater possibilities inherent in genre painting. His early essays in genre helped to establish a foundation in tradition from which he would pursue his study of the poignant human subject and its expressive form.

SAVAGERY
REDEEMED
A Reinterpretation of
L'Enlèvement

VII

THE PROMINENCE OF VIOLENT THEMES in his early work has been noted by most historians of Cézanne's art. In drawings such as his *Scène de violence* of ca. 1869–1872 (fig. 84), certain watercolors, and a few paintings, this darker side of his early period is given striking expression in images of sexual brutality and murder. Despite the variety and sheer inventiveness of such scenes, they have traditionally been dismissed, like his overtly erotic works, simply as proof of Cézanne's romantic, adolescent passions. But recent indications suggest that critical attention is being refocused on some of this work. In a 1986 essay, Guy Cogeval suggested that Cézanne's *La Femme étranglée* of ca. 1867 (fig. 85), which shows a gruesome slaying in a bourgeois interior, exhibits the influence of the lurid stories and graphic style of contemporary journalism on realist painting.[1] Cézanne's painting of an even more haunting homicidal scene, *Le Meurtre* of ca. 1867–1868 (fig. 86), has been recently linked to Goya's *Los Desastres de la guerra* (Disasters of War), published in 1863.[2] The painting's violent and violently conceived figures and obviously narrative context suggest much more than the artist's imagination as a source for its dramatic imagery.

Perhaps the most provocative of Cézanne's paintings of brutal scenes is his large canvas (32½×46 in.) of 1867 entitled *L'Enlèvement* (The Rape; pl. x), which he gave to his friend Zola.[3] Although *L'Enlèvement* has always been grouped with and assessed in terms of Cézanne's other paintings and drawings of brutal scenes, it clearly stands apart. The dramatic landscape and monumental scale of the figures import a visionary quality not present in Cézanne's other works of this type and prove to be fundamental indications of its actual subject—a classical abduction scene.

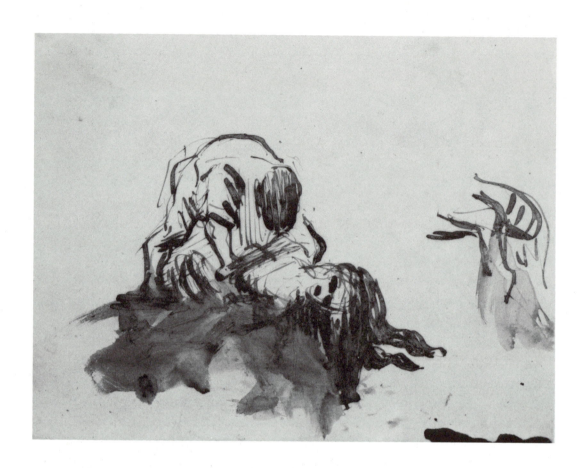

FIG. 84 Paul Cézanne, *Scène de violence*, reed pen, ink, and wash.

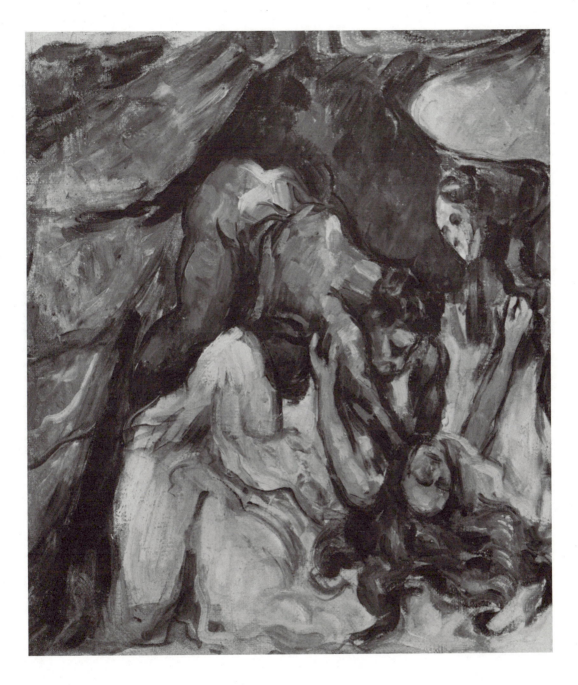

FIG. 85 Paul Cézanne, *La Femme étranglée*.

FIG. 86 Paul Cézanne, *Le Meurtre*.

Although most critics have not searched beyond the seemingly private connotations of *L'Enlèvement*,[4] the possibility of a literary source for the picture was indeed suggested by one early commentator. In his review of the Exposition Universelle of 1889, the Parisian poet and critic Gustave Kahn defended Degas's liking for historical and literary themes, so unlike his impressionist contemporaries, by asking rhetorically, "Was not Cézanne inspired by *Roland furieux*?"[5] Ariosto's Renaissance epic, an episodic saga of a maddened lover, rich in picaresque subplots, was much in vogue among romantic and later symbolist writers and painters, who delighted in its chivalrous exploits and lovelorn characters.[6] It is likely that Kahn, who could have seen *L'Enlèvement* at Zola's house on the rue Condamine, interpreted its imagery in terms of this popular narrative subject.[7] While the critic appears to have grasped the general literary import of Cézanne's vision, its antiromantic form makes it unlikely that the specific source was this idealized chivalric tale.

With an almost symmetrical composition and careful, even brushwork, Cézanne depicts not the tumultuous coastlines described in Ariosto's work or an imagined act on the part of his distracted hero but instead a specific antique terrain and a scene of abduction that are derived from classical mythology. Along with its even, circumspect execution, the landscape, background figures, and heroic protagonists of Cézanne's *L'Enlèvement* all have sources in classical literature.

The range of classical themes Cézanne chose to paint mirrored the spectrum of his early subject matter. His inclination was also in keeping with the classical tastes of his age and, more specifically, of the poetry of the Provençal revival. As a schoolboy in Aix, Cézanne read widely in the literature of ancient Greece and Rome and composed his first verses as deliberate parodies of the ancient authors.[8] It is not surprising, then, that classically derived themes of love and violence predominate in both his early paintings and poetry. Moreover, at this youthful stage of his career, he often manipulated elements of his style to heighten the emotional impact of his chosen theme and to underscore its antique origins.

Typical of Cézanne's classical scenes and of this stylistic tendency is his now lost painting of *The Amorous Shepherd with a Basket of Apples for His Lover*

(fig. 87). This obscure subject is taken from one of the elegies of Propertius and was first identified by Meyer Schapiro.[9] In its harmonious, friezelike composition and orderly, parallel brushstrokes, the style of the painting is consistent with the mood of its classical, pastoral literary source. A watercolor copy after one of Delacroix's paintings of *La Médée* (fig. 88) displays this reflective technique in a different classical context. Cézanne intensified the horror of the story. He stirred up the brushwork, emphasized the cold blade of Medea's dagger, rendered faceless the children about to be slain, and so produced an image closer in mood to its ancient Greek literary source than had Delacroix.[10] Medea's monumental figure, classical profile, and sculptural form bypass Cézanne's romantic source and address instead the stark immediacy of the antique original.

Aside from these more narrative subjects, Cézanne often illustrated specific historical moments from classical times and classical literature. Among such works are a pen-and-ink drawing of *Cicéron frappant Catilina*, a drawing and a watercolor of *Enée rencontrant Didon à Carthage*, a sketch of the *Mort de Cléopâtre* (possibly a copy of another work), and an early painting of the *Jugement de Pâris*.[11] Like his *Amorous Shepherd*, they all closely follow classical texts in imagery and mood and manifest the artist's familiarity with a broad range of classical literature and art. These affinities persisted well into Cézanne's later periods. As late as 1885, Gauguin would describe him as the "man of the south who spends days on the mountain tops reading Virgil and looking at the sky."[12] Thus, it seems all the more surprising that the true subject of Cézanne's *L'Enlèvement* has gone unrecognized. Unlike the *Le Meurtre* or *La Femme étranglée* in whose company it is always discussed, the figures in *L'Enlèvement* are not in contemporary dress but nude. They are drawn to a heroic scale in comparison with the tiny figures in the background, and the hair of the male figure is reminiscent of the wreaths and ringlets of classical statuary. Finally, as will be demonstrated, the action takes place in a very specific—and well-known—mythological landscape. A close study of the painting reveals its subject to be, in fact, the abduction of Persephone. A likely specific source for Cézanne's rendering of this much recounted myth is Ovid's *Metamorphoses*, to whose vividly pictorial text many details in the painting conform.

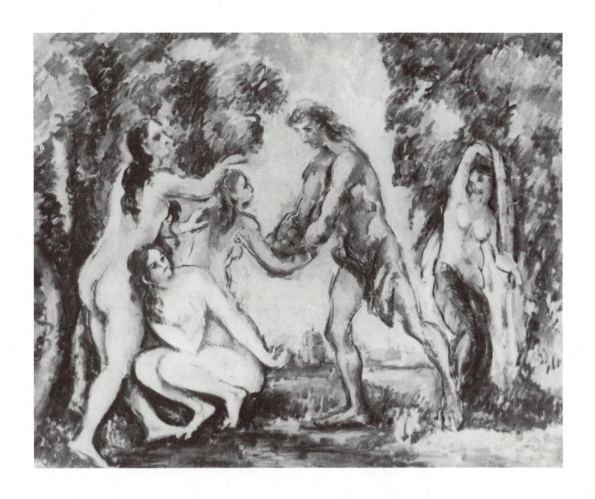

FIG. 87 Paul Cézanne, *The Amorous Shepherd with a Basket of Apples for His Lover* (*Le Jugement de Pâris*).

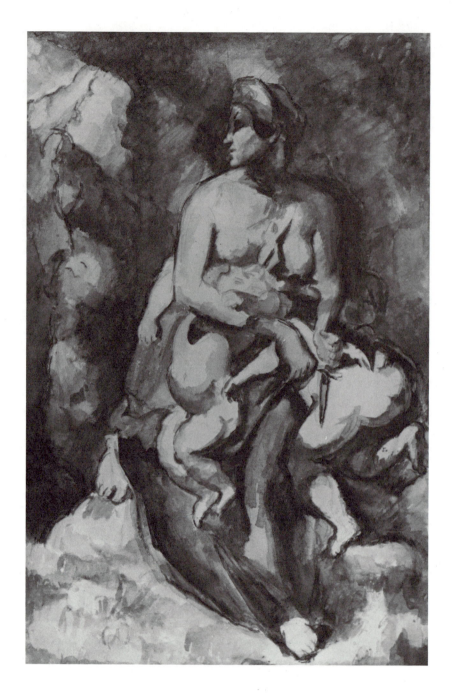

FIG. 88 Paul Cézanne, copy after Delacroix's *La Médée*, pencil and watercolor.

Ovid writes of this event in book 5 of the *Metamorphoses* (where Persephone is Proserpina). In it he describes the ancient island of Sicily and the eruptive Mt. Aetna looming over the shadowy glen where Proserpina plays with her companions. While Cézanne's horizon could have been drawn from the inspiration of the familiar Mont Sainte-Victoire,[13] the distant, truncated mountain in the dark background of *L'Enlèvement* seems to refer even more closely to his classical literary source and to such seventeenth-century prototypes as Jean-Françisque Millet's imaginary *Paysage de Sicile* of ca. 1650 (Musée des Beaux-Arts, Marseille). In addition to the profile of Mt. Aetna, Cézanne's landscape follows Ovid's text in other respects, and in particular his description of nearby Lake Pergus, where Pluto first spies Proserpina.

A wood crowns the heights around its waters on every side, and with its foliage as with an awning keeps off the sun's hot rays. The branches afford a pleasing coolness.[14]

The verdant foliage that frames Cézanne's composition on the right corresponds to Ovid's dense, sequestered woods. The prevailing deep shadow of the work creates a sense of the "pleasing coolness" the branches afford and the protection they offer from the sun. Beyond the lush woods, Lake Pergus itself can be seen, placed in the middle ground between two diagonals of the shoreline. Cézanne conveyed the watery surface with short, curling brushstrokes and broken touches of white pigment.

This palpably classical landscape is the site of an ancient conflict. At its exact center looms the colossal, nude figure of Pluto, carrying the pallid and languishing Proserpina. An earlier, very small watercolor-and-ink version of the same theme conveys a greater sense of violence and motion (fig. 89).[15] In contrast to the male figure in the watercolor, Pluto's hair in the painting is neatly plaited into a coif that places him firmly in antiquity. Moreover, he does not struggle with his captive but subdues her forcefully (in Ovid's account, "almost in one act did Pluto see and love and carry her off, so precipitate was his love,")[16] and strides with a powerful gait into the shadowy landscape behind him. Rewald has linked a small watercolor figure study (RWC 28, ca. 1867–1870) to the canvas, which gives us a sense of how the final painting took form. Although the hair and positioning of the legs are

FIG. 89 Paul Cézanne, study for *L'Enlèvement*, pen, india ink, and watercolor.

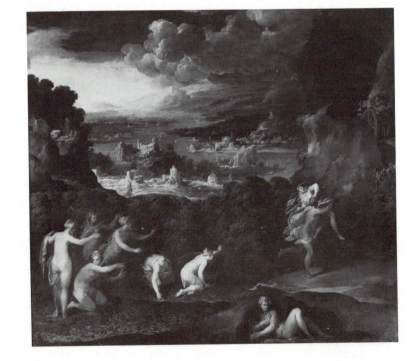

FIG. 90
Niccolo
dell'Abbate,
*L'Enlèvement de
Proserpine*.

different in the study, the muscular frame and walking pose the male figure assumes on canvas are suggested in the smaller work.[17] But only in the final painting does the classical myth fully take shape.

Pluto's inert victim also reflects the past and previous treatments and imagery. Her white figure is starkly contrasted with both the dark background and the bronze form of Pluto.[18] Like her captor she is nude and matches his colossal proportions. Trailing behind her is a deep blue cloak, mentioned by Ovid as having been torn from her shoulder.[19] Although the text does not specify the color of the riven garment, Cézanne's painting follows the example of such famous earlier versions of the encounter as Niccolo dell'Abbate's *L'Enlèvement de Proserpine* of ca. 1560 in the Louvre (fig. 90). It is interesting to note that the English Pre-Raphaelite Dante Gabriel Rossetti would later declare that a "tartean blue-grey" palette was most appropriate for images of the tragic Persephone.[20]

Cézanne's scene does not include Pluto's mythic chariot, which appears in dell'Abbate's version and also figures memorably in Rembrandt's painting of the theme (Kaiser-Friedrich Museum, Berlin).[21] But Pluto's mythic vehicle would be out of place in the human drama Cézanne has staged. However, Cézanne does include the island's nymphs, who mourn Proserpina's capture and are central figures in her story. The contorted figure who is closest to Pluto and who seems to sink into a watery middle ground is the weeping Cyane. Again, Ovid's text provided Cézanne with his image:

But Cyane, grieving for the rape of the goddess . . . nursed an incurable wound in her silent heart, and dissolved all away in tears; and into those very waters was she melted whose great divinity she had been but now. You might see her limbs softening, her bones becoming flexible And, finally, in place of living blood, clear water flows through her weakened veins and nothing is left that you can touch.[22]

Cézanne's twisted and mannered figure is in the process of becoming one with the pool that would bear her name. The luminous drapery she holds in her outstretched hand refers to a subsequent moment in Ovid's account, when Cyane retrieves the girdle Proserpina dropped at the moment of her capture and later gives it to her grieving mother, Ceres.

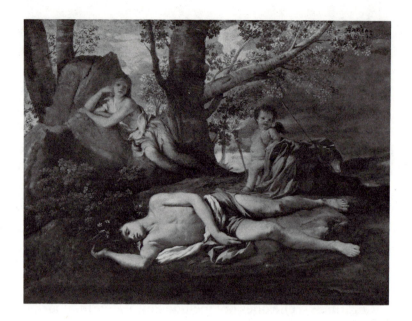

FIG. 91
Nicolas
Poussin, *Echo
et Narcisse*.

If the nymph had not been changed to water, she would have told all But still she gave clear evidence, and showed on the surface of her pool what the mother knew well, Proserpina's girdle, which had chanced to fall upon the sacred waters.[23]

Like her mannerist counterpart, featured so prominently in the foreground of dell'Abbate's painting, and in related engravings from the Fontainebleau school where the subject was very popular, in Cézanne's version the supple figure of Cyane is an essential part of the narrative and helps to explain the significance of the dark, liquid landscape.[24]

Gowing and others have linked the pose of the reclining nude on the far left of Cézanne's *L'Enlèvement* to another painting after Ovid—Poussin's *Echo et Narcisse* (fig. 91) in the Louvre.[25] A preparatory drawing Cézanne made for this figure (ca. 1866–1867, fig. 92) closely follows Poussin's Echo and supports this contention. Rewald notes that Cézanne applied for a student's card to sketch at the Louvre as early as 1863; his frequent drawing sessions there and deep admiration for Poussin are both well documented.[26] Yet his reclining nude, which appears in both the study and the painting, does not con-

FIG. 92
Paul Cézanne,
study for
L'Enlèvement,
pencil, detail.

form exactly to its baroque prototype. While the upper part of the torso is very similar to that of Poussin's figure, the legs are twisted and the pose is more recumbent. Moreover, her exaggerated posture matches the expressive mannerism of her companion, Cyane. Like Cyane, she seems to sink into the watery landscape, and she is, in fact, the water nymph Arethusa who appears with Cyane in Ovid's text. Again like Cyane, Arethusa has a lake in Sicily bearing her name, and this fact further establishes the island as the setting for Cézanne's painting.[27] In the context in which he was working it is not surprising that Cézanne was attracted to Poussin's famous painting of a nymph who drowns for love and grief. It offered not only a form but a subject he could transpose.

Viewed as a classical abduction rather than a violent, imaginary rape scene, Cézanne's *L'Enlèvement* becomes a far less radical statement, related more closely to tradition than to the excesses of the artist's private passions. Although many of his peers, especially Manet, held this type of subject in contempt, Cézanne's *L'Enlèvement* represents a major venture by the artist into the realm of history painting. Moreover, classical themes of this type

abounded in the Salons of the 1860s and may well have influenced his choice of subject during this formative period.

Mythological scenes of abduction were extremely popular in the 1860s, especially among those academic painters who openly catered to public taste and who sought acceptable pretexts to paint the idealized but still wanton nude.[28] At the Salon of 1865, two very large paintings by artists now long forgotten, Louis-Frédéric Schützenberger's *Europe enlevée par Jupiter* and an eight-foot-high *Enlèvement d'Amymone* by Félix-Henri Giacomotti, typified this trend on its most monumental scale.[29] Alexandre Cabanel, though best known for his prurient *Naissance de Vénus* of 1863, achieved his first real success several years earlier at the Salon of 1861 with his equally suggestive *Nymphe enlevée par un faune* (fig. 93). Concealed behind a thin veil of mythology, such depictions of abduction allowed an artist to exhibit paintings of almost openly erotic content, appealing to the less sophisticated of his viewers. This pretext of mythology made such vaguely classical scenes acceptable even on an official level. Napoléon III purchased Cabanel's 1861 painting of a nymph (which also featured a monumental bronze abductor and a pale, white victim) and re-exhibited it to renewed acclaim at the Exposition Universelle of 1867, where Cézanne would have seen it.[30]

As has been noted earlier, Cézanne was impressed by the academic works he saw in the Salon shortly after arriving in Paris in 1861. Letters home recorded his deep admiration for many of the works displayed and, in his own small pictures on mythological themes, *Satyres et nymphes* (ca. 1864–1868, fig. 94) and *Nymphe et tritons*, discovered by John Rewald and dated by him ca. 1867 (fig. 96), Cézanne strove for the same popularization of the subjects.[31] Less specific in subject matter than his painting of Proserpina and therefore not dependent on literary sources, such works nonetheless constitute paeans to classicism in form as well as in subject matter. Leo Steinberg has suggested that the central standing nude in Cézanne's *Satyres* derives from Rubens's major mythological painting *Ixion trompé par Junon* (fig. 95), and a comparison of the two works bears out his observation.[32] In fact, the horizontal formats and strong, friezelike compositions of both of Cézanne's paintings underscore their debt to such classical precedents even more pointedly than do their hazy references to classical themes.

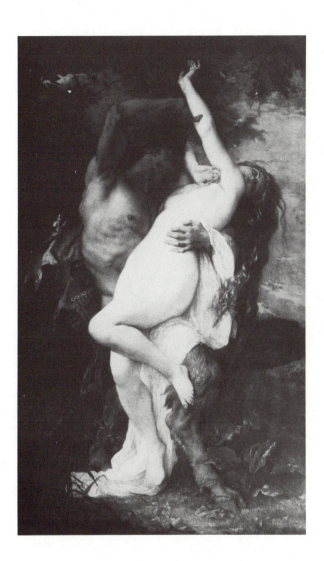

FIG. 93
Alexandre Cabanel,
Nymphe enlevée par un faune.

FIG. 94 Paul Cézanne, *Satyres et nymphes*.

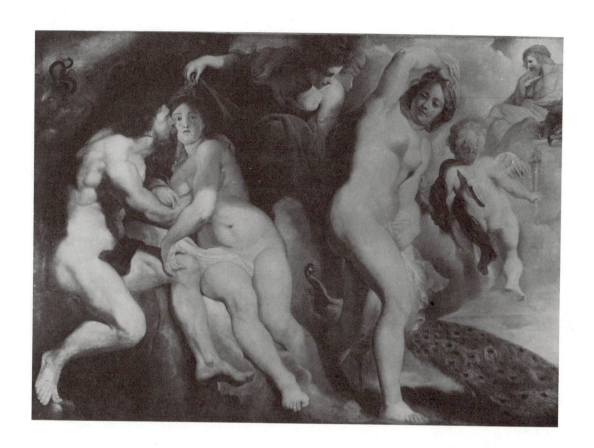

FIG. 95 Peter Paul Rubens, *Ixion trompé par Junon*.

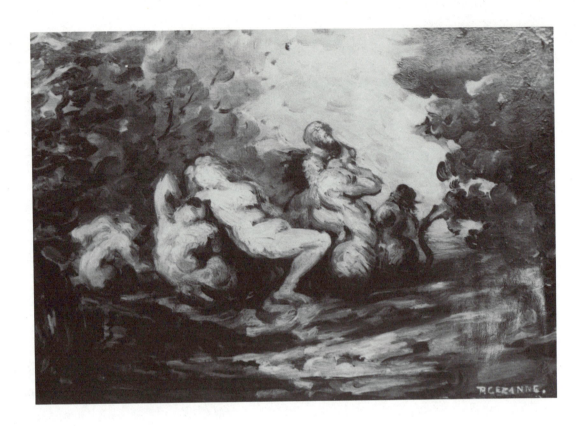

FIG. 96 Paul Cézanne, *Nymphe et tritons*.

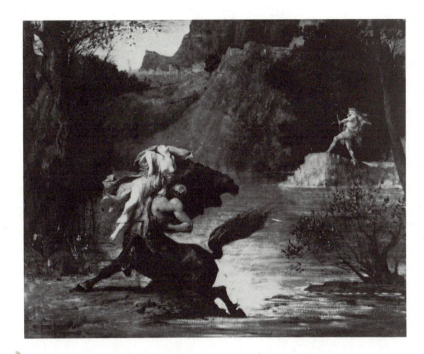

There is an even closer parallel to suggest the prevalence of classical subjects at the time. Another abduction painting, entitled the *Mort du centaure Nessus*, was painted by Jules-Elie Delaunay (fig. 97) and exhibited at the Salon of 1870. Like Cézanne's *L'Enlèvement*, it probably derived its subject matter from Ovid.[33] In book 10 of the *Metamorphoses*, Ovid narrates the fate of the centaur Nessus who offered passage across the River Evanus to the lovely Deianira. When he attempted to abduct her, Nessus was pursued by her husband, Hercules, who slew him from the other side of the river with a poisoned arrow. Although Delaunay's painting was very warmly received, it provoked criticism because of the proportion of the canvas given over to landscape. But for him, as for Cézanne, that landscape was essential to the classical narrative.

L'Enlèvement, then, is a vivid example of a compelling work that has been misinterpreted because it dates to the painter's first decade, the decade of the legendary rough and tumultuous Cézanne. Like his later fantasy paintings, it drew its subject matter as well as elements of its style from a well-known

literary source and also suggests Cézanne's awareness of popular academic painting in the 1860s.

In this large and most traditional of his early paintings, Cézanne's perfectly balanced composition, heroic figures, careful brushwork, somber palette, and isolated hints of mannerist style can be reconciled with his dark image of violent passion only when its classical subject matter is understood. Yet this understanding does not unify all of the painting's inherent contradictions. Rather, it illuminates them and reveals *L'Enlèvement* to be neither the random product of the artist's infamous febrile imagination nor a polite *révérence* to the Salon tradition, but part of the embattled dialogue carried on by so many of the early paintings (such as *Loth et ses filles*) between traditional subjects and compositional choices and Cézanne's own irrational and romantic inclinations.

In its deeply felt conflict between style and image, Cézanne's picture of an abduction becomes its own symbol. The massive, bronzed, classical Pluto embraces the luminous, langorous, romantic Proserpina, just as Cézanne's sense of form encompassed his violent sensibilities. Painted in 1867, the year of Ingres's death and one in which nearly every French art critic elegized the related demise of the grand tradition of history painting,[34] Cézanne's *L'Enlèvement* presents a poignant contradiction.

THE LANDSCAPE
OF TEMPTATION

Literature and Music
in the Fantasies of 1870

C EZANNE'S PREDILECTION FOR THEMES drawn from literature shaped a number of his early subject paintings and also allowed him to address many of the major issues in the art world of the 1860s. Much more typical of his early work than the brooding classicism of *L'Enlèvement* was the unrestrained romanticism revealed in four fantastic scenes from ca. 1870: *Le Festin*, *La Tentation de Saint Antoine*, a small *Baigneuses*, and *L'Idylle*. In each, Cézanne's provocative figures, distortions of space, imaginative palettes, and visionary settings emphasize dramatic subject matter in a way that is unique to his early art. When considered as a group, an understanding of the elusive content of these works reveals the deep significance with which he imbued romantic literary themes. Moreover, the specific subjects of his fantasy paintings, as opposed to general stylistic characteristics, show not only the breadth of Cézanne's sources but his repeated attempts to reflect in his early art the most avant-garde themes of his day. Far from being the private fantasies they are often considered, Cézanne's four canvases of ca. 1870 attest to his ability to transform contemporary literary subjects into mediums for his own romantic sensibilities. Coming as they do at the end of his first decade of painting, they mark both an artistic era and a working method the artist would soon leave behind.

Cézanne's *Le Festin* (or *L'Orgie*, fig. 98), a raucous scene of revelers at a banquet table, places the artist squarely within the Parisian art world of his time, from which he is often thought to have been isolated. In this painting Cézanne, like so many of his contemporaries, took a traditional theme and reworked it in modern terms. Updated from Renaissance bacchanals,

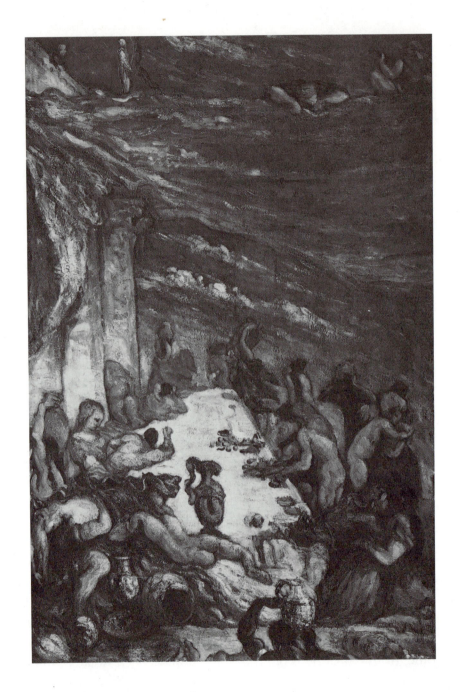

FIG. 98 Paul Cézanne, *Le Festin*.

baroque love feasts, and rococo *soupers*, the popular orgy theme was being revived on a grand scale in nineteenth-century France.[1] Even without the protective pretext of classical mythology or a moralizing genre, the theme invited the inclusion of sensual nudes, elaborate still lifes of food and drink, and, as often as not, historical or imaginary exotic settings. It thus held an obvious appeal for Salon painters and popular artists who catered to a pleasure-seeking public.

This sybaritic subject was also popular with nineteenth-century writers. Descriptions of orgies, with blatantly libertine atmospheres, figured frequently in the literature of the period. So familiar, in fact, was this particular type of scene that Théophile Gautier had one of the protagonists in a tale from his satirical collection *Les Jeunes-France* (1833) proclaim solemnly: "There is nothing so up to date as an orgy. Every new novel that comes out has an orgy; let us likewise have ours."[2]

Orgies were appearing in the theater as well. Offenbach's *Orphée aux enfers*, with its bacchanalian finale, appeared in 1858 to great acclaim and from that point the popular Paris stage would evolve into countless forms a subject already long established in opera.[3] Thus the orgy theme, so boldly transformed in Cézanne's painting, had long since captured the imagination of his generation.

Le Festin is not the only work in which Cézanne treated this clamorous and sensuous subject. It is reflected in the scenes of debauchery in some of his early erotic verses, in such intimate compositions as his ca. 1867 watercolor *Le Punch au rhum* (RWC 34), and in the series of paintings and drawings entitled *L'Après-midi à Naples* from ca. 1866–1870.[4] Casting its shadow before it, the theme is even recalled in a later fantasy, Cézanne's *La Préparation du banquet* of ca. 1890 (fig. 99), in many ways reminiscent of the earlier *Festin*. Cézanne's fascination with the orgy subject thus persisted well beyond his romantic first decade, and as usual we find that his impulse in this direction was not an isolated psychological spasm but a negotiation between private sensibility and current aesthetic.

Certainly the grandest restatement of the orgy theme in the nineteenth century and a major reason for its currency in Cézanne's time was Thomas Couture's *Les Romains de la décadence* (fig. 100). A massive scene of Roman

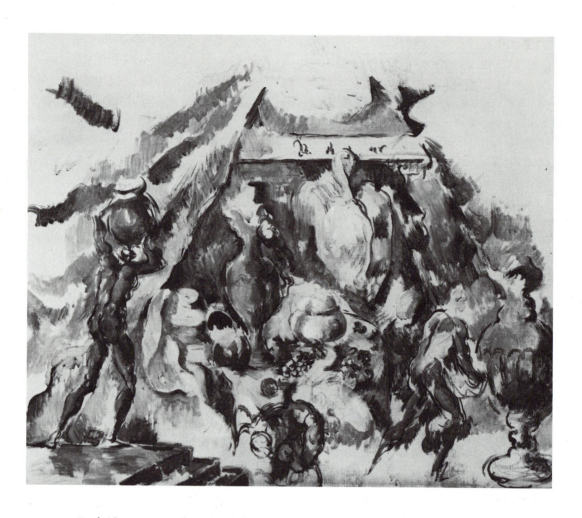

FIG. 99 Paul Cézanne, *La Préparation du banquet*.

debauchery in a shallow Corinthian vestibule, Couture's erotically suggestive painting received more public attention when it was unveiled at the Salon of 1847 than any other painting of the decade.[5] Its eclectic style, rich palette, and romantic theme of decadence brought it almost as much notice when it was re-exhibited at the 1855 Exposition Universelle. Later in his career Cézanne would be one of countless admirers to copy a figure from the painting (he also kept a photograph of it in his studio).[6] Couture's monumental *Romains* not only helped the orgy subject to prominence but provided a standard of opulence against which all later artists would judge their treatment of the theme.

For his composition Couture had turned to a vast array of pictorial sources, but perhaps the most influential was Veronese's well-known *Les Noces de Cana* in the Louvre (fig. 101).[7] While creating a work quite different in mood, Couture borrowed from the Venetian painter the architectural setting of columns, the distant blue sky, and the shallow, horizontal effect of the composition, which Veronese created with the table and Couture with the low couch or triclinium on which the Romans recline. Although most representations of orgies up to this time had been presented with this horizontal orientation—the nature of the subject obviously encouraged it—Couture's version made it the prevailing standard. Moreover, the superficial depth and stagelike quality of the *Romains*, with its figures dramatically posed and gazing out at the viewer, suggest the influence on Couture of nineteenth-century theatrical productions, where the subject of orgies was becoming standard fare.[8] This horizontal, theatrical orientation is an important point of departure for discussing Cézanne's *Le Festin*. Although Cézanne included many of the standard components for such scenes—the drunken revelers, wanton women, exquisite still lifes, and a table—his curiously deep perspective is quite foreign to other treatments of the topic.

Scholars have long searched for possible visual sources for Cézanne's unique perspective in *Le Festin* and also for its brilliant color. Sara Lichtenstein has suggested that Cézanne based both composition and coloring on Delacroix's mural at St. Sulpice, *Héliodore chassé du temple* (fig. 102), of which Cézanne owned an etching.[9] *Le Festin* indeed dates from a period when Cézanne was immersed in the study of Delacroix, and a comparison of the

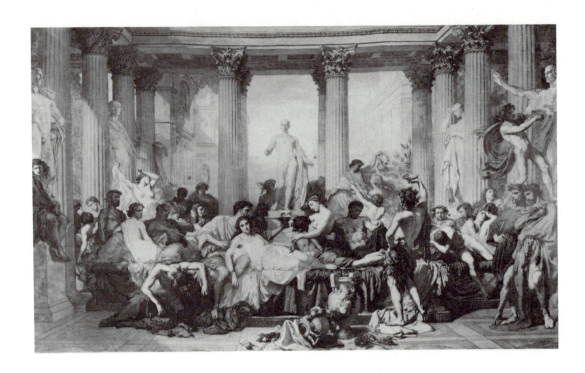

FIG. 100 Thomas Couture, *Les Romains de la décadence*.

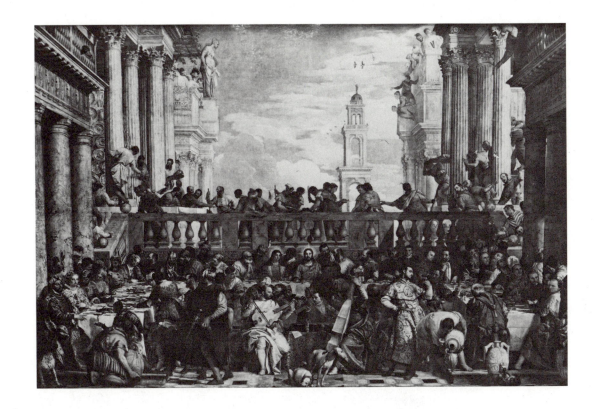

FIG. 101 Paolo Veronese, *Les Noces de Cana.*

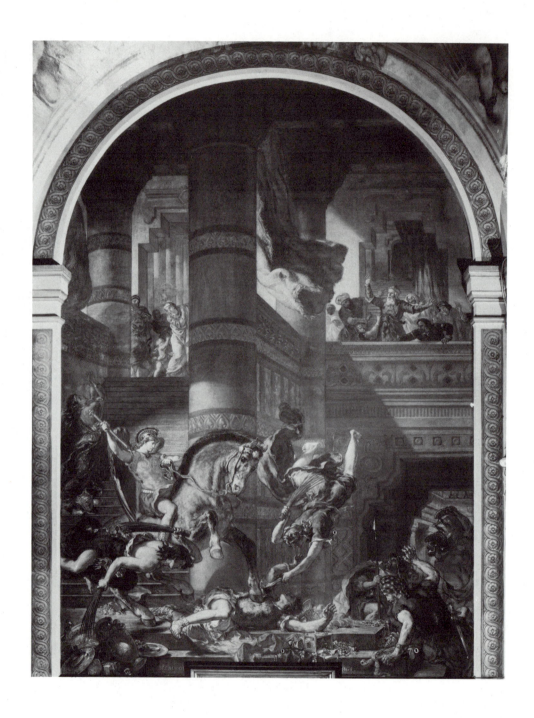

FIG. 102 Eugène Delacroix, *Héliodore chassé du temple.*

painting and mural reveals some common pictorial elements—most notably the diagonals of the central shadows in the Delacroix that are echoed by Cézanne's table. There are also large-scale columns and lustrous, flowing draperies in each. Yet as a presumed source the Delacroix mural does not explain the unusual composition and elusive subject of Cézanne's painting.

Among other influences, it is clear that Cézanne, like Couture, had also looked to Veronese's *Les Noces de Cana*. Cézanne deeply admired the Venetian work, which was revered by a number of his contemporaries. Gautier called it a "most radiant" masterpiece, and Delacroix and Fantin-Latour, among others, copied it repeatedly.[10] Cézanne himself had already copied details from the painting in the 1860s, and as late as the 1890s still spoke reverently of its composition and color.[11] An unusually complete study for *Le Festin* (pl. XI), dated ca. 1867 and only discovered by John Rewald in 1978, established Cézanne's debt to the Venetian painting; yet as the final version of *Le Festin* took shape, that relationship subtly changed. Rewald has noted that the study exhibits a number of elements drawn from Veronese that either do not figure in the later painting or else appear quite differently on canvas.[12] For example, in the background of the study, vertical columns and amphora bearers create an architectural screen that functions like the horizontal balustrade in the *Noces de Cana*; this background screen is absent from Cézanne's subsequent oil version. On the other hand, the somber tones of the study, executed in pastel and gouache, were replaced in the painting by a bright and luminous palette much closer to that of Veronese.

Though pictorial sources account for selected aspects of Cézanne's subject and its organization, none is responsible for his fantastic imagery and dreamlike space. Only by understanding the literary background of the subject can we begin to account for *Le Festin*'s unprecedented pictorial form. Among the numerous nineteenth-century written precedents most accessible to Cézanne were the works of Alfred de Musset, Victor Hugo, Gautier, and more locally, Frédéric Mistral, who describes a "Sardanapalen feast" in the epic *Calendau*.[13] Reff, correctly seeking a literary connection, has pointed out that the wild and erotic feeling of the painting makes it consistent with Cézanne's other romantic statements both in paint and in verse.[14] Yet his contention that Cézanne is illustrating one of his own youthful poems, the

Songe d'Annibal, is not convincing, especially in light of the rich context in which Cézanne was working. There exists a literary source much more congruent with Cézanne's painting, a feasting scene from Flaubert's *Tentation de Saint Antoine*.

The elaborate description of the riotous and alluring orgy at the banquet of Nebuchadnezzar, during which the hermit Saint Anthony is tempted by visions of luxury and wealth, was just the sort of scene that would have attracted a relatively young man still exploring his own voluptuous sensations. Flaubert's style is the literary equivalent of *Le Festin*'s texture:

Ranked columns half lost in the shadows, so great is their height, stand beside tables which stretch to the horizon— . . . a luminous vapour [appears] Fellow diners crowned with violets rest their elbows on very low couches. Wine is dispensed from tilting amphora Running slaves carry dishes. Women come around with drinks So fearful is the uproar that it might be a storm, and a cloud floats above the feast, what with all the meats and steamy breath.[15]

Cézanne's painting clearly refers to the Flaubert passage. In the upper left-hand portion of the canvas, two towering columns disappear, as Flaubert described, into a shadowy mist. The distorted perspective of the composition is heightened by the dramatically foreshortened table, which stretches, as in the text, into the distance. Above the lavish banquet hovers a luminous vapor, an element so critical to Flaubert's scene that when it was adapted for a shadow play at a Parisian cabaret, great effort was expended to recreate the effect.[16] The tilting amphorae, running slaves, and women bearing drinks have all been included in the painting. Even Flaubert's metaphoric cloud hovers above Cézanne's turbulent feast.

Flaubert's own visualization had been inspired in part by the descriptions in the book of Daniel of the epic towers and palaces of Babylon, built during Nebuchadnezzar's reign in the sixth and seventh centuries B.C.[17] Both Flaubert and Cézanne could have been aware of the account in Daniel of another magnificent feast, that of Belshazzar. The latter, a popular subject among baroque artists, had been revived by romantic painters and may have had some influence on Cézanne's overall scheme.[18] However, the exactitude with which Cézanne rendered the Flaubert passage—with such additional details

as the broken and scattered crockery on the banquet table, which refers to a subsequent line from the text ("The king eats from sacred vessels, then breaks them")—clearly establishes that Cézanne's primary debt was to his literary contemporary.

It is not only in detail but also in thematic approach and feeling that the painter mirrored the novelist. Like Flaubert, Cézanne has deliberately emphasized the idea of temptation in his orgy scene. In the story the vision of Nebuchadnezzar's copious wealth was so enticing that the envious saint took on the persona of the king, only to become "instantly sick" and seized with a craving to "wallow in filth." In order to underscore powerfully the sense of desperate compulsion, the saint in Flaubert's version warded off the temptation with a brutal, self-inflicted lashing. Cézanne augments the theme of temptation in his painting by manifesting Nebuchadnezzar's riches with frequent touches of golden-yellow paint and by adding a sinister, undulating serpent in the lower right corner. The serpent serves as both a motif of sin and betrayal and an ominous mirroring of the curves of the tempting female forms above.

Flaubert's *La Tentation de Saint Antoine*, a third and definitive version that was the result of numerous revisions, was not published until 1874. It is among the sources for Cézanne's later painting of *La Tentation de Saint Antoine* of ca. 1874–1875 (fig. 103).[19] But this overlapping of dates does not diminish the probability that Flaubert's text was the principal literary source for *Le Festin*. Three major fragments from the second version of the novel, a longer and more emotional text, had appeared serially in the popular journal *L'Artiste* in the years 1856 and 1857.[20] The excerpts described the monk's temptation by the Queen of Sheba, the visit of the heretic Apollonius, and the extravagant feast of Nebuchadnezzar cited above. Giula Ballas has recently documented that during the first two decades of his career, Cézanne frequently turned to the engraved reproductions of paintings published in *L'Artiste* for sources for his art. Ballas notes that it is highly likely that all of Cézanne's borrowing from *L'Artiste* came from back issues of the journal, dating from 1838 to 1858, and this supposition makes it even more likely that he would draw on literary extracts published in the journal during these years as well.[21]

FIG. 103 Paul Cézanne, *La Tentation de Saint Antoine*.

Le Festin's abundance of alluring temptations makes it a rich companion piece to Cézanne's more moody and somber but equally fantastic painting of ca. 1870, *La Tentation de Saint Antoine* (pl. XII). This *Tentation* also transforms a traditional subject that had long captured and was revivified by the romantic imagination.[22]

With the resurgence of interest in religious art in the mid-nineteenth century and the continuing romantic interest in sensual and exotic subjects, the enduring story of the Egyptian hermit had again become fashionable. In the second half of the century, there was new academic attention paid to the life of the fifth-century saint, and artists such as Fantin-Latour and Eugène Isabey also took up the subject.[23] Yet in many romantic versions, and in Cézanne's in particular, the saint's temptations are more sexual than physically torturous. Nude temptresses replace the symbolic monsters who tormented the saint in medieval and Renaissance versions of the story. Cézanne seemed to combine the two approaches in a romantic conflation of sexual and horrific elements, painting additional nudes who confront the cowering monk or the viewer and fill the gloomy landscape with their truly frightening forms. In comparison to his Flaubert-inspired *Festin*, Cézanne's *Tentation de Saint Antoine* gives more explicit and freer form to the artist's romantic longings, to his own temptations.

For his part, Flaubert's involvement in his own temptation imagery was acute. From reading the published fragments, Baudelaire concluded that Flaubert's *Tentation de Saint Antoine* "unveiled the author's secret chamber."[24] Flaubert himself saw the capacity for self-revelation, writing in a letter, "In *Saint Anthony*, I myself was the saint."[25] With Cézanne, not only the Saint Anthony pictures but all the fantastic imagery of ca. 1870 revealed aspects of the artist's struggle with sensuality—a struggle given shape by a myriad of sources but resolved by none.

Closely related to Cézanne's *Festin* and *Tentation de Saint Antoine* are two other paintings completed during the same period, a small *Baigneuses* (pl. XIII) and *L'Idylle* (or *Pastorale*, pl. XIV). With its somber palette, impassioned style, and intriguingly detailed landscape, this composition of bathers (unknown to Venturi) demands a thematic as well as a formal reading. Similarly, Cézanne's gloomy *Idylle*, which has long been viewed by scholars as a vague tormented sexual dream, also merits further thematic attention.[26]

As in the case of other vividly realized pictorial elements in Cézanne's work (see discussion of *La Toilette funéraire*, chap. VI), the highly specific imagery of these two works suggests an outside, literary stimulus. The emphasis in both on voluptuous nudes in dark, restless settings gives the paintings an aura of troubled romantic sensuality similar to the atmosphere of *Le Festin* and *La Tentation de Saint Antoine*. And it was, in fact, the story of another Christian hero, reborn in the romantic era, that inspired both pictures. Cézanne's *Baigneuses* and *Idylle* refer to the legendary Tannhäuser, a hero torn between the conflicting realms of the senses and of the spirit, and one whose struggles were given dramatic life by Wagner in the capital city the year Cézanne arrived in Paris.[27]

The production of *Tannhäuser* at the Paris Opéra in the spring of 1861 set off a controversy in Parisian political, social, and artistic circles that needs only brief summary here.[28] In an attempt to court Austria's favor and to woo liberal support back home, in 1860 Napoléon III had issued an order to the Opéra to perform the radical work. Many of Wagner's supporters were outraged by the alliance between the established state theater and the iconoclastic composer, a relationship that they regarded as a betrayal. The conservative upper classes and opera-goers, in particular members of the elite Jockey Club, were equally incensed, although not for political reasons. When they learned of the composer's plans to present a long, arduous production without the traditional interval of a grand ballet in the second act, they indignantly demanded one.[29] Wagner finally relented, after nearly a year of pressure, but he only agreed to expand the existing ballet in the first act's realm of Venus (the *Venusberg*), which he felt had been rather flat in an earlier production in Dresden.[30] Unfortunately, his concession pleased no one. After the first three performances were disrupted by members of the Jockey Club, some even blowing whistles, Wagner withdrew his score. A storm of protest arose on all sides; aided by Baudelaire's eloquent defense of Wagner, *Tannhäuser* quickly achieved mythic status in operatic circles.

Baudelaire's clarion cry included a call to "well-bred, open-minded *littérateurs*, artists, and even *gens du monde*" to encourage Wagner "to persist in his destiny."[31] Prominent among those answering this summons were the painters of the Café Guerbois. Auguste Renoir, who would later paint a pair of

overdoors inspired by *Tannhäuser*, recalled going with Bazille to hear Wagner's music at the *concerts populaires* in the 1860s.[32] An accomplished pianist as well as a painter, Bazille liked to play Wagner with his friend and fellow musician, Edmond Maître.[33] Manet's wife, who played the piano (see fig. 79), performed Wagner's music for her husband and their guests at home, and even for the celebrated Baudelaire shortly before his death in 1867.[34] Cézanne, who along with Zola joined the Wagner society in Marseille, mentions in a letter of 1865 "the noble tones of Wagner's music" he had enjoyed in concert.[35] At the same time, he was working on one of his realist paintings of a young woman at a piano, which he titled *L'Ouverture du "Tannhäuser"* as a tribute to the composer's controversial opera. Thus, the Wagnerist movement in Paris, which would grow in strength until the outbreak of the Franco-Prussian war diminished its popularity, became a true bond for the group of young painters later called the impressionists, Cézanne among them. Looking back at the 1860s in his novel *L'Oeuvre*, Zola would aptly describe Wagner's music of that decade as having sounded the "sublime hallelujah of the new century."[36]

Perhaps the most ardent *wagneriste* among the Café Guerbois painters was Fantin-Latour, whose tickets for the canceled fourth performance of the Paris *Tannhäuser* had to go unused. In three major works taken from the first act, a lithograph of 1862, a large oil painting which was exhibited at the Salon of 1864 (fig. 104), where Cézanne would have seen it, and a transfer lithograph of 1876, the painter highlighted the opera's romantic character. Set in the Venusberg, the opera's first act featured the elaborate bacchanalian ballet choreographed by Marius Petipa after Wagner's outline especially for the Paris production. With lovers embracing and fleeing from the "satyrs and fauns appearing from the cliffs" and forcing themselves upon the revelers, and throughout, "a general frenzy" that "gives way to maenadic fury," Wagner had envisioned an allegory in dance of rampant sexuality.[37] After the bacchanal Tannhäuser awakens from a reverie at Venus's side and suddenly, glutted with sensuality, longs to leave her balmy realm for that of harsh reality. In his three depictions of the scene, Fantin-Latour portrays the dilemma of the suffering Tannhäuser and contrasts his dark melancholy with the pleasurable character of his surroundings.

FIG. 104
Henri
Fantin-Latour,
*Tannhäuser:
Venusberg.*

Douglas Druick has noted how meaningful the Tannhäuser struggle was for Fantin-Latour. He had dreamt of being a great artist but saw himself caught, like Wagner's hero, "in the agitations and follies of this era . . . in the struggle between life and art."[38] The sensual side of this war between two worlds—what Baudelaire called Tannhäuser's "psychic duality"—was intensified in the revised Parisian production of the opera by the extension of the danced bacchanal. Like Flaubert's Saint Anthony, in Wagner's hands Tannhäuser became a typically romantic hero and precursor of symbolist decadence. Torn by inner conflicts and feelings of sensual degradation and tortured by a longing for ideal love, he remained medieval enough to be burdened by feelings of guilt and to desire extenuating physical pain as well as pleasure.[39] The themes of conflict in *Tannhäuser*, between unbridled sexual desire and sanctioned idyllic love, between pagan abandon and Christian rationality, and, in a larger framework, between romantic sensibility and harsh reality, directly mirror what we know of Cézanne's own troubled emotional makeup in the 1860s. The dark, sexual undercurrents and sense of isolation that lurk powerfully beneath the surface of so many of his early paintings distend their formal shape, as Wagner's music shapes Tannhäuser

into a potent symbol. At least as poignantly as Fantin-Latour, his probable source for aspects of *L'Idylle*, Cézanne would embrace this embattled, legendary subject, though in more formal, less literal terms.

Since he did not see the production, Fantin-Latour's Venusberg scenes were taken from descriptions and illustrations of the opera's elaborate staging in Paris.[40] A common source for contemporary illustrations of the Venusberg were the widely read prose translations of Wagner's operas, *Quatre Poèmes d'opéra*, and the French libretto, both published by 1861. In addition, fragmentary accounts by enthusiastic members of the audience kept Wagner's extravagant vision before the public eye. Despite minor disparities among translations and Wagner's last-minute changes in the actual production, a basic pictorial scheme of *Tannhäuser* can be derived that holds true for most productions. A small gouache of act 1, scene 2, attributed to Delacroix, conforms closely to the set and staging and probably made use of the same sources.[41]

For the principal feature of his realm of Venus, Wagner had envisioned a dark, subterranean grotto representing the interior of Venus Mountain. A wide, shadowy cavern at the front edge of the opera stage receded into a deep landscape with a blue lake and dramatic waterfall in the distance. The entire scene was "framed by irregular rocky peaks" and the foreground lit by a "bewitching roseate light from below."[42] As the curtain rose before the ballet began, Venus reclined in the foreground with the Three Graces at her feet. The set for this first act of *Tannhäuser*, absorbed by a number of his contemporaries, was clearly known to Cézanne as well, as it is closely recalled in his elusive *Baigneuses* (pl. XIII).

Although Cézanne may not have known the gouache attributed to Delacroix, he would have seen Fantin-Latour's *Tannhäuser: Venusberg* at the Salon of 1864. Yet Cézanne's *Baigneuses* suggests that he was directly familiar with the published descriptions of the opera. The black setting of his picture, curiously alien to even his earliest depictions of the bathers theme with their bright colors and intimations of sunlight, and here so out of keeping with his sensuous figures, is, in fact, the underground grotto where Venus dwells.[43] Strong black verticals on the left side of the landscape denote stalactite formations—these were standard in *Tannhäuser* sets and also figure in the

gouache.[44] The dimly lit area of blue in the center of Cézanne's painting is the lake, an element crucial to the opera's staging, while shimmering strokes of blue, which plunge on a sharp diagonal in the background, set forth the distant waterfall. A mountainous horizon and rocky terrain complete the Wagnerian landscape. In the foreground, the goddess reclines as Wagner placed her, with the Three Graces at her feet. Vibrant pink tones, which help to model the thickly painted nudes, allude to the first act's "bewitching roseate light." Even the composition of the *Baigneuses*, with its figures carefully stretched across a shallow foreground plane, suggests a staged tableau.

The mood and imagery of this *Baigneuses* is related to Cézanne's other fantasy paintings of this period, particularly his *Tentation de Saint Antoine*, with which it shares a dark, romantic mood, as well as a number of expressive forms. The standing nude at the center of *La Tentation* is echoed by the similar figure in the smaller painting. The nude with upraised arm, who aggressively confronts the frightened monk, has turned in the *Baigneuses* to face the viewer. Most striking in its reference to the earlier painting and its suggestion of a dramatic element is the figure set at the far left edge of the *Baigneuses*. Like the terrified Saint Anthony, this mysterious figure peers out onto a scene of voluptuous temptation and suggests the same conflict between sense and spirit. As much as Cézanne's swirling, impassioned strokes, this figure embodies the unrestrained romantic dualism the artist reveals in his early fantasy images.

Finally, Cézanne's painting *L'Idylle* of ca. 1870 (pl. xiv), like the small *Baigneuses*, was also inspired by Wagner's staging and story of *Tannhäuser*. Yet in *L'Idylle* Cézanne intended much more than a gloomy Wagnerian vision. Coming at the end of his romantic first decade, *L'Idylle* presents a poignant image of the artist and the fantasies and fears of his youth in a romantic genre Cézanne would soon abandon.

As in all three of Fantin-Latour's *Tannhäuser* depictions, Cézanne omits the dark grotto in his *L'Idylle* in favor of a more traditional, open landscape. The troubled hero, Tannhäuser, in whom Cézanne saw himself, lies in melancholic reverie as both Wagner and Fantin pictured him, just after the uproarious bacchanal. Facing him is the sensual Venus, reclining in the foreground. These two formally opposed figures symbolize the "struggle be-

tween the flesh and the spirit" that forms the dramatic core of the opera.[45] At the left, two nudes flaunt their charms with gestures recalling allied works: the pose of the standing nude recalls one of Fantin's dancing graces from the painting of 1864 while the seated nude with upraised arm is found in the same position in Cézanne's related *Baigneuses*.

Although there are references to Fantin-Latour's work in *L'Idylle*, Cézanne depicted Wagner's elaborate stage vision more exactly. The tumultuous atmosphere of the realm of Venus is captured in *L'Idylle*'s turbulent skies and restless landscape, while the carnal pleasures of the goddess's realm explain what Meyer Schapiro has described as the "eroticized thrust of the trees and clouds" and "the suggestive coupling of a bottle and glass" in the foregound.[46] Although Cézanne would add two male figures in contemporary clothes (who have sometimes been identified as his childhood friends Baille and Zola), his *Idylle* is distinguished from a Manet-like *Déjeuner sur l'herbe* by its dark mood and strikingly imaginative palette.[47] Despite the air of gloom created by its somber setting and troubled hero, *L'Idylle* is warmed by the intense blues of the lake and above all by the luminous pink tones of the nudes and sky. As in *Les Baigneuses*, this could only be the "bewitching roseate light" the libretto prescribes; as Tannhäuser confronts Venus in the second scene, this becomes an "even denser rosy mist" that "veils the whole background."[48] So essential was this warm-colored atmosphere to Wagner's vision of a world that bathed and saturated the senses that he ordered for the Parisian production a rose-toned gauze scrim to be lowered over the entire stage as the dialogue between Tannhäuser and Venus begins.[49] In *L'Idylle* Cézanne confronts his own sensual fantasies in the same heated environment.

Far more than a simple reading of the *Tannhäuser* text, the painting is an affecting portrait of the artist's youth, inspired by Wagner's romantic vision. Like Flaubert in his treatment of Saint Anthony, Cézanne transformed a legend into a personal vehicle and himself into the tormented hero. Emile Bernard, Cézanne's disciple, may have recognized the Wagnerian imagery of *L'Idylle* when he saw it in the collection of Dr. Gachet in Auvers years later, since he likewise gave a melancholic *Tannhäuser* his own features in a fantasy based on Wagner's opera.[50] And when, in a letter of 1904, the aged Cézanne warned Bernard about "the literary spirit which so often causes the

painter to deviate from his true path—the concrete study of nature," he must have seen in the younger artist's work the same propensity for romantic excess that characterized his own early efforts.[51]

A close reading of Cézanne's fantasy paintings of 1870 reveals much more than the youthful longings that have been dismissively supposed to have compelled them. Finding in Flaubert and Wagner equivalent forms for his own passionate sensibilities, Cézanne transformed such romantic subjects by making them into poignant personal vehicles. But the subjects of Saint Anthony and Tannhäuser, enjoying creative reassessment in his day, also provided the artist with modern pretexts for heroic, traditional compositions in which he could rival the painting of the old masters. Thus, the sensual nudes, imaginary landscapes, rich palettes, and narrative gestures in this intriguing quartet, which effectively culminates a decade of romantic imagery in his art, link the pictures more profoundly to the art of the past than to the painting of his contemporaries, evincing Cézanne's determination to align himself with a tradition of painting he would soon after transform.

Above all, the evocative intensity of Cézanne's four fantasy paintings, lurking palpably beneath their elusive forms, reveals the artist's alchemic capacity for combining personal vision, traditional form, and modern subjects in images so raw and powerful that even he would retreat from them.

FORM AS SUBJECT

The Transitional Years

CEZANNE CLOSED HIS FIRST, TUMULTUOUS DECADE of painting on a strikingly poignant note with the four emotional subject paintings *Le Festin*, *La Tentation de Saint Antoine*, the small *Baigneuses*, and *L'Idylle*. As retold in modern terms by Flaubert and Wagner, the visionary narratives of Saint Anthony and the tragic hero Tannhäuser became mediums through which Cézanne could freely confront his own demons of loneliness and tormented love. More significantly, they inspired compositions in which the artist could test himself against the art of the past and explore popular contemporary subject matter while attempting to come to formal terms with his own feelings.

Cézanne's growing interest in landscape painting, particularly evident in the early 1870s, also indicated a modern orientation. Although genre painting continued to predominate at the Salon, by the late 1860s the work of the future impressionists was drawing increased attention to naturalist paintings of landscape. Through the intervention of Charles-François Daubigny, a leading light in the seminal Barbizon school, Camille Pissarro, Claude Monet, Alfred Sisley, and Berthe Morisot were all able to exhibit landscapes at the Salon of 1868.[1] Two years earlier Cézanne had expressed to Zola a desire to work *en plein air*, and by 1870 at the latest had begun to paint the familiar terrain of his native Provence as he studied it firsthand.[2] Yet it would be some time before his landscapes would approach the more objective creations produced by his friends from the Café Guerbois. Vestiges of his earlier fantasies are evident in a number of his landscapes from the 1870–1871 period and evidence a brief transference of his personal emotional dramas to the motifs he found in nature.

In July 1870 France declared war on Prussia. After a disastrous defeat at Sedan, where Napoléon III and 100,000 of his men were captured, a bloodless revolution occurred in Paris. The emperor was forced to abdicate and the Third Republic was proclaimed on 4 September. Yet by late that month Paris was surrounded by enemy troops and a grueling siege began. Preparations for war in France, remarkably inefficient compared with those in Prussia, escalated frantically, and hordes of young men were conscripted to offer resistance to the invaders. Inevitably, the Franco-Prussian war and its bitter aftermath, memorably portrayed by Zola in *Le Débâcle* (1892), took its toll on the ambitions of the impressionists, who were scattered and therefore denied the creative camaraderie of earlier years. A few of the group were involved in the confrontation (Bazille would die in battle), but most escaped conscription.

Cézanne had left Paris shortly after the Salon of 1870 and spent the summer of 1870 in Aix with his family at the Jas de Bouffan.[3] It is there, Gowing believes, that some of the major fantasy paintings of ca. 1870 may have taken shape.[4] By fall, no doubt responding to the news from Paris, Cézanne had moved to the small fishing village of L'Estaque, just west of Marseille, where he quietly evaded the draft. He joined Hortense Fiquet, whom he had met a year before in Paris, and spent a clandestine winter with her there, living in fear of discovery by both the conscriptors who would force him into the war and his parents, who did not know about Hortense. Although the authorities searched for him and other defaulters in Aix, Cézanne's stay in L'Estaque seems to have gone undiscovered and undisturbed.[5] As he later recounted, he divided his time between landscape and studio painting, and though far removed from the turmoil that pervaded most of France, his restless views of L'Estaque from this period seem to parallel the personal and social contexts in which they were created.

Gowing has aptly described Cézanne's *La Neige fondue à L'Estaque* (pl. xv), a work typical of those winter months, as "the fearful image of a world dissolved, sliding downhill in a sickeningly precipitous diagonal between the curling pines which are themselves almost threateningly unstable and Baroque, painted with a wholly appropriate slipping wetness and a soiled noncolour unique in his work."[6] It is hard to imagine a better description than

this of the later expressionist landscape, which Cézanne's *Neige fondue* surely anticipates. A precipitous rooftop view plunging unevenly to a swirling shore and sea in *Le Village des pêcheurs* of the same period is only slightly less disquieting (fig. 105). These landscapes from L'Estaque convey the same tumultuous world and unsettled passion we associate with the narrative works of Cézanne's first decade, but now the painter's means of expression had become purely formal.

Several of Cézanne's figure paintings dating from the same period also display powerful emotions mediated by formal means. Throughout his life, Cézanne's portrayal of the female figure remained hectic with feelings that were successfully sublimated in his paintings of other subjects. As Meyer Schapiro has written, "He could not convey his feeling for women without anxiety There is for him no middle ground of simple enjoyment."[7] This observation is supported by Cézanne's own confession to Renoir, "Women models frighten me. The sluts are always watching to catch you off your guard."[8] Zola captured his friend's anxiety in the character of the tormented painter Claude Lantier in his roman à clef, *L'Oeuvre*: "Those girls whom he chased out of his studio he adored in his paintings; he caressed or attacked them, in tears of despair at not being able to make them sufficiently beautiful, sufficiently alive."[9] Such secondary evidence of Cézanne's struggle to distance himself from the female model did much to promote his legendary image as a blustering but painfully timid provincial whose anxieties about women were never fully resolved. It is a legend, however, that gains credence in the face of such torturous female figures as those found in his painting *Les Courtisanes* (or *Four Women*) of ca. 1871 (fig. 106). Although not a major early work, this painting, with its emphasis on the inherent meaning of form—in the face of a subject that might once have compelled narrative or romantic treatment—is an arresting example of the dramatic metamorphosis Cézanne's painting underwent during this period of transition.

Cézanne's tiny canvas (6¾ × 6¾ in.) is remarkably close in feeling to his contemporaneous views of L'Estaque. With its bold streaks of intensely colored pigment, crowded space, and crude, slashing figures, Cézanne's formal evocation of savage sexuality is as threatening and close to expressionist painting as are his landscapes. Yet the imagery and attitudes of his

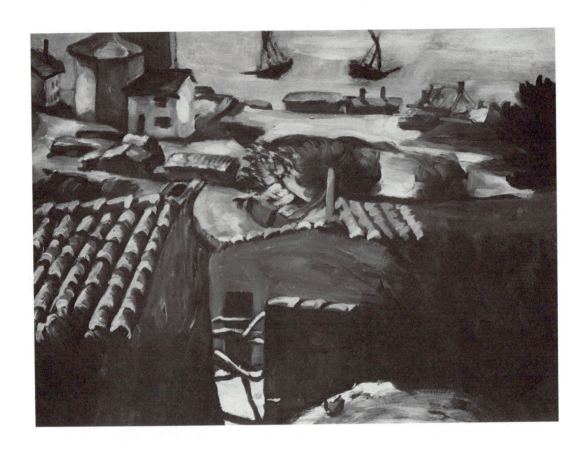

FIG. 105 Paul Cézanne, *Le Village des pêcheurs à L'Estaque*.

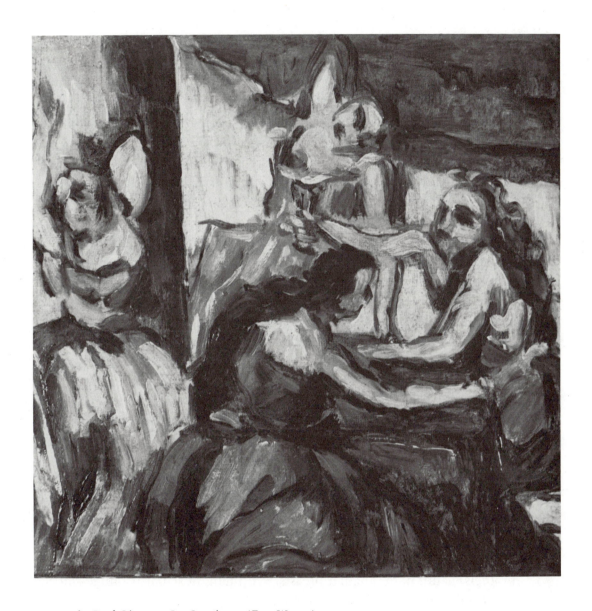

FIG. 106 Paul Cézanne, *Les Courtisanes (Four Women)*.

Courtisanes derive directly from the earlier romantic fantasies, showing that he could draw on an increasingly rich and flexible pictorial vocabulary in this transitional period.

In the crowded interior of his painting, Cézanne's four prostitutes are shown clustered around a central table. The foreground figure, with dark hair flowing down her back, turns away from the viewer and reaches sideways with one arm. The line of her bare arm repeats the curve of the draperies in the background; along with her voluminous skirt, the gesture effectively cuts off the composition's foreground and reinforces its claustrophobic effect. The courtesan on the right, whose masklike face reflects the work's underlying theme of savage sexuality, is a virtual mirror image of the woman in the foreground. She, too, has cascading hair but faces the viewer. Her bare arm reaches inward to the center of the composition, and she holds out a large goblet. This pose, represented twice here, appears only one other time in Cézanne's early works, on a page of drawings dated to about the same period. In the upper left corner of that page (see fig. 25), a similar figure is shown holding out a large chalice. Lightly sketched above her sleeve is the curving outline of a bare, outstretched arm, much like that of the two courtesans. As noted previously, Gowing has recently written that the drawing may be based on a mourning figure at the foot of the cross;[10] it may in fact refer to Mary Magdalen. It is indeed tempting to imagine that Cézanne could have equated the mourning penitent saint with a formal image of her earlier *volupté*.

The poses of the two standing figures in the *Courtisanes* are more familiar, and carry a number of associations. Facing the viewer, they boldly project the painting's intense eroticism. Although dressed, their revealing costumes, like those worn by the prostitutes in Degas's later monotypes of brothels, flaunt hard, angular breasts. With taut, flexed arms, huge staring eyes, and heads cocked stiffly to one side, their garish and shameless postures are exaggerated versions of the attitude, described by Reff as one of "brazen provocation," of the background nude in Cézanne's *La Tentation de Saint Antoine* (pl. XII).[11] A similar figure had also appeared in his Wagnerian *Baigneuses* (pl. XIII) and *L'Idylle* (pl. XIV).[12] But, in contrast to the earlier works, the figures in the *Courtisanes* are not defined by a narrative context or

softened by narrative elements. Their forms alone convey the full force of the painting's subject matter.

Recent research has explored the widespread fascination in nineteenth-century France with prostitution and the wide range of images from both popular and high art it inspired. Most notable in this vein are T. J. Clark's studies on Manet's *Olympia* and Hollis Clayson's book on prostitution in the Third Empire.[13] Such sociohistorical contexts, however, have a limited bearing on the intensely private vision of Cézanne's *Courtisanes*. The degree to which the painter employed his own formal vocabulary in the imagery of this small work separates it from the countless better-known images of prostitutes, Manet's *Olympia* among them, and from the social and cultural issues they might raise. Even when he parodied Manet's painting in his ironic *Une Moderne Olympia* (fig. 107) of ca. 1869–1870, the first of two he painted on the subject, Cézanne's interest was in "modernizing" or embellishing along more expressive and personal lines what he saw as Manet's markedly reticent and thus somehow dated image.[14] As Clayson has noted in her analysis of this *Moderne Olympia*, there is "no sense in arguing for a material connection with this or that form of contemporary Parisian brothel prostitution, or with this or that entrenched ideology thereof. [Cézanne's painting] is instead, a fantasy of voluptuousness gone wrong."[15] It is also, we might argue, a fantasy whose image of visual confrontation would soon be transformed in Cézanne's painting *Les Courtisanes*.

Cézanne's *Courtisanes* prefigures a twentieth-century fascination with sexuality in its antisocial or aberrant manifestation. But the true modernity of the works from this transitional period lies in their expressive forms. By conveying a painting's subject matter in a visual language he himself had made meaningful, Cézanne replaced traditional narrative elements with personal, iconic images representing his own sensibilities and states of mind. As has been observed, these paintings from the early 1870s indicate a move away from both the dramatic romantic content and traditional compositions of his earlier subject pictures to a concentration on form itself. At the same time Cézanne began to render on canvas the forms he observed in nature. The formal power that became so explicit in his later works had clearly been anticipated in paintings like his small fantasy *Les Courtisanes*; and its forceful

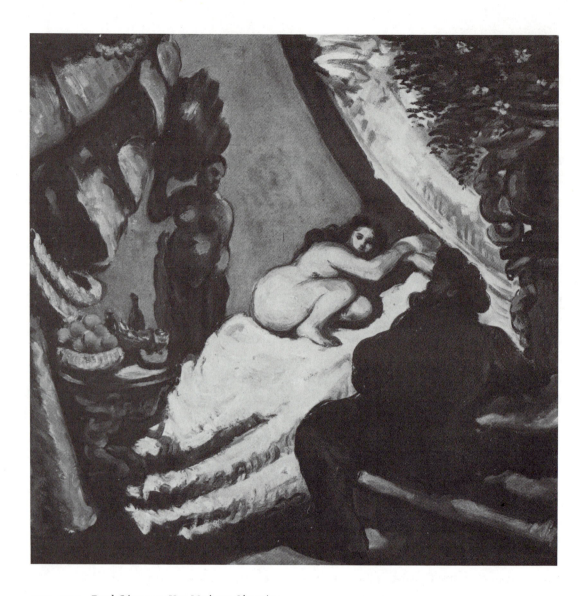

FIG. 107 Paul Cézanne, *Une Moderne Olympia*.

pictorial language rendered the earlier, more narrative approach to subject matter not only inappropriate but restrictive. It is no wonder then that Picasso would write, "what forces our interest is Cézanne's anxiety—that is Cézanne's lesson; the torments of Van Gogh—that is the actual drama of the man."[16] For it is ultimately to himself that Cézanne turned for the potent formal imagery of paintings like his *Courtisanes*. The novel force of its subject matter was rendered all the more meaningful and modern by Cézanne's immediate and transparent new style.

By 1872 Cézanne had turned away not only from the literary narratives but also from the compelling romantic fantasies that pervaded his earlier work. In the spring of that year he went to Pontoise to paint with the impressionist Camille Pissarro. Under Pissarro's tutelage, he channeled much of the passionate energy manifested in his earlier subject pictures into a study of the visual motifs in nature. So absolute was the transformation of Cézanne's style during this year that it is difficult to reconcile the intense emotions and seething pigments of the earlier paintings with the harmonies achieved so soon after in paintings like *La Maison du pendu* of ca. 1873 (pl. XVI). Yet the dramatic changes in Cézanne's art were not, in fact, escapes from feeling but reflections on the new course Cézanne's life was taking, one in which creative and emotional impulses flowed together. The influence of Pissarro, the satisfying discoveries of his plein-air work, and the peaceful domestic life he now openly shared with Hortense Fiquet seem to be embodied in the impenetrable equilibrium of the landscapes from Pontoise and Auvers-sur-Oise. His new working method contributed to that sense of harmony. Momentarily distanced at L'Estaque from his confrontations with the art of the past and the conventions of the Salon world—confrontations that must have been as emotionally wrenching for him as were the despair and sexual frustration that fueled his romantic works—and subsequently invigorated and shaped by Pissarro's tutelage and thus ready to deal with these challenges as never before, Cézanne's painting took on a new force and complex unity in 1872.

Cézanne showed *La Maison du pendu* (*The House of the Hanged Man*, which he preferred to call, less sensationally, *The Cottage at Auvers*) at the first impressionist exhibition of 1874 held in Paris. There, in the photographer

Nadar's studio on the boulevard des Capucines, the compatriots from the Café Guerbois came together and inaugurated the movement that would be called Impressionism.[17] Cézanne would contribute sixteen canvases to the third group exhibition of 1877, mostly landscapes and still lifes similar to *La Maison du pendu*.[18] Critics, aware of his self-styled image and recalling the provocative paintings of the 1860s, were slow to separate his new style of painting from the legends that had come to surround his name.[19] But when Georges Rivière, one of the more perceptive reviewers of the 1877 exhibition, described Cézanne's newest works as possessing "the calm and heroic serenity of the paintings and terra-cottas of antiquity," he distinguished them not only from the momentary images of Cézanne's impressionist peers but also from the emotional and narrative-laden paintings of his first decade.[20]

From this point on, emotional and fantastic elements played a smaller role in his art and gave form to a very different type of image. Though the familiar currency of the pastoral reveries and intimations of eroticism and violence occasionally still appear, Cézanne's later fantasy paintings are distinct from the nightmarish imaginings of his first decade. The harsh, unsettled quality—both compositionally and emotionally—and the disturbing imagery that characterize the early works and make them so potent are absent from such paintings as *Scène fantastique* of ca. 1875 (pl. XVII). Although set in an enchanted landscape that is strongly reminiscent of *L'Idylle* (pl. XIV), this later pastoral is far removed from the oppressive, dark dream that had drawn its impetus from Wagner. The phallic vegetation and turbulent atmosphere of the earlier painting have been replaced by delicate trees and a sky softly rendered in short, even strokes of paint. Elegantly dressed women (at least one of whom may have been adapted from an earlier painting by Cézanne done after a fashion plate), top-hatted bourgeois gentlemen, and frolicking children share the idealized setting with industrious fishermen.[21] Along with the warm palette, the figures lend the piece an air that is closer to Georges Seurat's later musings on La Grande Jatte than to the paintings of Cézanne's first decade. And across the sparkling expanse of water we see intimations of the architectural horizon that will appear in the later large *Baigneuses* (V. 719).

Cézanne included his *Scène fantastique* among the canvases he contributed to the third impressionist group show. Exhibited apart from his other paintings, it hung above the door of a room devoted to pastoral themes and represented the distinctive realm his imagination would inhabit in the future.[22] Cézanne's love of the pastoral tradition is one we can trace throughout his long career. It is a tradition he vehemently confronted, assimilated, and, ultimately gave modern form to in his later bather pictures and landscapes. In a vivid watercolor of ca. 1878 (fig. 108) he recalled the Louvre's famous Venetian *Concert champêtre*, a triumph of the High Renaissance. Not long after, he formulated his own tribute to this school in his two paintings and related studies entitled *La Lutte d'amour* (for example, pl. XVIII). In each, mythological lovers forcefully struggling in a wild wooded landscape may at first glance seem to revive the earlier passions played out in hostile settings. Yet the violence of this later work is thoroughly diffused by the ordered, diagonal brushstrokes, brilliant atmospheric color, and harmonious interplay of figures and sunlit space. Cézanne's fertile imagination in these gentled fantasies was focused on his passionate admiration for Giorgione, Titian, Veronese, and Tintoretto, whom he called the "great ones of Venice," and the pastoral tradition he took from them intact.[23]

As an old man, working in virtual isolation in Aix, Cézanne drew ever closer to the Provence that had inspired his earliest images. It was a romantic attachment to its pastoral grandeur, a mellow rekindling of earlier fires, that now sustained the aged painter. "Were it not that I am deeply in love with the landscape of my country," he wrote to the young regional poet Joachim Gasquet, "I should not be here." To the end of his life, Cézanne was still reading Flaubert and Baudelaire and no doubt still listening to Wagner, distilling now not images or private symbols from their texts but instead critical ideas, sensations, even perhaps notations about color.[24] *Madame Bovary*, he allegedly told Gasquet, was filled with a melancholic blue.[25] Writing to Emile Bernard shortly before his own death, Cézanne swore never to submit to "the debasing paralysis which threatens old men who allow themselves to be dominated by passions which coarsen their senses."[26] Such thoughts vividly expressed a persistent terror of the emotional forces that had ravaged his

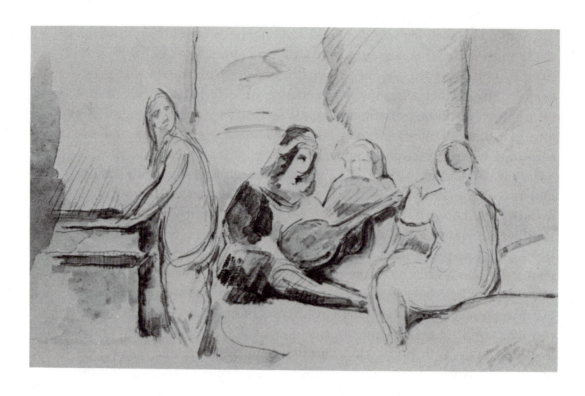

FIG. 108 Paul Cézanne, study after *Concert champêtre*, pencil, watercolor, and gouache.

early paintings. "My method if I have one," Gasquet records him as saying at this point, "is based on hatred of the imaginative."[27] Nonetheless the emotional, fertile imagination of the youthful painter still finds expression in the extraordinary intensity of the later subjects.

Cursed by critical failure in their own day and virtually neglected since, Cézanne's early subject paintings are not easy to take in at a glance. Few artists have matched the ebullient emotions and furious technique combined in these works. Fewer still have produced such uncompromising, private images which present us at once with highly personal statements, trenchant readings of the art of the past, and cogent reflections of their contemporary cultural milieu. Both Cézanne's ardent early style and the fantastic and deeply moving subjects it seemed to inspire, perhaps even to necessitate, were transformed in 1872 when the accreted vehemence of the first decade was finally dispelled at Pontoise and Auvers-sur-Oise. With a quieter ardor and Pissarro's example and encouragement, Cézanne turned to nature and to a more formally oriented style that was sustained even in his later fantasies.

It is difficult to reconcile the works after 1872, those that are recognizably "by Cézanne," with the paintings that went before. Yet we can appreciate neither Cézanne's problematic youthful creations nor his later achievements if we isolate the early from the mature work or fail to see in it the metamorphic power of a burgeoning genius working passionately to reconcile the various contexts of aesthetic tradition, contemporary culture, and romantic sensibility. To the serene essence of the later Cézanne, the questing alembics of this first decade are important—and coherent—precursors.

BIOGRAPHICAL,
CULTURAL,
AND HISTORICAL
OUTLINE, 1839–1874

DATE	CEZANNE	CULTURAL AND HISTORICAL EVENTS IN PROVENCE AND PARIS
1839	19 January, birth of Paul Cézanne to Louis-Auguste Cézanne and Anne-Elisabeth Aubert in Aix-en-Provence.	
1840	Birth of Emile Zola in Paris.	
1844	29 January, marriage of Louis-Auguste Cézanne and Anne-Elisabeth Aubert.	
1844–1849	Paul Cézanne at primary school, rue des Epinaux in Aix.	
1846		Loubon founds the *Société des amis des arts de Marseille*, which would become the *Société littéraire et artistique des Bouches-du-Rhone* in 1850 and would then include the painters and writers of Aix. Roux-Alpheran, *Les Rues d'Aix*.

DATE	CEZANNE	CULTURAL AND HISTORICAL EVENTS IN PROVENCE AND PARIS
1847		Paris Salon: Couture's *Romains de la décadence*.
1848		Balzac, *Comédie humaine*, complete edition finished (1842–1848).
		Revolution in Paris; Louis-Philippe abdicates.
1848–1851		Mistral studies law in Aix.
1849–1852	Cézanne at the Ecole Saint-Joseph, Aix.	Bequest by Granet of his paintings and drawings to the Musée d'Aix; they become accessible to Cézanne at a later (uncertain) date.
1851		The last fête-Dieu in Aix is held; Mistral is a spectator.
1852		Napoléon III proclaimed Emperor; Second Empire established.
1852–1858	Cézanne at the Collège Bourbon; friendship with Zola and Baptistin Baille.	
1853		A festival of Provençal poets is held in Aix, entitled *Roumavagi des troubaires*; Mistral recites his *Mort du moissonneur*; Zola attends.

DATE	CEZANNE	
1854		*Le Félibrige* founded.
1855		*L'Armana prouvençau*, the annual almanac of Provençal literature and information founded by the Félibrige.
		Paris Exposition Universelle; Ingres and Delacroix given private installations; Couture's *Romains de la décadence* re-exhibited; Courbet arranges his own exhibition opposite the Palais des Beaux-Arts.
1856–1857		Excerpts from Flaubert's second version of *La Tentation de Saint Antoine* appear in *L'Artiste* through the influence of his friend Théophile Gautier.
1857	Cézanne's first inscription at the Ecole de Dessin d'Aix, conducted by the painter Joseph Gibert.	Salon: Ingres and Delacroix do not participate; genre painting predominates.
		Baudelaire, *Nouvelles histoires extraordinaires par Edgar Poe* (translations); and *Les Fleurs du mal*; Flaubert, *Mme Bovary*; Flaubert prosecuted; Baudelaire fined for breach of public morality; six of Baudelaire's poems are banned.
		Death of Alfred de Musset, romantic poet, novelist, and dramatist.

DATE	CEZANNE	CULTURAL AND HISTORICAL EVENTS IN PROVENCE AND PARIS
1858	Zola leaves Aix in February for Paris but returns for summer vacation; begins correspondence with Cézanne. 12 November, Cézanne passes his baccalaureate examinations on his second attempt; November 1858–August 1859 Cézanne works at the Ecole de Dessin d'Aix; may have also begun to paint copies of paintings in the Musée d'Aix.	Paul Gachet, then a young medical student, visits Marseille and meets the painters Adolphe Monticelli and Paul Guigou; in Aix he meets Cézanne's father and perhaps the young painter himself. Offenbach, *Orphée aux enfers*.
1859	Cézanne studies law at the Université d'Aix; November 1859–August 1860 again works at Ecole de Dessin and is awarded a second prize for a painted figure study; Louis-Auguste Cézanne acquires the Jas de Bouffan.	The 1859 Marseille salon is reviewed in *Gazette des beaux-arts*; Loubon is praised for his efforts to establish a Provençal school of art. Mistral's *Mireio* published, for which, along with his poetry, he would be awarded a Nobel prize in 1904. Salon: Manet's *L'Absinthe*, Whistler's *Au piano*, and Fantin-Latour's *Deux Soeurs* rejected; Breton's *Plantation d'un calvaire* is shown. Baudelaire, *Salon de 1859*; Gautier, *Voyage en Espagne*; Hugo, *La Légende des Siècles*; Gounod, *Faust*; Darwin, *Origin of Species*. War of France and Piedmont against Austria.

DATE	CEZANNE	CULTURAL AND HISTORICAL EVENTS IN PROVENCE AND PARIS
1860	Cézanne still studies law but with increasing reluctance; Zola encourages him to come to Paris; his father refuses. In a letter, Zola praises the painting of Ary Scheffer and attacks realism. November 1860– spring 1861 Cézanne again works at municipal drawing school in Aix.	Emperor Napoléon III and Eugénie visit Marseille and inaugurate the annual exhibition; Delacroix sends an *odalisque*; restoration of Saint-Baume is completed.
		Aubanel's *La Miougrano entreduberto*.
		Degas, *Petites Filles spartiates provoquant des garçons*, a history painting, and Whistler, *The Music Room*.
		Wagner conducts concert of excerpts from his operas in Paris; Napoléon III commands the Imperial Opera to perform Wagner's *Tannhäuser*, and the composer begins revisions; Wagner also writes *The Music of the Future*.
		Houssaye, *Histoire de l'art français au dix-huitième siècle*; Baudelaire, *Les Paradis artificiels*; E. and J. de Goncourt, *Charles Demailly* and *L'Art au dix-huitième siècle*; Lacordaire, *Sainte Marie-Madeleine*.
		France annexes Nice and Savoy.

DATE	CEZANNE	CULTURAL AND HISTORICAL EVENTS IN PROVENCE AND PARIS
1861	Cézanne abandons his law studies and spends April–September in Paris. Visits the Salon; admires Doré, Meissonier, and others; meets Pissarro at the Atelier Suisse on the quai des Orfèvres. But in September returns to Aix, discouraged, and works in his father's bank; also works again at municipal drawing school.	Loubon's massive Salon exhibition, intended to rival the 1855 Paris Exposition universelle, is held in Marseille; over 1200 paintings from all periods are shown.
		Mistral is honored by the French Academy for *Mireio*.
		Manet's *Joueur de guitare* exhibited at Salon; Cabanel's *Nymphe enlevée par un faune*, Gérôme's *Phryné devant l'aréopage* at the Salon.
		Degas paints *Sémiramis construisant Babylone*, and Delacroix completes his murals at St.-Sulpice.
		Blanc begins publication of his massive *Histoire des peintres de toutes les écoles* with 2 volumes on the *Ecole hollandaise*.
		Jules-Etienne Pasdeloup institutes the Concerts Pasdeloup, popular Sunday concerts of classical music in Paris, which would include, in the 1860s, Wagner's scores; Wagner, *Tannhäuser* produced at the Opéra in Paris; prose translations of his operas published in French; Baudelaire publishes a spirited defense of Wagner's work in *Revue européenne* (1 April 1861). Garnier begins the Opéra.
		French expedition to Mexico.

DATE	CEZANNE	CULTURAL AND HISTORICAL EVENTS IN PROVENCE AND PARIS
1862	Cézanne takes up painting again and in November returns to Paris and the Atelier Suisse; apparently fails examinations for the Ecole des Beaux-Arts; Zola spends the summer with Baille and Cézanne in Aix and works on his first novel, *La Confession de Claude*, published 1865.	Honoré Gibert, son of the artist Joseph Gibert, compiles first catalogue of the collection of the Musée d'Aix. Loubon dies in Marseille. Manet paints *Musique aux Tuileries* and is praised by Baudelaire; Fantin-Latour's lithograph of *Tannhäuser: Venusberg*. Blanc, *Ecole française*. Flaubert, *Salammbô*; Hugo, *Les Misérables*. Bismarck appointed Prussian premier.

1863	Cézanne probably stays the entire year in Paris; enjoys sketching excursions with Zola on city outskirts; exhibits at the Salon des Refusés; works at the Atelier Suisse, where he meets Guillemet, Oller, and Guillaumin; in November, he applies for a student permit to make copies at the Louvre.	Reorganization of Ecole des Beaux-Arts.

Cabanel's *Naissance de Vénus* is successful at the Salon; Salon des Refusés instituted, and includes Manet's *Déjeuner sur l'herbe* and Whistler's *White Girl*; also paintings by Pissarro, Jongkind, Guillaumin, Fantin-Latour, and Cézanne.

Blanc, *Ecole anglaise*; Baudelaire, *Eugène Delacroix* (which Cézanne would later read) and *Peintre de la vie moderne*; Renan, *Vie de Jésus*.

Berlioz, *Les Troyens*.

Death of Alfred de Vigny, romantic poet and novelist, and of Delacroix.

DATE	CEZANNE	CULTURAL AND HISTORICAL EVENTS IN PROVENCE AND PARIS
1864	Cézanne is rejected at the Salon; copies a painting by Delacroix, which one uncertain; in April he begins to copy Poussin's *Les Bergers d'Arcadie* in the Louvre; returns to Aix in the summer, and in August is in L'Estaque.	Gounod, *Mireille*, opera based on Mistral's *Mireio*.

Salon: Manet, *Christ aux anges* and *Episode d'une course de taureaux*; Corot, *Souvenir de Mortefontaine*; Fantin-Latour, *Tannhäuser: Venusberg* and *Hommage à Delacroix*; Feyen-Perrin, *Une Leçon d'anatomie de Dr. Velpeau*.

Blanc, *Ecole flamande*; Zola's *Contes à Ninon*, a collection of tales, is published; E. and J. de Goncourt, *Renée Mauperin*; Renan, *Histoire générale et système comparé des langues sémitiques.*

Offenbach, *La Belle Hélène*. |

DATE	CEZANNE	CULTURAL AND HISTORICAL EVENTS IN PROVENCE AND PARIS
1865	Spends most of the year in Paris, again works at the Atelier Suisse; lives in the same house as the painter Oller and admires his work. Cézanne's paintings refused at the Salon; he visits the studio shared by Baille and Monet; returns to Aix in the summer; friendship with Valabregue, Marion, and the German musician Heinrich Morstatt; enjoys "the noble tones of Richard Wagner." Cézanne's admiration for Ribera and Zurbarán is noted by Marius Roux in a review of Zola's *La Confession de Claude*.	Manet's *Olympia* (1863) and *Jésus insulté par les soldats* accepted for the Salon; Degas exhibits his history painting, *Scène de guerre au moyen-âge*; Pissarro has two landscapes accepted, and Oller one; Ribot's *Saint Sebastien*, also shown at the Salon, is a popular success. Monet paints his *Déjeuner sur l'herbe*. Zola, *La Confession de Claude*; E. and J. de Goncourt, *Germinie Lacerteux*; Taine, *Philosophie de l'art*; Proudhon, *Du Principe de l'art*. Wagner writes *Tristan and Isolde*.

1866

Cézanne returns to Paris in February; Manet compliments his still lifes. Cézanne's two submissions to the Salon, one a portrait of Valabregue, are rejected; he writes two letters of protest to M. de Nieuwerkerke, the director of fine arts, and requests another Salon des Refusés. Spends July at Bennecourt, a village on the right bank of the Seine not far from Giverny, with Zola, Guillemet, Valabregue, and others. In August returns to Aix and stays through December; describes in a letter to Zola (19 October) an interest in painting out-of-doors; also, in a letter to Pissarro (23 October) Cézanne notes he will not send anything to the Salon that year in Marseille. Guillemet describes Cézanne's *L'Ouverture du Tannhäuser* in a letter to Zola (2 November); in a postscript to the same letter, Cézanne tells Zola that his attempt to paint a *Soirée de famille* was unsuccessful. Zola becomes the book reviewer for *L'Evénement*.

Daudet, a friend of Mistral, publishes his sketches of Provençal life in *Le Figaro*; they appear in book form in 1868 as *Lettres de mon moulin*.

In October Cézanne is invited by J. Gibert to visit the Bourguignon collection of old masters that had recently been bequeathed to the Musée d'Aix and first installed in the former chapel of the White Penitents.

Salon: Courbet's *La Femme au perroquet* is shown; Monet's *Camille* a great success; Manet's *Le Fifre* and *L'Acteur tragique* rejected.

Thoré's "Van der Meer de Delft" appears in *Gazette des beaux-arts*; Zola publishes his critical reviews of the Salon and *Madeleine Férat* in serial form in *L'Evénement*; Baudelaire, *Les Epaves*; Verlaine, *Poèmes saturniens*.

Offenbach, *La Vie parisienne*.

Prussia defeats Austria and establishes military alliances against France.

DATE	CEZANNE	CULTURAL AND HISTORICAL EVENTS IN PROVENCE AND PARIS
1867	Cézanne spends January to June in Paris and submits to the Salon two paintings, *Le Punch au rhum* and *L'Ivresse*; they are rejected; Zola defends him in a letter to *Le Figaro*. Cézanne returns to Aix for the summer. One of his paintings, exhibited in a shop window in Marseille, has to be withdrawn so as not to be smashed by an unruly crowd. Cézanne returns to Paris in the fall. Becomes acquainted with fellow Provençal painter Adolphe Monticelli at the Café Guerbois. Paints *L'Enlèvement*.	Mistral's *Calendau* published, including the long poem honoring the 1851 fête-Dieu in Aix. Zola publishes his *Mystères de Marseille* in serial form in *Le Messager de Provence*. Exposition Universelle held in Paris; Courbet and Manet hold private exhibitions outside the Exposition Universelle. Salon: Fantin-Latour's portrait of Manet, Ribot's *Le Supplice d'Alonso Cano*; Degas shows two portraits; Monet's *Femmes au jardin* rejected. Zola, *Edouard Manet* (pamphlet) and *Thérèse Racquin*; Blanc's *Ecole espagnole* begins to appear in periodical form; Baudelaire's *Curiosités esthétiques*; Gautier, Verlaine, and Baudelaire form Les Parnassiens. *Tannhäuser* performed in Munich. Death of Ingres and Baudelaire. Emperor Maximilian executed in Mexico.

DATE	CEZANNE	CULTURAL AND HISTORICAL EVENTS IN PROVENCE AND PARIS
1868	Cézanne again rejected at the Salon; in February acquires renewed student permit to make copies at the Louvre; spends May to December in Aix working at the Jas de Bouffan. In a letter notes his good fortune to hear the overtures to Wagner's *Tannhäuser*, *Lohengrin*, and *The Flying Dutchman*. Excursion to the village of Saint-Antonin, at the foot of Mont Sainte-Victoire.	The annual exhibition in Marseille includes works by Delacroix, Ingres, Meissonier, Diaz, Gérôme, Decamps, Couture, and others. Degas's *Mlle Fiocre* and Manet's *Portrait de M. Emile Zola* shown at the Salon; Pissarro, Monet, Morisot, and Sisley exhibit landscapes with Daubigny's help. Blanc, *Ecole vénitienne*; Baudelaire (posth.), *L'Art romantique*; Zola's *Madeleine Férat* appears in book form.
1869	Cézanne spends most of the year, perhaps all, in Paris; is again rejected by the Salon. At about this time he meets Hortense Fiquet. Cézanne reads Stendhal's *Histoire de la peinture en Italie*.	Palais des Longchamps (the new Musée des Beaux-Arts) completed in Marseille. Manet exhibits *Le Balcon* and *Déjeuner dans l'atelier* at the Salon; Degas shows *Portrait de Mme G.*; Isabey, *La Tentation de Saint Antoine*. Blanc, *Ecole espagnole*; Flaubert, *L'Education sentimentale*. Death of Thoré, Berlioz.

DATE	CEZANNE	CULTURAL AND HISTORICAL EVENTS IN PROVENCE AND PARIS
1870	Cézanne submits two paintings, a large *Nu couché* (now lost) and his *Portrait d'Achille Emperaire* (V. 88) to the Salon; both are rejected and figure in the caricature of the artist published in the *Album Stock* (20 March). Cézanne is a witness at Zola's wedding in Paris on 31 May; soon after, returns to Aix. Withdraws to L'Estaque to avoid the draft, lives there in secret with Hortense Fiquet; divides his time between landscape and studio painting.	Honoré Gibert becomes curator of Aix museum. First volume of Zola's *Les Rougon-Macquart*, entitled *La Fortune des Rougons*, begins to appear in serial form in the newspaper *Le Siècle*, but its publication is interrupted by the Franco-Prussian War. Manet, Degas, Pissarro, Renoir, Sisley, Bazille, and Morisot exhibit at the Salon. Blanc, *Ecole ombrienne et romaine*. July: France declares war on Prussia; September: French suffer crushing defeat at Sedan; Napoléon III abdicates; revolution in Paris; Third Republic proclaimed; Paris besieged by Prussian troops.
1871	Cézanne leaves L'Estaque in March, apparently returns to Aix. By the fall, he is again in Paris and lives in the same house as Philippe Solari, a childhood friend from Aix; in December moves to new quarters on the rue de Jussieu, opposite the Halle aux Vins, where Emperaire visits him briefly.	Zola, *La Fortune des Rougon*. January: Paris capitulates to Prussians; 18 March–28 May: Paris Commune; 31 August: Thiers, from Marseille and educated in Aix, is elected French president.

DATE	CEZANNE	CULTURAL AND HISTORICAL EVENTS IN PROVENCE AND PARIS
1872	In January Hortense Fiquet gives birth to a son, christened Paul Cézanne by his father. Cézanne is apparently again rejected at the Salon. With Hortense and their child, he moves to Pontoise to work with the painter Pissarro; toward the end of 1872 or early the following year, Cézanne and his family settle in Auvers-sur-Oise, where they remain until 1874.	Zola's *La Curée* published, his key novel in the *Rougon-Macquart* cycle set in rural Plassans (Aix) and Second Empire Paris. Daudet, *Tartarin de Tarascon*. In the spring, Dr. Gachet buys a house at Auvers-sur-Oise, not far from Pontoise. Manet exhibits *Combat du Kearsarge et de l'Alabama* (1864) at the Salon.
1873	Friendship with Dr. Gachet. Duret expresses an interest in Cézanne's painting.	Zola's *Le Ventre de Paris* published, in which appears a painter, Claude Lantier, partially based on Cézanne. Manet's *Le Bon Bock* very successful at the Salon; a new Salon des Refusés is instituted. France suffers an economic crash, followed by a six-year depression; death of Napoléon III.
1874	Cézanne in Auvers; exhibits three works in first impressionist exhibition, and sells one, *La Maison du pendu*, for 100 francs to Count Doria. Pissarro paints his portrait. In June Cézanne returns to Aix but is back in Paris by the fall.	Zola, *La Conquête de Plassans*. First impressionist exhibition, held at Nadar's studio, 35 blvd des Capucines; Manet refuses to participate. Flaubert's *La Tentation de Saint Antoine* (3rd version) finally published in full.

NOTES

NOTES TO CHAPTER I

1. On the troubadours in Provence, see Hugh Quigley, *The Land of the Rhone: Lyons and Provence* (Boston: Houghton Mifflin, 1927), pp. 128–44.

2. See *Le Roi René en son temps, 1382–1481*, exh. cat. (Aix-en-Provence: Musée Granet, 1981); and Noël Coulet et al., *Le Roi René: Le Prince, le mécène, l'écrivain, le mythe* (Aix-en-Provence: Edisud, 1982).

3. On the plague, see Marcel Bernos et al., *Histoire d'Aix-en-Provence* (Aix-en-Provence: Edisud, 1977), pp. 212ff.; and on its reflection in art, see E. Pluyette, "Les Oeuvres d'art qui commémorent le souvenir de la peste de 1720 à Marseille," *Revue de Marseille* 15 (August 1920): 457.

4. See René Borricand, *Les Hôtels particuliers d'Aix-en-Provence* (Aix-en-Provence: Chez l'auteur, 1971), with van Loo's fête-galante in the Hôtel de Ricard de Bregançon, repro. p. 271.

5. Quigley, *Land of the Rhone*, pp. 241–44. On the movement as a whole, see Aaron Sheon, "The Provençal Renaissance," in *Monticelli: His Contemporaries, His Influence*, exh. cat. (Pittsburgh: Museum of Art, Carnegie Institute, 1979), pp. 45–49.

6. Quigley, *Land of the Rhone*, p. 241.

7. Quigley, *Land of the Rhone*, p. 241.

8. On Le Félibrige see Quigley, *Land of the Rhone*, pp. 244–53; Tudor Edwards, *The Lion of Arles: A Portrait of Mistral and His Circle* (New York: Fordham Univ. Press, 1964), pp. 37–58; Rob Lyle, *Mistral* (New Haven: Yale Univ. Press, 1953), pp. 20ff.; and Frédéric Mistral, *The Memoirs of Frédéric Mistral*, trans. George Wickes (New York: New Directions, 1986), pp. 139–43, 153–62.

9. Mistral, *Memoirs*, pp. 123ff.

10. Mistral, *Memoirs*, chapter 2, "My Father," pp. 17–25.

11. Mistral, *Memoirs*, p. 143.

12. Mistral, *Memoirs*, p. 143.

13. Sheon, *Monticelli*, pp. 30–31.

14. A 1978 exhibition in Marseille at the Musée des Beaux-Arts, *La Peinture en Provence au XVII^e siècle*, again brought this school to light.

15. For the fullest study of Finson, see Didier Bodart, *Louis Finson* (Brussels: Académie Royale de Belgique, 1970); on his tenure in Provence—Aix, Marseille, and Arles—see esp. pp. 17–26.

16. On Finson's relationship to Caravaggio, see Bodart, *Finson*, pp. 94–109; Alfred Moir, *Caravaggio and His Copyists* (New York: College Art Association, 1976), pp. 23, 37, n. 97; and *La Peinture en Provence au XVII^e siècle*, exh. cat. (Marseille: Musée des Beaux-Arts, 1978), p. 69.

17. *La Peinture en Provence*, p. 69.

18. Bodart, *Finson*, p. 65.

19. Numa Coste, "Jean Daret, peintre bruxellois," *Réunion des sociétés des beaux-arts des départements* 25 (1901). See also the extensive bibliography on Daret in *La Peinture en Provence*, pp. 34–53, 170–73.

20. For repro., see Jean-Louis Vaudoyer, *Les Peintres provençaux de Nicolas Froment à Paul Cézanne* (Paris: La Jeune Parque, 1947), pl. 37.

21. *La Peinture en Provence*, cat. no. 51, repro. This canvas was only recently discovered and acquired by the Musée des Beaux-Arts, Marseille.

22. Theodore Reff, "Cézanne's *Cardplayers* and Their Sources," *Arts Magazine* 55, no. 3 (November 1980): 104–17.

23. These references have been discussed most notably by Bruno Ely in "Cézanne, l'école de dessin et le Musée d'Aix," in Denis Coutagne et al., *Cézanne au Musée d'Aix* (Aix: Musée Granet, 1984), pp. 137–206.

24. See Ch. 207, 499, 502–6, 575–78, 976–78, 999–1006, 1057–60, 1131, 1196, 1200, 1201, 1208 A; and on Cézanne's professed admiration for Puget, see John Rewald, *Cézanne: A Biography* (New York: Abrams, 1986), p. 194.

25. Cézanne would thank the young poet Joachim Gasquet for his efforts to see his art in light of its Provençal context: "I commend myself to you and your kind remembrance so that the links which bind me to this native soil . . . do not snap and detach me, so to speak, from the earth whence I have imbibed so much even without knowing it." Letter dated 21 July 1896 in John Rewald, ed., *Paul Cézanne: Letters*

(New York: Hacker Art Books, 1976), p. 250, written in response to Gasquet's first article on Cézanne, published in his periodical *Les Mois dorés* (excerpted, *Letters*, pp. 248–49).

NOTES TO CHAPTER II

1. Robert Fernier, *La Vie et l'oeuvre de Gustave Courbet*, 2 vols. (Lausanne: Bibliothèque des Arts, 1977), vol. 1, cat. no. 88, p. 52, repro. The work is now in the collection of the Musée Courbet, Ornans.

2. Letter dated 13 June 1860 in John Rewald, ed., *Paul Cézanne: Letters* (New York: Hacker Art Books, 1976), pp. 67–69.

3. Musée des Beaux-Arts, Lille; deposited at the Musée des Arts et Traditions Populaires, Paris. Repro. in Hollister Sturges, *Jules Breton and the French Rural Tradition*, exh. cat. (Omaha, Nebr.: Joslyn Art Museum, 1982), p. 42, fig. 12.

4. For example, Gauguin's *Vision after the Sermon: Jacob Wrestling with the Angel* (National Gallery, Edinburgh). On its relationship with Breton fêtes, see Mathew Herban III, "The Origin of Paul Gauguin's *Vision after the Sermon*," *The Art Bulletin* 59, no. 3 (September 1977): 415–20.

5. Michèle Boudignon-Hamon and Jacquelin Demoinet, *Fêtes en France* (Paris: Chêne, 1977), p. 139.

6. And it was the fête-Dieu procession itself that the Council of Trent (1545–1563) approved as a religious manifestation. See Boudignon-Hamon and Demoinet, *Fêtes en France*, p. 140.

7. The literature on the Aix fête-Dieu is extensive. In addition to the primary sources cited below, see especially Michel Vovelle, *Les Métamorphoses de la fête en Provence de 1750 à 1820* (Paris: Flammarion, 1976), pp. 70–71, and Jean-Paul Clébert, *Les Fêtes en Provence* (Avignon: Editions Aubanel, 1982), pp. 97–107, and, repro. on p. 105, Pierre Grivolas's 1878 painting of the fête-Dieu at Avignon. Historical reenactments in 1950 and 1964 brought much of the fête's primary imagery to light. On these modern fêtes, see Claude Tchoy, *Guide de la Provence mystérieuse* (Paris: Les Guides Noirs, éditions Tchou Princesse, 1976), p. 30, and A. Toursky, *La Reconstitution historique de l'entrée du Roi-René dans la ville et les jeux de la fête-Dieu* (Aix-en-Provence, 1964).

8. Martine Challet, "La Fête-Dieu à Aix-en-Provence au XVIIIIème siècle: 1701–1785," Mémoire de maîtrise (Université de Paris X-Nanterre, 1972–1973), p. 2. Some may also have been destroyed in the invasion of 1536.

9. For example, René's elite order of knights from his military campaign at Angers, the *Chevaliers du croissant*, guided the procession of antique deities through the city streets, imparting an almost mystical aura to the king's own men and underlining a specific victory gained during his reign. Challet, "La Fête-Dieu," pp. 165–66.

10. "La célébration des *Jeux de la Fête-Dieu d'Aix*, interrompue par la révolution de 89, a été accidentellement reprise depuis le rétablissement du culte par l'empéreur Napoléon, dans quelques circonstances solennelles par example en 1807, en l'honneur de la princesse Pauline, en 1814, lors du passage du comte d'Artois, depuis Charles x, et en 1823 pour fêter la visite de l'auguste fille de Louis xvi, madame duchesse d'Angoulème." From introduction to J.-B.-S. Guiet, *Explication nouvelle des jeux de la fête-Dieu d'Aix* (Aix-en-Provence: Makaire et Deleuil, 1851).

11. Frédéric Mistral, *The Memoirs of Frédéric Mistral*, trans. George Wickes (New York: New Directions, 1986), pp. 124–25.

12. Details of the screen are reproduced in *Le Roi René en son temps, 1382–1481*, exh. cat. (Aix-en-Provence: Musée Granet, 1981), pp. 237–43, 245–46. The screen is now in the Musée Granet.

13. Musée du Vieil Aix.

14. Musée Arbaud, Aix-en-Provence.

15. Exhibition labels, Musée du Vieil Aix, on display summer 1980.

16. Gaspard Grégoire, *Explication des cérémonies de la fête-Dieu d'Aix* (Aix-en-Provence: E. David, 1777). Two other accounts differ with Grégoire's but are not considered as accurate. Pierre de Haitze's *Esprit du cérémonial d'Aix en la célébration de la fête-Dieu* (Aix-en-Provence, 1708) discusses only the fête's religious aspects and symbolism. Abbé Guiet's *Explication nouvelle*, occasioned by the momentous celebration of 1851, is a carefully constructed account of its allegorical elements and their meaning. Yet it is doubtful that the piety and complexity he accorded the fête reflected its meaning in the nineteenth century. For a discussion of these three sources and also of the fête's artifacts, see Jean Cuisenier, *French Folk Art*, trans. T. W. Lyman (Tokyo: Kodansha, 1977), pp. 30–34. Such diverse accounts suggest that the fête was a vehicle open to manipulation and free interpretation. As such, its re-creation on a lavish scale in 1851 was as much a celebration of prideful Aixois heritage as it was a religious manifestation.

17. Grégoire's sons became artists in their own right and are discussed in Jean Boyer's "La Peinture et la gravure à Aix-en-Provence au XVI–XVIIIème siècles," *Gazette des beaux-arts* sér. 6, 78 (July–September 1971): 129.

18. Guiet, *Explication nouvelle*, pp. 7–8; François-Ambroise-Thomas Roux-

Alpheran, *Les Rues d'Aix* (Aix-en-Provence: Aubin, 1846–1848; reprint Montpellier: Les Presses du Languedoc, 1985), reproductions pp. 114–24. Also, Jan B. Gaut, an Aixois poet and member of Le Félibrige, reprinted several of Grégoire's engravings in his *Leis Juéchs de la festo de Diou: Consouns nouvellos* (Aix-en-Provence, 1851).

19. See, for example, the *têtière* of Moses reproduced in Charles Galtier and Jean-Maurice Rauquette, *La Provence et Frédéric Mistral en museon arlaten* (Arles: J. Cuenot, 1977), p. 58, fig. 1. Such unusual features in the Aix fête-Dieu have been used to link it to similar festivals in Urbino at the time of Federico da Montefeltro, whom René emulated. See Edouard Aude, *Une Énigme historique dans les jeux de la fête-Dieu* (Aix-en-Provence, 1937). Aude also establishes that Mistral paraphrased, in part, Grégoire in his fête-Dieu poem in the *Calendau*, further proof of the study's renown in mid-nineteenth-century Aix.

20. Ch. 1.

21. Lawrence Gowing, introduction to *Watercolor and Pencil Drawings by Cézanne*, exh. cat. (London: Arts Council of Great Britain, 1973), pp. 21–22.

22. "Mes Confidences" in Ch. 1:49ff.

23. Letter dated 9 January 1903, Rewald, *Letters*, p. 193.

24. See André Gouirand, *La Musique en Provence, et la conservatoire de Marseille* (Marseille: P. Ruat, 1908), pp. 39–43, 173–77.

25. John Rewald, *Paul Cézanne: A Biography* (New York: Simon and Schuster, 1948), p. 4. See also: Ambroise Vollard, *Paul Cézanne: His Life and Art*, trans. Harold L. Van Doren (New York: Crown, 1937), p. 16; Gerstle Mack, *Paul Cézanne* (New York: Knopf, 1935), p. 21; and Jack Lindsay, *Cézanne, His Life and Art* (Greenwich, Conn.: New York Graphic Society, 1969), p. 14.

26. Franck Baille, *Les Petits Maîtres d'Aix à la belle époque 1870–1914* (Aix-en-Provence: Roubaud, 1981), p. 94, repro.

27. This painting is described as a memento mori by Theodore Reff in "Painting and Theory in the Final Decade," in William Rubin et al., *Cézanne: The Late Years*, exh. cat. (New York: The Museum of Modern Art, 1977), p. 33, and in his "Cézanne: The Severed Head and the Skull," *Arts Magazine* 58, no. 2 (October 1983): 90–91. Meyer Schapiro sees it as "the imagery of the romantic student with thoughts of love and death"; Meyer Schapiro, "The Apples of Cézanne: An Essay on the Meaning of Still-life," in *Modern Art, 19th & 20th Centuries: Selected Papers* (New York: George Braziller, 1979), p. 14. The precedents for such images are many. To Reff's suggestions I would add the significant example of Jacques Claeuw's *Vanitas*, Musée des Beaux-Arts, Marseille. Some of the material on skull imagery in Aix, which originally ap-

peared in my dissertation "Cézanne's Religious Imagery," Ph.D. diss., Univ. of Pennsylvania, 1981, was discussed by Reff in "The Severed Head."

28. Robert Ratcliffe, "Cézanne's Working Methods and Their Theoretical Background," Ph.D. diss., Univ. of London, 1960, pp. 34–74.

29. Reff, "Painting and Theory," p. 33.

30. Rewald, *Letters*, pp. 355ff. In one poem, as has often been noted, Cézanne rhymes his own name with *crâne* (skull).

31. Repro. in *La Peinture en Provence au XVIIᵉ siècle*, exh. cat. (Marseille: Musée des Beaux-Arts, 1978), cat. nos. 201, 202, and 203.

32. National Gallery of Art, Washington, D.C. On the painting, see Pierre Rosenberg, *The Age of Louis XV: French Painting 1710–1744*, exh. cat. (Toledo: Toledo Museum of Art, 1975), cat. no. 23 and pp. 31–32.

33. Fr. P. Desplanches, *Les Pénitents gris d'Aix-en-Provence* (Aix-en-Provence, 1976).

34. Michel Clerc, *Aquae Sextiae* (Aix-en-Provence: A. Dragon, 1916), pp. 53–57. For the fullest discussion of these excavations, see R. Ambard, *Aix romaine* (Aix-en-Provence: Association archéologique "Entremont," 1984).

35. Marcel Provence, "Art celto-ligure," *France illustration* 2 (15 December 1945): 264, notes the academic research of 1817, 1824, 1834, 1839, 1846, 1877, and 1907.

36. This was noted by Guillemet in a letter of 2 November 1866 to Zola with a postscript by Cézanne; Rewald, *Letters*, p. 118.

37. Reff, "The Severed Head," p. 103, cites Clerc, *Aquae Sextiae*, p. 62n. 1 and p. 100n. 3, where Numa Coste's article "Le Camp d'Entremont," *Le Sémaphore de Marseille*, 1–2 March 1903, is mentioned.

38. Clerc, *Aquae Sextiae*, p. 55.

39. See also the bas-reliefs of Entremont, Musée Granet, Aix; repro. in Robert Doré, *L'Art en Provence* (Paris: Les Beaux-Arts, 1930), pl. 140, fig. 319.

40. See the *portique du sanctuaire celtique de Roquepertuse*, Musée Borely, Marseille; repro. in Raymond Lantier, *Les Origines de l'art français* (Paris: Guy Le Prat, 1947), fig. 42.

NOTES TO CHAPTER III

1. The problematic imagery of Cézanne's *Visitation* is discussed at length in my dissertation, "Cézanne's Religious Imagery," Ph.D. diss., Univ. of Pennsylvania, 1981, pp. 61–66. On such naive and disjointed compositions, see John Rewald, *Paul*

Cézanne: A Biography (New York: Simon and Schuster, 1948), p. 44. For the Puget painting, see *Amours et phobies: Stendhal et les peintures du Musée des Beaux-Arts de Marseille*, exh. cat. (Marseille: Musée des Beaux-Arts, 1983), p. 31.

2. Charles Blanc, *Histoire des peintres de toutes les écoles*, 14 vols. (Paris: Librairie Renouard, 1861–1877), *Ecole espagnole*, 1869. Lawrence Gowing, "The Early Work of Paul Cézanne," in *Cézanne: The Early Years, 1859–1872*, exh. cat. (London: Royal Academy of Arts, 1988), pp. 12, 136–37.

3. Originally part of the mural decoration in the large salon at the Jas de Bouffan, the entire work was detached from the wall when the Musées Nationaux refused to accept it as a gift in 1907; it was subsequently divided in two. The limbo painting was formerly in the Pellerin collection in Paris; the *Madeleine* was acquired by the Louvre in 1952 and now hangs in the Musée d'Orsay.

4. Although Reff can agree with the notion of a thematic and visual unity for the work as a whole, he has recently disputed the generally accepted identification of the woman on the right as the Magdalen. Theodore Reff, "Cézanne: The Severed Head and the Skull," *Arts Magazine* 58, no. 2 (October 1983): 91. The figure is clearly meant to portray an exaggerated melancholy. Even so, it is difficult to accept Reff's contention that Cézanne's deeply symbolic figure set in mysterious, dark surroundings represents only a generalized image of sorrow, and that such a figure could, as he asserts, convey the same potent meaning. As Reff himself notes, the "intense pathos of Cézanne's picture" and the "vehemence of its execution" separate it from the many genre scenes of death and mourning produced by realist artists in the 1860s (p. 91). Certainly the extreme pathos of Cézanne's Magdalen, the beloved saint and protectress of Provence, helps to confirm her identity and suggests the special significance of the subject for the artist.

5. Robert A. Koch, "La Sainte-Baume in Flemish Landscape Painting of the Sixteenth Century," *Gazette des beaux-arts* sér. 6, 66 (November 1965): 272–82; Marguerite Roques, *Les Apports néerlandais dans la peinture du sud-est de la France* (Bordeaux: Union française d'impression, 1963), pp. 244–51.

6. See Camille Chabaneau, *Sainte Marie Madeleine dans la littérature provençale* (Paris: Maisonneuve Frères et Ch. Leclerc, 1887), pp. 146, 181ff.

7. Carol S. Kiefer, "Cézanne's *Magdalen*: A New Source in the Musée Granet, Aix-en-Provence," *Gazette des beaux-arts* sér. 6, 103 (February 1984): 92–93. Kiefer has also argued that Cézanne's image was inspired by a small seventeenth-century study of the Magdalen in the Bourguignon collection, a work at that time attributed to the Provençal painter Pierre Subleyras. Both canvases feature a large, solitary fig-

ure draped in blue and set in an ambiguous dark space; in each case a skull lies in front of the figure and dramatic lighting from above illuminates the figure's right side. Equally, Cézanne's *Madeleine* could be likened to a *Madeleine pénitente* from the circle of Domenico Feti that was also in the Bourguignon collection. Its primary source, however, still must be Feti's famous painting in the Louvre.

8. John Rewald, ed., *Paul Cézanne: Letters* (New York: Hacker Art Books, 1976), p. 13.

9. Lancelot C. Sheppard, *Lacordaire: A Biographical Essay* (New York: Macmillan, 1964), pp. 168–69.

10. Louis Réau, *Iconographie de l'art chrétien*, vol. 3, pt. 2 (Paris: Presses universitaires de France, 1958), p. 848.

11. On this, see Francis Haskell, *Past and Present in Art and Taste* (New Haven: Yale Univ. Press, 1987), pp. 55–56 and nn. 33–35. I am grateful to John McCoubrey for suggesting Canova's sculpture in this context.

12. Lee Johnson, *The Paintings of Eugène Delacroix* (Oxford: Clarendon Press, 1986), vol. 3, cat. no. 428 and vol. 4, pl. 238.

13. Jean Adhémar, *Honoré Daumier* (Paris: Editions Pierre Tisné, 1954), pl. 51.

14. Adhémar, *Daumier*, p. 38.

15. Gesta Salvatoris, *The Gospel of Nicodemus*, ed. H. C. Kim (Toronto: The Pontifical Institute for Medieval Studies, 1973), p. 5.

16. Salvatoris, *Gospel of Nicodemus*, p. 5.

17. Sr. John of Carmel Chauvin, "The Role of Mary Magdalen in Medieval Drama" (Ph.D. diss., Catholic Univ. of America, Washington, D.C., 1951), p. 146.

18. Karl Young, *The Drama of the Medieval Church*, 2 vols. (Oxford: Clarendon Press, 1933), 1:45.

19. On this and the gradual absorption of the harrowing of hell into the Easter plays, see Sir Edmund Kerchever Chambers, *The Medieval Stage*, 2 vols. (London: Oxford Univ. Press, 1963), 2:73–75.

20. I am indebted to the late Louis Malbos of the Musée Granet, Aix, who told me of the yearly passion play performed in Aix by the *Cercle de Saint Mitre*, one of several youth groups in existence during Cézanne's lifetime. The Cercle de Saint Mitre was the most religiously oriented of the Aix societies; it performed a Christmas drama as well, for which the texts survive.

21. I am grateful to Lawrence Gowing for first suggesting to me a possible correlation between Cézanne's composition and images of the penitent saints.

22. Alte Pinakothek, Munich.

23. For example, de La Tour's *Madeleine répentante* in the Louvre or the related painting in the collection of the Los Angeles County Museum of Art.

24. Gisela Hopp has identified Cézanne's drawing as having been inspired by an engraving in Blanc's *Ecole lombarde* (1875), representing a painting of Mary Magdalen often attributed in the nineteenth century to Correggio. See her *Europäische Meisterwerke aus schweizer Sammlungen* (Munich: Bavarian Graphic Collection, 1969), no. 26. See also Chappuis's discussion on p. 109, where Hopp's arguments are cited.

25. Gowing, *The Early Years*, cat. no. 85.

26. Jacobus de Voragine, *The Golden Legend*, fol. xv–xvi. In addition, the flames recall the symbolism of the candle ceremonies often incorporated into the *Visitatio* scene of the Easter liturgy.

27. From a 1671 edition of the poetry of P. Le Moyne, quoted by Françoise Bardon in her valuable article, "Le Thème de la Madeleine pénitente au XVIIème siècle en France," *Journal of the Warburg and Courtauld Institutes* 31 (1968): 282. It is an interesting coincidence that two of Reni's paintings of the Magdalen were shown in the 1861 exhibition in Marseille. See Etienne Parrocel, *Concours régional 1861, exposition des beaux-arts* (Marseille, 1861), cat. nos. 833 and 835.

I am grateful to Professor Mary Ann Cawes for sending me a copy of La Roque's rarely published "La Madeleine."

La Madeleine

Enfin la belle Dame orgueilleuse et mondaine
Changea pour son salut et d'amant et d'amours,
Ses beaux palais dorés aux sauvages séjours,
Sa faute au repentir, son repos à la peine,

Son miroir en un livre, et ses yeux en fontaine,
Ses folastres propos en funèbres discours,
Changeant mesme d'habits en regrettant ses jours
Jadis mal employez à chose errante et vaine.

Puis ayant en horreur sa vie et sa beauté,
Mesprise le plaisir, l'aise et la vanité,
Les attraits de ses yeux, l'or de sa tresse blonde.

O bienheureux exemple! O sujet glorieux!
Qui nous montre ici bas que pour gagner les Cieux
Il faut avant la mort abandonner le monde.

1. Job 2.

2. Chappuis notes that a signature appears in the same upper right corner but feels it is not the artist's (p. 83). This curious feature can be found in other early drawings, for example, Ch. 55.

3. For discussions of the theme of Job, see W. Weisbach, "L'Histoire de Job dans les arts," *Gazette des beaux-arts* sér. 6, 16 (September 1936): 102–12, and Marguerite L. Brown, "The Subject Matter of Dürer's *Jabach Altar*," *Marsayas* 1 (1941): 55–68. For Gothic examples, see Adolph Katzenellenbogen, *The Sculptural Programs of Chartres Cathedral* (Baltimore: The Johns Hopkins Univ. Press, 1959), fig. 59, and Willibald Sauerländer, trans. Janet Sondheim, *Gothic Sculpture in France, 1140–1270* (New York: H. N. Abrams, 1973), fig. 245. Katzenellenbogen also discusses the relationship of Job to Christ in Christian typology (p. 68).

4. For Lavergne's rarely reproduced painting, see New York Public Library Picture Collection on the subject of Job. On Decamps's *Job et ses amis* (1850, Minneapolis Institute of Art) and Delacroix's appreciation of it, see Dewey Mosby, *Alexandre-Gabriel Decamps 1803–1860* (New York: Garland, 1977), pp. 228–31, 432–33. Max Liebermann's *Job and His Friends* of 1899 continues the same motif; repro. in *The Bible in Art*, ed. C. Hardy (New York: Civici and Friede, 1936), p. 117.

5. See "Quelques Oeuvres théâtrales consacrées au saint homme Job," *Jeux, trétaux, et personnages* 4, no. 31 (15 July 1933): 187–89. In Spain, "La Patience de Job" was one of the mystères included in celebrations of the fête-Dieu, but it does not seem to have figured in the Aix festival. However, the Provençal play *Moralitas patientie Job*, first presented at nearby Draguignan in 1534, may have stimulated the introduction of Job's narrative into other regional fêtes. See Claude Tchoy, *Guide de la Provence mystérieuse* (Paris: Les Guides noirs, éditions Tchou Princesse, 1976), p. 186.

6. Another example is Noël Hallé's *Death of Seneca* (Museum of Fine Arts, Boston), repro. in Anita Brookner's *Jacques-Louis David* (New York: Harper & Row, 1980), fig. 2.

7. Now in the collection of the Art Institute of Chicago, this painting was later attributed to the school of Ribera but is now more generally assigned to the seventeenth-century Spanish school. See J. Guidol, *Velázquez* (New York: Greenwich House, 1974), cat. no. 14, fig. 30. On its subject, see "Velázquez's *Dying Seneca*," *Bulletin of the Art Institute of Chicago* 19, no. 6 (October 1925): 83–84.

8. Chappuis, p. 84.

9. Cézanne's copy (V. 708) is usually dated ca. 1899. However, Rewald mentioned a ca. 1863–1864 copy of the same Delacroix painting in his article "Sources d'inspiration de Cézanne," *L'Amour de l'art* 17 (May 1936): 191.

10. John Rewald, ed., *Paul Cézanne: Letters* (New York: Hacker Art Books, 1976), p. 350.

11. Jon Douglas Levenson, *The Book of Job in Its Time and in the Twentieth Century* (Cambridge: Harvard Univ. Press, 1972), pp. 1ff.

12. Blake's interpretation also emphasized the theme of temptation. See Northrop Frye, "Blake's Reading of the *Book of Job*," in *William Blake—Essays for S. Foster Damon* (Providence, R.I.: Brown Univ. Press, 1969), pp. 221–34.

13. For a comparison of Renan's and Leroux's interpretations, see Edmund Silberner, "Pierre Leroux's Ideas on the Jewish People," *Jewish Social Studies* 12, no. 4 (October 1950): 373–74.

14. On this, see James Doolittle, *Alfred de Vigny: The Man and the Writer* (New York: Twayne Publishers, 1967), pp. 60–63. The tragic story of Jephthah also appealed to Degas, who treated it in his *La Fille de Jephté* of 1866 (Smith College Museum of Art, Northampton, Mass.).

15.
> *Oui, regardez-moi bien, et puis dites après*
> *Qu'un Dieu de l'innocent défend les intérêts;*
>
>
>
> *Seul, toujours seul, par l'âge et la douleur vaincu,*
> *Je meurs tout chargé d'ans, et je n'ai pas vécu.*

Alfred de Vigny, *Oeuvres complètes* (Paris: Editions du Seuil, 1965), p. 65, lines 143–48; prose translation in Doolittle, *Alfred de Vigny*, pp. 62–63.

16. Both Dubufe's painting and Cézanne's copy are reproduced in Denis Coutagne et al., *Cézanne au Musée d'Aix* (Aix-en-Provence: Musée Granet, 1984), pp. 168–69. Ely notes in the same catalogue that in the first catalogue of the museum's collection, compiled by Honoré Gibert (1862), Dubufe's painting was cited with a short passage from Byron's poem (p. 202n. 65).

17. Lawrence Gowing, *Cézanne: The Early Years, 1859–1872*, exh. cat. (London: Royal Academy of Arts, 1988), cat. no. 3. I am grateful to Lawrence Gowing for bringing this work to my attention.

18. I am indebted to Joshua Kind's extensive study of the rarely treated subject and its established visual motifs in his *The Drunken Lot and His Daughters*, Ph.D. diss., Columbia Univ., 1967.

19. Ch. 140.

20. For Kind's discussion of the typically planar composition of the theme and its formal and subjective implications, see his *Drunken Lot*, pp. 175ff. See also the compilation of works on the subject in Andor Pigler, *Barockthemen*, vol. 1 (Budapest: Akadémiai Kiadó, 1956), pp. 38–43.

21. Robert Fernier, *La Vie et l'oeuvre de Gustave Courbet*, 2 vols. (Lausanne: Bibliothèque des Arts, 1977), vol. 1, cat. no. and pl. 13; discussed by Linda Nochlin in *Gustave Courbet: A Study of Style and Society* (New York: Garland, 1976), pp. 11–14. On the earlier version, Nochlin (p. 11n. 1) cites Théophile Silvestre, *Les Artistes français: Etudes d'après nature* (Leipzig: A. Schnée, 1861).

22. Kind, *Drunken Lot*, p. 149 and fig. 17.

23. Kind, *Drunken Lot*, figs. 53 and 54, cat. no. 86. On its problematic attribution see cat. no. 86, and for its evident popularity, fig. 54. Marco Liberi's *Lot and His Daughters* (priv. coll., Budapest; repro. in Pigler, *Barockthemen*, p. 43) offers a related version of the composition but places it in the pastoral setting favored by Italian painters of the theme.

24. Kind, *Drunken Lot*, pp. 252ff.

25. Kind, *Drunken Lot*, p. 111.

26. Kind, *Drunken Lot*, pp. 135ff.; see, for example, Lucas van Leyden's *Lot and His Daughters* in the Louvre.

27. Pigler, *Barockthemen*, p. 545; Kind, *Drunken Lot*, pp. 103–5.

28. Kind, *Drunken Lot*, pp. 236–40.

29. *L'Après-midi à Naples* (V. 224) was recently acquired by the Australian National Gallery, Canberra.

30. Jack Spector discusses the cycle of love and death in Delacroix's *Mort de Sardanapale* in *Delacroix: The Death of Sardanapalus* (New York: Viking Press, 1974), pp. 89ff. Mario Praz treats the subject throughout *The Romantic Agony*, 2d ed. (London: Oxford Univ. Press, 1979) and quotes H. Kräger, p. 90n. 48, on this attitude in Byron: "Byron had an almost morbid predilection for such conflicts of feeling . . . he was never so satisfied as when he saw the shadows of death blighting a marriage-bed." H. Kräger, *Der Byronsche Heldentypus*. Forschungen zur neuren Litteraturgeschichte, vi (Munich: Haushalter, 1898), p. 136n. 24.

31. On this peculiar romantic fascination, see Eino Railo's "Incest and Romantic Eroticism," in *The Haunted Castle: A Study of the Elements of English Romanticism* (London: G. Routledge & Sons, 1927), pp. 267ff. Railo credits Walpole with bringing the theme to light in *The Mysterious Mother* (1768); it subsequently appeared in Chateaubriand's "René" (1802), in Shelley's *Laon and Cynthna* (1817) and *The Cenci* (1819),

and in Byron's *Manfred* (1817) and *Cain* (1821). Praz discusses this theme in Chateaubriand and in Byron, *Romantic Agony*, pp. 111–12; 71–75 and 89–90.

32. On such intimations of incest in Flaubert's work, see Praz, *Romantic Agony*, p. 188n. 158.

33. Spector, *Sardanapalus*, p. 123n. 46; found in Delacroix's album at the Louvre, RF 23.357, inside front cover. As far as is known, he never pursued the idea.

34. Theodore Reff, "Cézanne and Hercules," *The Art Bulletin* 48 (March 1966): 35ff., fig. 6. Meyer Schapiro questions Reff's reading of the drawing's subject matter in "The Apples of Cézanne: An Essay on the Meaning of Still-life," in *Modern Art, 19th & 20th Centuries: Selected Papers* (New York: George Braziller, 1979), 38n. 86.

35. On the slung-leg motif, see Leo Steinberg, "The Metaphors of Love and Birth in Michelangelo's Pietàs," in *Studies in Erotic Art*, eds. Theodore Bowie and Cornelia V. Christenson (New York: Basic Books, 1970), pp. 241–42, 274, and, for an example of its association with the theme of Lot and his daughters, fig. 127.

36. Kind, *Drunken Lot*, p. 184. See also his cat. no. 204, fig. 66 for Etienne Delaune's graceful engraving (after Luca Penni?) with the same motif.

37. On Vouet's painting in Strasbourg, see W. Crelly, *The Paintings of Simon Vouet* (New Haven: Yale Univ. Press, 1962), cat. no. 143, p. 217, fig. 51. Crelly does not elaborate on all of the copies. But in his *Caravage et le caravagisme européen* (Aix-en-Provence: Libr. Dragon, 1941) George Isarlo cites a copy of a Vouet painting of the subject in a private collection in Aix in 1790, p. 256. Unfortunately, I have been unable to locate that copy.

38. For a discussion of Lot as the aggressor, especially in seventeenth-century depictions, see Kind, *Drunken Lot*, pp. 210ff.

39. Gowing, *The Early Years*, p. 74.

NOTES TO CHAPTER V

1. On the wide range of reactions and continuing controversies generated by the rococo, see Carol Duncan, *The Pursuit of Pleasure: The Rococo Revival in French Romantic Art* (New York: Garland, 1976), pp. 23–27; and in a broader context, Hugh Honour, *Neo-Classicism* (Harmondsworth, Middlesex: Penguin, 1968), p. 19, cited in Aaron Sheon, *Monticelli: His Contemporaries, His Influence*, exh. cat. (Pittsburgh: Museum of Art, Carnegie Institute, 1979), p. 15. My discussion of the movement's revival is indebted especially to Duncan and Sheon.

2. Armand Dayot, *Carle Vernet* (Paris: Le Goupy, 1924), pp. 18–19. Vernet be-

came best known for his graceful scenes of racing and the hunt. See *Carle Vernet, quelques aspects de son oeuvre*, exh. cat. (Bordeaux: Musée des Beaux-Arts, 1959).

3. Duncan, *Pursuit of Pleasure*, pp. 21, 26–27, 35; Sheon, *Monticelli*, pp. 19–21.

4. Duncan, *Pursuit of Pleasure*, pp. 35n. 2, 39.

5. Michael Fried, "Manet's Sources: Aspects of His Art, 1859–1865," *Artforum* 7 (March 1969): 48–49.

6. Arsène Houssaye, *Histoire de l'art français au dix-huitième siècle* (Paris: Henri Plon, 1860), p. 163. See also Sheon, *Monticelli*, pp. 16–17. Sheon notes Houssaye was editor of *L'Artiste* from 1859 to 1875.

7. Théophile Gautier, *Tableaux à la plume* (Paris: G. Charpentier, 1880), pp. 9–10, cited in Duncan, *Pursuit of Pleasure*, p. 40. See also Joanna Richardson, *Théophile Gautier: His Life and Times* (London: M. Reinhardt, 1958), pp. 137–38 and Sheon, *Monticelli*, p. 17.

8. Duncan, *Pursuit of Pleasure*, pp. 35–36 and Sheon, *Monticelli*, pp. 17–18, describe this group of artists and writers, living in the Impasse du Doyenné in the 1830s, for whom the revival of rococo ideals became a common bond. In addition to Houssaye and Gautier, the illustrator Camille Rogier and the writer Gérard de Nerval helped to rekindle the modes of the eighteenth century.

9. Théophile Thoré, "Etudes sur la sculpture française depuis la renaissance," *Revue de Paris*, nouvelle sér., 25 (1836): 333; cited in Frances Suzman Jowell, *Thoré-Bürger and the Art of the Past* (New York: Garland, 1977), p. 52n. 10.

10. Baudelaire's "Les Phares" from *Les Fleurs du mal* is a hymn to the poet's favorite artists, and Watteau is one of those praised. Much later, Charles Camoin would write in a letter to Cézanne that he, Cézanne, deserved a verse in Baudelaire's famous poem. John Rewald, ed., *Paul Cézanne: Letters* (New York: Hacker Art Books, 1976), p. 282. See also Maxine G. Cutler, *Evocations of the Eighteenth Century in French Poetry 1800–1869* (Geneva: Droz, 1970), pp. 193–246.

11. Edmond and Jules de Goncourt, *French Eighteenth-Century Painters*, trans. Robin Ironside (Ithaca: Cornell Univ. Press, 1981), pp. 52ff.

12. See André M. Alauzen, *La Peinture en Provence*, nouvelle éd. (Marseille: J. Laffitte, 1984), pp. 97–98, 123–24, and 131–32, and pls. 21, 27, and 29.

13. Duncan, *Pursuit of Pleasure*, pp. 39–40; Sheon, *Monticelli*, p. 20.

14. See *Ingres and Delacroix through Degas and Puvis de Chavannes: The Figure in French Art 1800–1870*, exh. cat. (New York: Shepherd Gallery, 1975), p. 117 and repro. on p. 118.

15. Sheon, *Monticelli*, pp. 29–30. See also André Gouirand, *Les Peintres provençaux* (Paris: Soc. d'éditions littéraires et artistiques, 1901), p. 20, and Alauzen, *La Peinture en Provence*, pp. 181–82, who describes his relationship with Roqueplan, and also with Diaz, a major figure in the rococo revival. In his exhibition catalogue *Loubon* (Marseille: Musée des Beaux-Arts, 1974), Henri Wytenhove has suggested that in such paintings as *Madame Loubon à l'ombrelle* (fig. 10), Loubon prefigures Monet's *Femmes au jardin* of 1867 (Musée d'Orsay). Finally, Venturi notes Loubon's influence on Cézanne: see Lionello Venturi, *Cézanne* (New York: Rizzoli, 1978), p. 55.

16. Sheon, *Monticelli*, p. 43; see also Marius Chaumelin, *Les Trésors d'art de la Provence exposés à Marseille en 1861* (Paris: Jules Renouard, 1862), pp. 252–53.

17. Alauzen, *La Peinture en Provence*, pp. 185–86; on Grésy, see also Etienne Parrocel, *Annales de la peinture* (Paris: Ch. Albessard et Berard, 1862), pp. 319 and 463; and Jean-Louis Vaudoyer, *Les Peintres provençaux de Nicolas Froment à Paul Cézanne* (Paris: La Jeune Parque, 1947), p. 103.

18. Alauzen, *La Peinture en Provence*, p. 186, proposes Grésy's prefigurement of Cézanne. Grésy gave this large canvas to the Musée des Beaux-Arts, Marseille, in 1854. Duncan, *Pursuit of Pleasure*, p. 52 and fig. 34, discusses Fantin-Latour's fantasies of nymphs in a similar light.

19. Sheon, *Monticelli*, p. 13n. 2 cites Jules Charles-Roux, *Souvenir du passé: Le Cercle artistique de Marseille* (Paris: Lemerre, 1906), p. 193. Sheon's discussion of Monticelli's role in the rococo revival is traced in chapters II through IV. See also André Alauzen and Pierre Ripert, *Monticelli: Sa Vie et son oeuvre* (Paris: Bibliothèque des Arts, 1969), pp. 123–56.

20. Alauzen and Ripert, *Monticelli*, figs. 53 and 71.

21. Sheon, *Monticelli*, pp. 41–44, 63–80. But as the critic Guigou (not the painter) would later point out, Monticelli's "fantaisies lyriques et féeriques" were rooted, above all, in his view of nature: "c'est la Nature réelle qui fournissait à Monticelli l'excitation première; c'est en elle qu'il ramassait le plus souvent la matière de ses créations." His "mirage splendide" combined, as would Cézanne's later works, a debt to tradition and to direct observation of nature. See Paul Guigou, *Adolphe Monticelli* (Paris: Boussod, Valadon et Cie, 1890), p. 8.

22. John Rewald, *Paul Cézanne: A Biography* (New York: Abrams, 1986), p. 146.

23. Hugh Quigley, *The Land of the Rhone: Lyons and Provence* (Boston: Houghton Mifflin, 1927), pp. 241–43.

24. Quigley, *Land of the Rhone*, p. 251.

25. Jules Valles, *Littérature et révolution*, ed. R. Bellet (Paris, 1969), pp. 140–41, cited in Frederic W. Hemmings, *The Life and Times of Emile Zola* (London: Elek, 1977), p. 49.

26. Sheon, *Monticelli*, pp. 24ff.

27. Robert Ratcliffe, "Cézanne's Working Methods and Their Theoretical Background," Ph.D. diss., Univ. of London, 1960; and Theodore Reff, "The Pictures Within Cézanne's Pictures," *Arts Magazine* 53 (June 1979): 90–104.

28. Michael Komanecky, "A Perfect Gem of Art," in *The Folding Image: Screens by Western Artists of the Nineteenth and Twentieth Centuries*, exh. cat. (New Haven: Yale Univ. Art Gallery, 1984), pp. 43–45. According to Wally Findlay, the screen's present owner, the verso panels have disappeared. See Edgar Munhall, *Paul Cézanne: "Les Environs d'Aix-en-Provence"* (New York: Wally Findlay Galleries, 1974), n.p.

29. Reff, "The Pictures within Cézanne's Pictures," p. 97n. 36. Reff's argument that Cézanne drew on engravings of two Lancret paintings (Georges Wildenstein, *Lancret* [Paris: G. Servant, 1924], cat. nos. 320 and 321) and then "greatly simplified" them in his work is not entirely convincing when the works are compared.

30. Komanecky, *Folding Image*, p. 43. Unfortunately, Cézanne's *Le Baigneur au rocher*, now in the collection of the Chrysler Museum, Norfolk, Virginia, has been cut away from the delicate landscape that once surrounded it. On the landscape see Munhall, *"Environs,"* but his suggestion that the facades in the left-most panel include that of the Jas de Bouffan seems doubtful.

31. Sheon, *Monticelli*, pp. 71–72. On this, see also Lawrence Gowing, "Notes on the Development of Cézanne," *The Burlington Magazine* 98 (June 1956): 188.

32. On this painting and its problematic subject matter (and title), see Margaret Morgan Grasselli and Pierre Rosenberg, *Watteau 1684–1721*, exh. cat. (Washington, D.C.: National Gallery of Art, 1984), cat. no. 61, pp. 396–406, esp. biblio., pp. 401–6. On its sources in past art, see esp. Oliver Banks, *Watteau and the North: Studies in the Dutch and Flemish Baroque Influence on French Rococo Painting* (New York: Garland, 1977), pp. 227ff.

33. Donald Posner, "The Poetry of the Fêtes-Galantes," in *Antoine Watteau* (London: Weidenfeld & Nicholson, 1984), pp. 151ff. My discussion of the tradition is indebted to Posner.

34. Posner, "Fêtes-Galantes."

35. Auguste Rodin, *On Art and Artists*, trans. Paul Gsell (New York: Philosophical Library, 1957), pp. 95–98; French ed. (1911) cited in Grasselli and Rosenberg, *Watteau*, pp. 400–401.

36. Linda Nochlin, *Realism* (Harmondsworth, Middlesex: Penguin, 1971), pp. 145–47.

37. Interestingly, however, both paintings included the traditional motif of the promenade.

38. Anne Coffin Hanson, *Manet and the Modern Tradition* (New Haven: Yale Univ. Press, 1977), p. 94. See also Fried, "Manet's Sources," pp. 40–43.

39. Similarly, Sheon, *Monticelli*, p. 26 and fig. 34, has described Tissot's *Partie carrée* (The Saint Louis Art Museum) as an academic revival of the rococo.

40. For a recent and more psychoanalytical reading of this painting, see Mary Louise Krumrine, "Parisian Writers and the Early Work of Cézanne," in Lawrence Gowing, *Cézanne: The Early Years, 1859–1872*, exh. cat. (London: Royal Academy of Arts, 1988), esp. pp. 25–27.

41. Alec Brown, introduction to Emile Zola, *Madeleine Férat*, trans. Alec Brown (London: Elek Books, 1957), p. 7.

42. Rewald, *Cézanne* (1986), p. 37.

43. Rewald, *Cézanne* (1986), pp. 37–38. Zola notes that Cézanne sketched the spot, but the drawing has not been identified.

44. Zola, *Férat*, p. 94.

45. Zola, *Férat*, p. 19.

46. Zola, *Férat*, p. 15. The original text (Paris: Librairie Internationale, 1868), pp. 3–4:

Madeleine touchait à sa vingtième année. Elle portait une toilette très-simple d'étoffe grise, relevée par une garniture de rubans bleus . . . ses admirables cheveux d'un roux ardent. . . . C'était une grande et belle fille, dont les membres souples et forts annonçaient une rare énergie. . . .

Guillaume avait cinq ans de plus que Madeleine. C'était un garçon grand et maigre, d'allure aristocratique. Son visage long, aux traits amincis, eût été laid sans la pureté du teint et la hauteur du front. . . . Légèrement courbé, il parlait avec des gestes hésitants.

47. Zola, *Férat*, pp. 94–95. In the original, pp. 97–98:

Et ils reprenaient alors leur promenade attendrie, goûtant un nouveau charme dans ce silence et cette fraîcheur. . . . La jeune femme apportait toujours quelques fruits. Elle sortait de son rêve, et mangeait ses provisions à belles dents, faisant mordre son amant dans ses pêches et ses poires. Guillaume s'émerveillait à la voir devant lui; chaque jour, elle lui semblait d'une beauté plus éclatante.

48. Zola, *Férat*, p. 18.

49. This is a reference to Guillaume's and Madeleine's daughter, Lucie. Brown,

introduction to *Férat*, pp. 9ff., discusses Zola's remarkably unscientific views on heredity.

50. Discussed by Theodore Reff, "Painting and Theory in the Final Decade," in William Rubin et al., *Cézanne: The Late Years*, exh. cat. (New York: The Museum of Modern Art, 1977), p. 21, as an image suggesting "a melancholy resignation."

51. Zola, *Férat*, p. 74.

52. Krumrine, "Parisian Writers," p. 26, has noted in this figure "a striking resemblance" to Cézanne's elder sister, Marie, as she appears in *Jeune Fille au piano* (pl. IX). But Gowing has suggested other possible identifications for the *Tannhäuser* figure and thus leaves open the question of who is portrayed in *Le Déjeuner sur l'herbe* (*The Early Years*, p. 158).

53. Yale Univ. Art Gallery, gift of Mr. and Mrs. Paul Mellon, 1983. See *Yale University Art Gallery Bulletin* (Fall 1984): 50.

54. Meyer Schapiro, "The Apples of Cézanne: An Essay on the Meaning of Still-life," in *Modern Art, 19th & 20th Centuries: Selected Papers* (New York: George Braziller, 1979), pp. 1–5; originally published in *Art News Annual* 34 (1968): 34–53.

55. See Albert Boime's discussion of the motif in Couture's *Les Romains de la décadence* (see fig. 100) in *Thomas Couture and the Eclectic Vision* (New Haven: Yale Univ. Press, 1980), p. 143.

NOTES TO CHAPTER VI

1. See Cézanne's letter to Huot, 4 June 1861, in John Rewald, ed., *Paul Cézanne: Letters* (New York: Hacker Art Books, 1976), pp. 84–87.

2. John Rewald, *Paul Cézanne: A Biography* (New York: Abrams, 1986), p. 54; on pp. 36–37, Rewald compares a Courbet landscape with one by Cézanne.

3. Lionello Venturi, *Cézanne* (New York: Rizzoli, 1978), p. 62.

4. Patricia Mainardi, *Art and Politics of the Second Empire: The Universal Expositions of 1855 and 1867* (New Haven: Yale Univ. Press, 1987), pp. 89ff. My discussion of genre painting in the 1860s is indebted to Patricia Mainardi, Gabriel Weisberg, and Linda Nochlin.

5. On this purchase and its effect, see Mainardi, *Art and Politics*, p. 91.

6. Mainardi, *Art and Politics*, p. 119; see also Gabriel Weisberg and Petra Ten Doesschate-Chu, *The Realist Tradition: French Painting and Drawing 1830–1900*, exh. cat. (Cleveland: Cleveland Museum of Art, 1980), p. 41.

7. Mainardi, *Art and Politics*, p. 119, quoted and trans. from Jules Castagnary, *Salons 1857–1870*, 2 vols. (Paris: G. Charpentier et E. Fasquelle, 1892), 1:3.

8. Mainardi, *Art and Politics*, pp. 163–64; Théophile Thoré, *Salons de W. Bürger, 1861 à 1868*, 2 vols. (Paris, 1870), 2:371.

9. Mainardi, *Art and Politics*, pp. 175–76.

10. Mainardi, *Art and Politics*, pp. 168–69, quoted from Ernest Chesneau, *Les Nations rivales dans l'art* (Paris: Didier, 1868), pp. 242–44.

11. Unknown to Venturi, this painting was first exhibited at the Galerie Lucien Blanc, Aix-en-Provence, July 1953, no. 21. It was sold at Christie's, London, 11 April 1972, no. 46.

12. Linda Nochlin, *Realism* (Harmondsworth, Middlesex: Penguin, 1971), pp. 90–92.

13. Compare fig. 54, for example, with V. 78 or V. 89, generally acknowledged to be portraits of his sister Marie.

14. For a thorough discussion of the role of ex-votos in popular art and religion, see Jean Cuisenier's discussion of them in *French Folk Art*, trans. T. W. Lyman (Tokyo: Kodansha, 1977), pp. 97–112.

15. Lawrence Gowing, *Cézanne: The Early Years, 1859–1872*, exh. cat. (London: Royal Academy of Arts, 1988), p. 80.

16. On these holy water fonts, see *Religions et traditions populaires*, exh. cat. (Paris: Musée National des Arts et Traditions Populaires, 1979), cat. nos. 306–10, p. 100.

17. For example, Gauguin's *Le Christ jaune* or his *Bretonne en prière*, in Georges Wildenstein, *Gauguin* (Paris: Les Beaux-Arts, 1964), cat. nos. 327 and 518. As Merete Bodelsen has pointed out, Gauguin even adapted genre figures from Cézanne's Poussinesque landscape, *La Moisson* (V. 249, priv. coll.), in studies for a fan design and on a ceramic vase. See Merete Bodelsen, "Gauguin's Cézannes," *The Burlington Magazine* 104 (May 1962): 204–11 and figs. 44–47.

18. Quoted from Robert Rosenblum, introduction, *The Past Rediscovered: French Painting 1800–1900*, exh. cat. (Minneapolis: Minneapolis Institute of Arts, 1969), n.p.; and Nochlin, *Realism*, p. 92.

19. See *Christian Imagery in French Nineteenth-Century Art 1789–1906*, exh. cat. (New York: Shepherd Gallery, 1980), cat. no. 106, p. 288.

20. Nochlin, *Realism*, p. 90.

21. On Feyen-Perrin, see Weisberg, *Realist Tradition*, p. 180 and fig. 183; and Elizabeth Johns, *Thomas Eakins: The Heroism of Modern Life* (Princeton: Princeton Univ. Press, 1983), pp. 72–73.

22. See Ellwood Perry III, "*The Gross Clinic* as Anatomy Lesson and Memorial Portrait," *Art Quarterly* 32, no. 4 (Winter 1969): 380 and fig. 9. For Feyen-Perrin's influence on Thomas Eakins's much later paintings of autopsies, see Johns, *Eakins*, p. 73 and n. 57.

23. Mary Louise Krumrine, "Parisian Writers and the Early Work of Cézanne," in Gowing, *The Early Years*, pp. 22–31, citation on p. 22.

24. Roger Fry noted that "without losing all air of verisimilitude, these people look like diabolical maniacs engaged in eviscerating a corpse," in Roger Fry, *Cézanne: A Study of His Development* (London: L. & V. Woolf, 1927), p. 16.

25. Smith College Museum of Art, Northampton, Mass. Its subject was correctly identified by Hélène Toussaint in *Gustave Courbet 1819–1877*, exh. cat. (London: Royal Academy of Arts, 1978), cat. no. 24, pp. 97–99.

26. Géricault's realism here undoubtedly stems from his studies in the morgue. See *Christian Imagery*, p. 128.

27. Marius Roux, *Mémorial d'Aix*, 3 December 1865. As mentioned previously, with the publication in 1867 of Blanc's *Ecole espagnole*, Cézanne began to copy many engravings after the Spanish masters.

28. Albert Barnes and Violette de Mazia, *The Art of Cézanne* (New York: Harcourt Brace, 1939), p. 9. Gowing notes that this painting was exhibited in the Louvre beginning in 1869, *The Early Years*, p. 140.

29. For this and also for his discussion of Cézanne's art and theory in 1869, see Robert Ratcliffe, "Cézanne's Working Methods and Their Theoretical Background," Ph.D. diss., Univ. of London, 1960, pp. 315–19. On both Ribera paintings, see Musée National du Louvre, *Catalogue des peintures* (Paris: Musée du Louvre, 1926), cat. nos. 1722 and 1725A, pp. 162–63.

30. This Ribera composition, formerly in the Gemäldegalerie, Dresden, but lost during World War II, was known through its many copies. See Craig Felton, *Jusepe de Ribera: A Catalogue Raisonné*, 2 vols. (Ann Arbor, Mich.: UMI, 1983), 2:514, x-249.

31. Gowing, *The Early Years*, p. 13.

32. *Ingres and Delacroix through Degas and Puvis de Chavannes: The Figure in French Art 1800–1870*, exh. cat. (New York: Shepherd Gallery, 1975), p. 336.

33. Weisberg, *Realist Tradition*, p. 124.

34. Fry, *Cézanne*, p. 25.

35. For the fullest discussion of the influence of Dutch painting on nineteenth-century French art, see Petra Ten Doesschate-Chu, *French Realism and the Dutch Mas-*

ters (Utrecht: Haentjens Dekker & Gumbert, 1974), and in particular, on the accessibility of Dutch paintings, pp. 2–8. See also Stanley Meltzoff, "Nineteenth-Century Revivals," master's thesis, Institute of Fine Arts, New York Univ., 1941.

36. See Peter C. Sutton, *Pieter de Hooch* (Ithaca: Cornell Univ. Press, 1980), p. 72n. 35. Sutton points out that since Hegel's discussion of Dutch painting appeared in his *Vorlesungen über die Aesthetik* (1832), Dutch painting has served as the classic example for the idea that a causal relationship exists between social and environmental factors and style in art. This is disputed by Doesschate-Chu, *French Realism*, p. 34.

37. Doesschate-Chu, *French Realism*, pp. 33–34, 39.

38. Bruno Ely in Denis Coutagne et al., *Cézanne au Musée d'Aix* (Aix-en-Provence: Musée Granet, 1984), p. 192.

39. Theodore Reff, "Cézanne's *Cardplayers* and Their Sources," *Arts Magazine* 55, no. 3 (November 1980): n. 53.

40. Reff, "*Cardplayers*," p. 115.

41. Repro. in J. Davidson, *David Teniers the Younger* (Boulder, Colo.: Westview Press, 1979), pl. 24.

42. Reff, "*Cardplayers*," p. 115.

43. Doesschate-Chu, *French Realism*, p. 36.

44. Courbet's and Manet's versions, both in the Metropolitan Museum of Art, New York, are only the best-known examples of this subject, popular in the 1860s. Bouguereau's saccharine *L'Oiseau chéri* of 1867 is also part of this general tradition but, like many of his genre paintings, probably derives from his study of popular imagery. See *William Bouguereau*, exh. cat. (Paris: Musée du Petit Palais, 1987), figs. 87 and 88. Renoir, Mary Cassatt, Eva Gonzales, and countless other artists would subsequently treat the theme.

45. Mona Hadler, "Manet's *Woman with a Parrot* of 1866," *Metropolitan Museum of Art Journal* 7 (1973): 118.

46. On Van Mieris's problematic imagery and the motif's many meanings, see O. Naumann, *Frans van Mieris (1635–1681) The Elder*, 2 vols. (Doornspijk, Neth.: Davaco, 1981), vol. 1, p. 95 and vol. 2, p. 69; cat. nos. 1:54, 2:54.

47. On the erotic significance of birdcages in Dutch painting, see E. de Jongh, "Erotica in Vogelperspectief. De dubbel-zinnigheid van een reeks 17de eeuwse genrevoorstellingen," *Simiolus* 3 (1968–1969): 43–52 and figs. 19, 21, 23, and 24.

48. For Boucher's version, see Alexandre Ananoff, *François Boucher* (Lausanne:

Bibliothèque des Arts, 1976), vol. 1, p. 225n. 94. On Raoux's pendants, see Eric M. Zafran, *The Rococo Age*, exh. cat. (Atlanta: High Museum of Art, 1983), cat. no. 41, pp. 109–10.

49. In *Cézanne au Musée d'Aix*, pp. 178–80.

50. Rewald, *Cézanne* (1986), p. 13.

51. W. Bürger [Théophile Thoré], "Van der Meer de Delft," *Gazette des beaux-arts* 21 (1866): 297–330, 458–70, and 542–75.

52. Bonvin's watercolor copy of the painting, which is now attributed to Pieter Janssens Elinga (Alte Pinakothek, Munich), is in the Metropolitan Museum of Art, New York; repro. in Gabriel Weisberg, *Bonvin* (Paris: Editions Geoffroy-Dechaume, 1979), cat. no. 329.

53. Doesschate-Chu, *French Realism*, p. 38.

54. V. 9. For the de Hooch, see Sutton, *de Hooch*, cat. no. 141, fig. 144.

55. Fry, *Cézanne*, p. 25.

56. Wayne Andersen, "Cézanne's Portrait Drawings from the 1860s," *Master Drawings* 5, no. 3 (Fall 1967): 276–78.

57. Andersen, "Portrait Drawings," p. 278. The painting, now in the collection of the Museu de Arte, São Paulo, is dated ca. 1869–1870.

58. See, for example, Nicholaes Maes's *Housewife at Work* in the Wallace Collection, London.

59. Gowing, *The Early Years*, p. 156. Also, see de Hooch's similar use of it in Sutton, *de Hooch*, figs. 68, 71, 79, and 156–58.

60. For the fullest discussion of this painting and of the two versions that preceded it, see in particular Alfred H. Barr, Jr., "Cézanne: In the Letters of Marion to Morstatt, 1865–1868: Chapter III, Cézanne and Wagner," trans. Margaret Scolari, *Magazine of Art* 31 (May 1938): 288–91.

61. Barr, "Marion to Morstatt," p. 289.

62. See, for example, Emanuel de Witte's *Femme au clavecin*, 1665, Museum Boymans-Van Beuningen, Rotterdam.

63. Doesschate-Chu, *French Realism*, p. 47n. 4; Thoré, "Van der Meer de Delft," p. 469.

64. Vermeer's painting is now in the collection of the National Gallery, London.

65. See, for example, Bonvin's obviously Dutch-inspired drawing of 1860, *Woman at the Spinet* (Butkin Collection, Cleveland; repro. Weisberg, *Bonvin*, fig. 264), which is a sketch of his wife and early study for his painting *The Spinet* of 1862 (Burrell Collection, Glasgow; repro. Weisberg, *Bonvin*, fig. 32). In the painting,

however, the composition was substantially altered. Renoir's painting on the theme, *Femme au piano* (1875, Art Institute of Chicago), is less Dutch in inspiration, but the popular painter Alfred Stevens's later portrait of *Eva Gonzales au piano* of 1879 (Ringling Museum, Sarasota) renews the Dutch spirit of the motif.

66. Rewald notes that when Whistler's painting was rejected at the Salon of 1859, he was invited by Bonvin to exhibit it in Bonvin's studio, where it was admired, among others, by Courbet. John Rewald, *The History of Impressionism* (New York: The Museum of Modern Art, 1973), p. 32.

67. Doesschate-Chu, *French Realism*, p. 47.

68. Françoise Cachin and Charles S. Moffett, *Manet*, exh. cat. (New York: The Metropolitan Museum of Art, 1983), p. 287.

69. Fritz Novotny, "Zu einer 'Kopie' von Cézanne nach Ostade," *Pantheon* 25, no. 4 (July–August 1967): 276–80, repro. On van Ostade's influence in the nineteenth century, see Doesschate-Chu, *French Realism*, pp. 38–39, 67–69.

70. Emile Bernard, *Souvenirs sur Paul Cézanne, une conversation avec Cézanne* (Paris: Michel, 1926), p. 50.

71. Lawrence Gowing, lecture at symposium for *Cézanne: The Late Years*, Museum of Modern Art, New York, October 1977.

72. Bob Kirsch, "Paul Cézanne: *Jeune Fille au piano* and Some Portraits of His Wife. An Investigation of His Painting of the Late 1870s," *Gazette des beaux-arts* 110 (July–August 1987): 21–26.

73. Castagnary, *Salons*, 1:3, cited and trans. in Mainardi, *Art and Politics*, p. 119.

NOTES TO CHAPTER VII

1. Essay by Guy Cogeval, *From Courbet to Cézanne, A New Nineteenth Century: Preview of the Musée d'Orsay, Paris*, exh. cat. (Paris: Editions de la réunion des musées nationaux, 1986), 86–87.

2. Richard Thomson, review of the exhibition *Cézanne: The Early Years, 1859–1872*, "Greedy for Images," *Times Literary Supplement*, 6–12 May 1988, p. 504.

3. John Rewald notes this gift in his *Paul Cézanne: A Biography* (New York: Abrams, 1986), p. 79.

4. See, for example, *An Exhibition of Paintings by Cézanne*, exh. cat. (Edinburgh: The Royal Scottish Academy, 1965), cat. no. 4.

5. Gustave Kahn, "L'Art français à l'exposition," *La Vogue* 2 (1889): 131. I am grateful to Charles F. Stuckey and Lawrence Gowing for this reference.

6. Especially popular in the nineteenth century was a tale recounted in canto 10, in which the hero, Roger, comes to the rescue of the fair Angelica on his magical hippogriff. Ingres's most famous painting on the theme, of ca. 1830, is in the National Gallery, London. Another version, n.d., is in the Louvre, and a late painting of 1859 in the Museu de Arte, São Paulo, was exhibited in Paris in 1867 at the Ecole des Beaux-Arts. For all of Ingres's Roger and Angelica paintings, see Patricia Condon, *In Pursuit of Perfection: The Art of J.-A.-D. Ingres*, exh. cat. (Louisville, Ky.: J. B. Speed Art Museum, 1984), cat. no. 35, pp. 94ff. and 238. For Delacroix's, see Lee Johnson, *The Paintings of Eugène Delacroix* (Oxford: Clarendon Press, 1984), vol. 3, cat. nos. 324, 339, and 340. A modern viewer could easily confuse the subject of Cézanne's three drawings (Ch. 83, 84, and 499) after Pierre Puget's *Persée délivrant Andromède* in the Louvre with the closely related story of Roger and Angelica from *Orlando Furioso*. As dramatized by Euripides and recounted by Ovid (*Metamorphoses* 4), Perseus also rescued the beautiful Andromeda from a rock where she was exposed to a ravaging sea monster. But, although all three of Cézanne's studies were executed before Kahn's remark in 1889, it is doubtful that any of them could be the source of his speculations. Cézanne's drawings were virtually unknown before the late 1890s, and, as Chappuis notes, were treated then with "a hint of indulgence" even by those close to the artist (pp. 9–10). Except for early sketches in his letters, few drawings had left the artist's possession by 1889; therefore it is highly unlikely that Kahn could have seen his copies after Puget. On the relationship between the two stories, see Robert Rosenblum, *Ingres* (New York: Abrams, 1985), p. 138; on Cézanne's appreciation of Puget, see Joachim Gasquet, *Cézanne* (Paris: Bernheim-Jeune, 1926), p. 191. Finally, Roger and Angelica were depicted by Bayre, Doré, and Redon, among others.

7. On Kahn and Zola, see J. C. Ireson, *L'Oeuvre poétique de Gustave Kahn* (Paris: Nizet, 1962), p. 617. Much later, Kahn would become the vice president of the literary society Amis de Zola and call Zola's work "la plus représentative du roman français moderne et le plus clair miroir de son temps" (*Bulletin de la société littéraire des "Amis d'Emile Zola"* [1932]: 6n. 16).

8. The most famous example would be Cézanne's *Annibalis somnium* (*Songe d'Annibal*), written by the artist in a letter to Zola of 23 November 1858. See John Rewald, ed., *Paul Cézanne: Letters* (New York: Hacker Art Books, 1976), pp. 351–53.

9. Meyer Schapiro, "The Apples of Cézanne: An Essay on the Meaning of Still-life," in *Modern Art, 19th & 20th Centuries: Selected Papers* (New York: George Braziller, 1979), pp. 34–53.

10. RWC 145, repro. p. 20. See pp. 119–20 for a discussion of which Delacroix

version Cézanne may have copied. Giula Ballas has suggested that Cézanne used a lithograph of the painting in the Lille museum, which was published in 1838 in *L'Artiste*. See Giula Ballas, "Paul Cézanne et la revue *L'Artiste*," *Gazette des beaux-arts* sér. 6, 98 (December 1981): 224 and n. 16.

11. RWC 1, repro. The Cicero drawing illustrated a long parodic verse in a letter to Zola of 1858. See Rewald, *Letters*, pp. 14–15. For the Aeneas, see RWC 43, repro.; and for the *Jugement de Pâris*, see Rewald, *Cézanne* (1986), p. 41. On the classical form of Cézanne's *Jugement de Pâris*, see Roger Fry, *Cézanne: A Study of His Development* (London: L. & V. Woolf, 1927), p. 24.

12. Quoted in Schapiro, "Apples," p. 2, from Paul Gauguin, *Lettres à sa femme et à ses amis*, ed. M. Malingue (Paris: Bernard Grasset, 1946), p. 45, letter to Emile Schuffenecker, 14 January 1885.

13. Rewald, *Cézanne* (1986), p. 79.

14. Ovid, *Metamorphoses*, trans. F. J. Miller (Cambridge: Harvard Univ. Press, 1944), 5.5.

15. RWC 30, p. 90.

16. Ovid, *Metamorphoses* 5.5.

17. Sara Lichtenstein suggests that Delacroix's painting *Hercule étouffant Antée* may have provided Cézanne with a prototype for the two central figures in his painting, but his watercolor studies argue against this. See Sara Lichtenstein, "Cézanne and Delacroix," *The Art Bulletin* 46 (March 1964): 57. Jean Adhémar has linked Cézanne's work to Daumier's sketch entitled *Le Baiser* or *Adam et Eve* of ca. 1850, but Daumier's hero is clearly trying only to support a fainting female figure; in contrast, Cézanne's protagonist carries her off. See Jean Adhémar, *Daumier: Dessins et aquarelles* (Paris: Braun, 1954), p. 18 and fig. 8.

18. Ratcliffe has suggested that this figure was influenced by the Christ in Delacroix's mural *Mise-au-tombeau* at St. Denis-du-Saint-Sacrement, Paris, which Cézanne also knew from an engraving he copied that was reproduced in *L'Artiste*. See Ch. 167 and p. 84.

19. Ovid, *Metamorphoses* 5.398.

20. D. G. Rosetti, *Art Journal* (1892): 251–52, quoted in *The Pre-Raphaelites*, exh. cat. (London: Tate Gallery, 1984), p. 232.

21. See Abraham Bredius, *Rembrandt: The Complete Edition of the Paintings*, 3d ed.; rev. Horst Gerson (London: Phaidon, 1969), Br. 463.

22. Ovid, *Metamorphoses* 5.425–37.

23. Ovid, *Metamorphoses* 5.465–70.

24. On the subject of Proserpina at Fontainebleau see *The Age of Correggio and the Carracci: Emilian Painting in the Sixteenth and Seventeenth Centuries*, exh. cat. (Washington, D.C.: National Gallery of Art, 1986), p. 52; and for a related image, see Jean Mignon's engraving after a design by Luca Penni, reproduced in Henri Zerner, *The School of Fontainebleau: Etchings and Engravings* (London: Thames and Hudson, 1969), fig. J.M. 32.

25. Ch. pp. 93–94; he cites specifically Theodore Reff, "Copyists in the Louvre, 1850–1870," *The Art Bulletin* 46 (December 1964): 555, and Wayne Andersen, *Cézanne's Portrait Drawings* (Cambridge: MIT Press, 1970), p. 268.

26. Rewald, *Cézanne* (1986), p. 267. Rewald notes that the next April, in 1864, Cézanne began to copy Poussin's *Les Bergers d'Arcadie* in the Louvre.

27. Ovid, *Metamorphoses* 5.409–10. Originally a nymph and attendant of Diana, Arethusa escaped the pursuit of the river god Alpheus through a secret passage Diana opened under the earth and sea and then rose again in Sicily. Arethusa is also sometimes shown in a pool of water with the grieving Ceres, who listens to her sad story. See, for example, the Master L. D.'s etching of the two together, reproduced in *L'Ecole de Fontainebleau*, exh. cat. (Paris: Grand Palais, 1972), p. 311, fig. 397.

28. See Timothy J. Clark, *The Painting of Modern Life* (New York: Knopf, 1985), pp. 116–31.

29. Repro. in Clark, *Modern Life*, p. 118, fig. 40, and p. 120, fig. 42.

30. *The Second Empire 1852–1870: Art in France under Napoléon III*, exh. cat. (Philadelphia: Philadelphia Museum of Art, 1978), p. 263.

31. Letter to Joseph Huot dated 4 June 1861, Rewald, *Letters*, pp. 84–87; Rewald, *Cézanne* (1986), p. 40.

32. Although Rubens's painting would not be acquired by the Louvre until after 1914, Cézanne's nude is so close as to suggest he knew Rubens's design from other sources or from a reproduction. See Leo Steinberg, "Resisting Cézanne: Picasso's *Three Women*," *Art in America* 66 (November 1978): 132n. 16. On Rubens's painting, see A. Roy, *Le XVIIᵉ siècle flamand au Louvre, Histoire des collections*, Les Dossiers du département des peintures (Paris: Musée du Louvre, 1977), pp. 44–45. Finally, Bruno Ely has linked the *Nymphe et tritons* to Greuze's painting of *Le Triomphe de Galatée* in the Musée Granet in Aix, in Denis Coutagne et al., *Cézanne au Musée d'Aix* (Aix-en-Provence: Musée Granet, 1984).

33. On Delaunay's painting, see *The Second Empire*, p. 295.

34. For the most recent discussion of this reaction in 1867, see Patricia Mainardi,

Art and Politics of the Second Empire: The Universal Expositions of 1855 and 1867 (New Haven: Yale Univ. Press, 1987), pp. 151–57.

NOTES TO CHAPTER VIII

A slightly revised version of this chapter was published as "Literature, Music, and Cézanne's Early Subjects" in Lawrence Gowing, *Cézanne: The Early Years, 1859–1872*, exh. cat. (London: Royal Academy of Arts, 1988), pp. 32–40.

1. For the fullest discussion of the theme's revival, see Albert Boime, *Thomas Couture and the Eclectic Vision* (New Haven: Yale Univ. Press, 1980), pp. 143–52 and 165–68.

2. Théophile Gautier, "Bowl of Punch," *The Complete Works of Théophile Gautier*, trans. and ed. F. C. de Sumichrast, 12 vols. (London: Postlethwaite, Taylor and Knowles, 1909), 11:326.

3. Gustave Doré, who designed the costumes for Offenbach's *Orphée aux enfers*, later recorded the final orgy on canvas. See Alexander Faris, *Jacques Offenbach* (London and Boston: Faber and Faber, 1980), p. 65, fig. 6, for an engraving after Doré's painting. For a discussion of the operetta's orgy and its popular success, see pp. 63–72.

4. For example, Cézanne's *Songe d'Annibal*, published in John Rewald, ed., *Paul Cézanne: Letters* (New York: Hacker Art Books, 1976), pp. 351–53. For the best discussion of Cézanne's *Le Punch au rhum* and related works, see RWC, pp. 90–91.

5. Boime, *Couture*, p. 131.

6. See Wayne Andersen, "A Cézanne Drawing after Couture," *Master Drawings* 1, no. 4 (Winter 1963): 44–46.

7. On Couture's numerous pictorial sources for his *Romains*, see Boime, *Couture*, pp. 152–60.

8. Boime, *Couture*, p. 139.

9. Sara Lichtenstein, "Cézanne and Delacroix," *The Art Bulletin* 46 (March 1964): 57–58.

10. Théophile Gautier, "Les *Noces de Cana* de Paul Veronese" (1852), in *Souvenirs de théâtre, d'art et de critique* (Paris: G. Charpentier, 1883), pp. 205–14. On Delacroix's lost copies after details in Veronese's painting, see Lee Johnson, *The Paintings of Eugène Delacroix* (Oxford: Clarendon Press, 1981), vol. 1, p. 180. For Fantin-

Latour's copies, see Douglas Druick and Michel Hoog, *Fantin-Latour*, exh. cat. (Ottawa: National Gallery of Canada, 1983), pp. 164–66.

11. Joachim Gasquet, *Cézanne* (Paris: Bernheim-Jeune, 1926), pp. 163, 166ff.

12. RWC 23, pp. 87–88. Rewald also notes that two pieces of paper, one at the bottom center and a strip along the top, were pasted onto the original sheet to allow room for revisions. This would also suggest that the artist gradually altered his scheme to depict a specific setting.

13. See, for example, Musset's *Rolla* (1833) or *La Nuit de décembre* (1843), Hugo's "Noces et festins" from *Les Chants du crépuscule* (1835), cited by Boime, *Couture*, p. 166, or Gautier's *Les Jeunes-France* (1833), discussed above. On the orgy in Mistral's *Calendau*, see Rob Lyle, *Mistral* (New Haven: Yale Univ. Press, 1953), p. 26.

14. Theodore Reff, "Cézanne's *Dream of Hannibal*," first published in *The Art Bulletin* 45 (June 1963): 148–52; revised for *Cézanne in Perspective*, ed. Judith Wechsler (Englewood Cliffs, N.J.: Prentice-Hall, 1974), pp. 148–59.

15. Gustave Flaubert, *The Temptation of Saint Anthony*, trans. Kitty Mrosovsky (Ithaca: Cornell Univ. Press, 1981), pp. 81–82. From the original text:
Des colonnes, à demi perdues dans l'ombre tant elles sont hautes, vont s'alignant à la file en dehors des tables qui se prolongent jusqu'à l'horizon, . . . une vapeur lumineuse. . . . Les convives, couronnés de violettes, s'appuient du coude contre des lits très bas. Le long de ces deux rangs, des amphores qu'on incline versent du vin. . . . Les esclaves courent portant des plats. Des femmes circulent offrant à boire. . . . La clameur est si formidable qu'on dirait une tempête, et un nuage flotte sur le festin, tant il y a de viandes et d'haleines.

16. On the shadow plays produced by Henri Rivière at the Chat Noir, see William Ritter, "Henri Rivière," *Die graphischen Künste* 22 (1899): 112–16; cited by Theodore Reff, "Cézanne, Flaubert, St. Anthony, and the Queen of Sheba," *The Art Bulletin* 44 (June 1962): n. 97.

17. Mrosovsky, "Notes to the Translation," Flaubert, *Temptation*, pp. 248–52.

18. For example, John Martin's *Feast of Belshazzar*, repro. in William Feaver, *The Art of John Martin* (London: Oxford Univ. Press, 1975), pl. III. See also Andor Pigler, *Barockthemen* (Budapest: Akadémiai Kiadó, 1956), vol. 1, pp. 213–16.

19. For the fullest discussion of Flaubert's role in Cézanne's later *Tentation de Saint Antoine* paintings, see Reff, "Cézanne, Flaubert," pp. 119ff.

20. The publication in *L'Artiste* was thanks to Flaubert's friend Théophile Gautier. The entire second version was published in 1908 by Louis Bertrand under the title *La Première Tentation de Saint Antoine*. On the three versions, see Mrosovsky, introduction to Flaubert, *Temptation*, pp. 12–18.

21. Giula Ballas, "Paul Cézanne et la revue *L'Artiste*," *Gazette des beaux-arts* sér. 6, 98 (December 1981): 223–32.

22. See Jean Seznec, "The *Temptation of Saint Anthony* in Art," *Magazine of Art* 40 (1947): 86–93.

23. Mrosovsky, *Temptation*, p. 5. On Fantin-Latour's interest in the theme, which began in the 1860s and continued throughout his life, see Druick and Hoog, *Fantin-Latour*, p. 353. For Isabey's painting at the Salon of 1869, see sale cat., Hôtel Drouot, Paris, 21 May 1909, no. 26, repro.; cited in Reff, "Cézanne, Flaubert," n. 104.

24. Charles Baudelaire, *Oeuvres complètes*, ed. Claude Pichois, 2 vols. (Dijon: Gallimard, Bibliothèque de la Pleiade, 1975–1976), 2:86.

25. Flaubert to Louise Colet, 6 July 1852, in Enid Starkie, *Flaubert: The Making of the Master* (Harmondsworth, Middlesex: Penguin, 1971), p. 185.

26. See especially Sylvie Gache-Patin, "Douze Oeuvres de Cézanne de l'ancienne collection Pellerin," *La Revue du Louvre et des musées de France* no. 2 (1984): 130–33.

27. Tannhäuser, a medieval minstrel, gives himself up for a year to Venus and the pleasures of her realm. His consequent sensual debasement causes him to lose his true love, Elizabeth, when he attempts to return to earth. His sin is purged only by death. It was Wagner's extreme musical forms, rather than anything inherently riotous in the story, which he revived from a medieval legend, that was the source of controversy.

28. For the best study of Wagner's *Tannhäuser* in Paris, see Carolyn Abbate, "The Parisian *Tannhäuser*," Ph.D. diss., Princeton Univ., 1984. For a broader study of Wagner's reception in France, see Gerald Turbow, "Art and Politics, Wagnerism in France," in *Wagnerism in European Culture and Politics*, eds. David Large and William Weber (Ithaca: Cornell Univ. Press, 1984), pp. 134–66.

29. Abbate, "Parisian *Tannhäuser*," pp. 269–70. Programming the ballet in the second act ensured that it would be performed only after everyone had arrived at the opera. The custom had evolved in deference to Jockey Club members, who, after a leisurely dinner, expected to be entertained with dance upon their (late) arrival. For Wagner's account, see his letter to Liszt, 29 March 1860, in Richard Wagner, *Briefwechsel zwischen Wagner und Liszt*, ed. Erich Kloss (Leipzig, 1910), vol. 2, p. 279.

30. See Wagner's letter to Mathilde Wesendonck, Paris, 10 April 1860, in Herbert Barth et al., *Wagner: A Documentary Study* (New York: Oxford Univ. Press, 1975), pp. 193–94.

31. Charles Baudelaire, "Richard Wagner et *Tannhäuser* à Paris," in *Oeuvres complètes*, 2:814–15; first published May 1861.

32. Barbara E. White, *Renoir: His Life, Art, and Letters* (New York: Abrams, 1984), pp. 95–96; Jean Renoir, *Renoir: My Father*, trans. Randolph and Dorothy Weaver (Boston: Little, Brown, 1962), pp. 169–70.

33. See François Daulte, *Frédéric Bazille et son temps* (Geneva: Pierre Cailler, 1952), pp. 47, 78, and 94–95; John Rewald, *The History of Impressionism* (New York: The Museum of Modern Art, 1973), p. 116.

34. For Manet's painting, *Mme Manet au piano* of 1867–1868, see fig. 79. On her admiration of Wagner's music, see Françoise Cachin and Charles S. Moffett, *Manet*, exh. cat. (New York: The Metropolitan Museum of Art, 1983), pp. 286–87.

35. On the Wagner society in Marseille, see Oswald Georg Bauer, *Richard Wagner: The Stage Designs and Productions from the Premieres to the Present* (New York: Rizzoli, 1983), p. 147. Rewald, *Letters*, 23 December 1865, p. 103; cited by Rewald, *Impressionism*, p. 116. On Cézanne's appreciation of Wagner, see Alfred H. Barr, Jr., "Cézanne: In the Letters of Marion to Morstatt, 1865–1868: Chapter III, Cézanne and Wagner," trans. Margaret Scolari, *Magazine of Art* 31 (May 1938): 288–91.

36. Emile Zola, *L'Oeuvre* (Paris: F. Bernouard, 1928), p. 218, cited in Turbow, "Art and Politics," p. 153.

37. Quoted in Bauer, *The Stage Designs*, pp. 79–80.

38. Druick and Hoog, *Fantin-Latour*, p. 152.

39. Wagner's opera made the legend very popular and it became the subject of countless lyric poems, verse epics, short stories, novels, and dramas. On Tannhäuser's transformation by Wagner into a popular nineteenth-century hero, see John Wesley Thomas, *Tannhäuser: Poet and Legend* (Chapel Hill: Univ. of North Carolina Press, 1974), pp. 83ff.

40. Druick and Hoog, *Fantin-Latour*, pp. 152–53. See also Larry Curry, "Henri Fantin-Latour's *Tannhäuser on Venusberg*," *Los Angeles County Museum of Art Bulletin* 16, no. 1 (1964): 3–19.

41. Barth et al., *Wagner: A Documentary Study*, fig. 128. The gouache, which is signed "Eug. Delacroix," is in the collection of W. Coninx, Zurich. On the prose translations and the libretto, see Turbow, "Art and Politics," pp. 147–48, and Druick and Hoog, *Fantin-Latour*, pp. 152–53.

42. Richard Wagner, *Tannhäuser and the Minstrels*, trans. Mrs. John P. Morgan (Berlin: A. Fürstner, 1891), pp. 5–6. See also Antonio Livio, *Richard Wagner: L'Oeuvre lyrique* (Paris: Editions Le Chemin Vert, 1983), pp. 268–69, and for a discussion of the first act, pp. 263–65. The *Tannhäuser*'s frenetic bacchanal, which is choreographed on the banks of a lake, provides a fascinating analogy to Cézanne's

later scenes of riotous love in his *Lutte d'amour* paintings (for example, pl. xviii), of ca. 1880.

43. The subject of bathers had held only a minor place in his oeuvre up to this date, but Cézanne's dark palette here separates this painting from such works as V. 113, repro. in color in *The Early Years*, cat. no. 38.

44. See, for example, the stalactites in Michael Echter's illustration of the bacchanal setting from the Munich production of 1867 (Bauer, *The Stage Designs*, p. 68), which also had pink and blue lighting.

45. Charles Baudelaire, *The Painter of Modern Life and Other Essays*, ed. J. Mayne (London: Phaidon, 1970), p. 126; cited in Druick and Hoog, *Fantin-Latour*, p. 152. The pose of Cézanne's central figure, who bears his own likeness, may have also been inspired by Delacroix's meditative hero in his *Mort de Sardanapale* (Louvre). The Assyrian king is likewise surrounded by voluptuous nudes and confronted with his own gloomy fate.

46. Meyer Schapiro, "The Apples of Cézanne: An Essay on the Meaning of Still-life," in *Modern Art, 19th & 20th Centuries: Selected Papers* (New York: George Braziller, 1979), 8.

47. So identified by Guy Cogeval in *From Courbet to Cézanne, A New Nineteenth Century: Preview of the Musée d'Orsay*, exh. cat. (Paris: Editions de la réunion des musées nationaux, 1986), p. 45.

48. Wagner, *Tannhäuser*, p. 6.

49. Noted in the thirteenth episode of Wagner's plan for the opera scenario. See Abbate, "Parisian *Tannhäuser*," p. 291.

50. For Bernard's 1906 painting that vaguely echoes Cézanne's composition, see Jean-Jacques Luthi, *Emile Bernard, catalogue raisonné* (Paris: Editions Side, 1982), p. 104 and fig. 700; coll. Mme L. Horowitz, Paris .

51. Letter to Emile Bernard dated 12 May 1904, Rewald, *Letters*, p. 301.

NOTES TO CHAPTER IX

1. John Rewald, *The History of Impressionism* (New York: The Museum of Modern Art, 1973), pp. 185ff. and n. 59. In 1868 Pissarro exhibited two views of Pontoise, Monet showed his *Navires sortant des jetées du Havre*, Sisley, a landscape from Saint-Cloud, and Morisot, a landscape from Finistère. Cézanne's entry, no longer identifiable, was rejected.

2. Letter to Emile Zola dated 19 October 1866 in John Rewald, ed., *Paul Cézanne:*

Letters (New York: Hacker Art Books, 1976), pp. 112–13; see also Lawrence Gowing, *Cézanne: The Early Years, 1859–1872*, exh. cat. (London: Royal Academy of Arts, 1988), p. 15.

3. John Rewald, *Paul Cézanne: A Biography* (New York: Abrams, 1986), pp. 85–86. Rewald notes that Cézanne was a witness at Zola's wedding in Paris on 31 May 1870.

4. Gowing, *The Early Years*, p. 15.

5. Rewald, *Cézanne* (1986), pp. 86–91, quotes Marius Roux's letter to Zola on the efforts of the Aix authorities to find Cézanne, and Paul Alexis's letter to Zola on Cézanne's and Hortense Fiquet's departure from L'Estaque.

6. Gowing, *The Early Years*, p. 166. Cézanne's *Paysage provençal* (V. 54), though dated slightly earlier by Venturi, seems to have stylistic affinities with V. 51 and V. 54. Rewald also notes the manifestation of the artist's passionate temperament in the L'Estaque views, *Cézanne* (1986), pp. 93–94.

7. Meyer Schapiro, "The Apples of Cézanne: An Essay on the Meaning of Still-life," in *Modern Art, 19th & 20th Centuries: Selected Papers* (New York: George Braziller, 1979), p. 10.

8. Quoted in Jean Renoir, *Renoir: My Father*, trans. Randolph and Dorothy Weaver (Boston: Little, Brown, 1962), p. 106.

9. Quoted in Rewald, *Cézanne* (1986), p. 78.

10. Gowing, *The Early Years*, cat. no. 85, p. 214.

11. Theodore Reff, "Cézanne, Flaubert, St. Anthony, and the Queen of Sheba," *The Art Bulletin* 44 (June 1962): 121. See also Reff's "Cézanne: The Enigma of the Nude," *Art News* 58 (November 1959): 28.

12. This pose, and related gestures in Cézanne's early erotic images, are discussed in Leo Steinberg, "Resisting Cézanne: Picasso's *Three Women*," *Art in America* 66 (November 1978): 132n. 16. Given the equally powerful, strikingly similar image of aggressive female sexuality in Picasso's famous painting of prostitutes of 1906–1907, *Les Demoiselles d'Avignon*, it seems surprising that the vast literature on its myriad sources has dwelt so little on Cézanne's *Courtisanes* as a prototype. To my knowledge, the only suggestion of a direct connection is made by Mary M. Gedo in "Art as Exorcism: Picasso's *Demoiselles d'Avignon*," *Arts Magazine* 55 (October 1980): 74. Cézanne's painting would have been available to Picasso in Vollard's collection in Paris; the two works, moreover, are easily likened. Both exhibit a vertical orientation in the angular, left-most figures and background elements, which are countered by figures with more curving forms on the right. In each, a similar and provoc-

atively posed middle figure holds the viewer's attention and acts as a strong central pole in the composition. And the proffered glass in Cézanne's painting finds a parallel suggestion in Picasso's still life of fruit. Overall, the abrasive, formal evocation of a ferocious female sexuality put forth in the *Courtisanes* is reincarnated in much more violent form in Picasso's *Demoiselles*. Thus, while nearly every discussion of Picasso's famous prostitutes has linked them to the evocative images of Cézanne's bathers, and many to the early *Tentation de Saint Antoine* (and rightly so), Cézanne's *Courtisanes* represents a true turning point in Cézanne's method, and one that Picasso seems to have appreciated. In the same issue of *Arts Magazine*, see also Ron Johnson's "The *Demoiselles d'Avignon* and Dionysian Destruction," pp. 94–101. The most recent discussion of the sources for Picasso's painting is William Rubin's "La Genèse des *Demoiselles d'Avignon*," in *Les Demoiselles d'Avignon*, exh. cat., 2 vols. (Paris: Musée Picasso, 1988), 2:367–487.

13. Timothy J. Clark, "Preliminaries to a Possible Treatment of *Olympia* in 1865," *Screen* 21, no. 1 (Spring 1980): 18–41, and "Olympia's Choice" in *The Painting of Modern Life* (New York: Knopf, 1985), pp. 79–146; Susan Hollis Clayson, *Representations of Prostitution in Early Third Republic France* (Ann Arbor, Mich.: UMI, 1984). The literature on nineteenth-century prostitution and art is large. In his book Clark outlines the nineteenth-century critical reaction in extensive footnotes as part of his formulation of the underlying social and class issues such images evoke. Clayson's bibliography documents the twentieth-century interest in the subject. For a recent reassessment of such approaches, see Richard Shiff, "Art History and the Nineteenth Century: Realism and Resistance," *The Art Bulletin* 70, no. 1 (March 1988): 45–46.

14. On this, see Gowing, *The Early Years*, p. 150. Cézanne's later version (V. 225) is linked by Mary Louise Krumrine to Balzac's fictional painter Frenhofer in "Parisian Writers and the Early Work of Cézanne" in *The Early Years*, p. 28.

15. Clayson, *Prostitution*, p. 133.

16. From "Statement by Picasso: 1935" in Alfred H. Barr, Jr., *Picasso: Fifty Years of His Art* (New York: The Museum of Modern Art, 1946), p. 274.

17. On Cézanne's participation and reaction, see Rewald, *Cézanne* (1986), pp. 105–6. The most recent discussion of the 1874 exhibition is Paul Tucker's "The First Impressionist Exhibition in Context" in Charles S. Moffett et al., *The New Painting: Impressionism 1874–1886*, exh. cat. (San Francisco: The Fine Arts Museums of San Francisco, 1986), pp. 93–117.

18. These works have been identified by Richard Brettel in "The 'First' Exhibition of Impressionist Painters" in *The New Painting*, pp. 195–96.

19. For example, the often quoted response in 1874 of the critic Pierre Toloza: "Shall we mention Cézanne who, by the way, has his own legend? No known jury has ever, even in its dreams, imagined the possibility of accepting a single work by this painter, who came to the Salon carrying his paintings on his back, like Jesus Christ carrying his cross." *Le Rappel*, 20 April 1874, quoted in *The New Painting*, p. 126.

20. Georges Rivière's *L'Impressioniste, journal d'art* (14 April 1877), quoted by Rewald, *Cézanne* (1986), pp. 112–13.

21. Compare the central figure in *La Promenade* (V. 119), with the woman facing the viewer at center in the *Scène fantastique*.

22. See *The New Painting*, pp. 194 and 213.

23. See also Gowing's discussion of Cézanne, Venetian painting, and the pastoral tradition in *The Early Years*, p. 17, to which I am indebted.

24. Rewald, *Letters*, 30 April 1896, p. 244; pp. 253, 329, and 333.

25. Joachim Gasquet, "Cézanne, What He Said to Me," *The Leaflet* no. 3 (San Francisco: H. Gentry, 1931).

26. Rewald, *Letters*, 21 September 1906, p. 330.

27. Joachim Gasquet, *Cézanne* (Paris: Bernheim-Jeune, 1926), p. 94; Gowing quotes this (*The Early Years*, p.11) and suggests (p. 18) that it is not one of Gasquet's literary interpolations.

SELECT BIBLIOGRAPHY

For a complete listing of exhibitions that included the early work, see Lawrence Gowing, *Cézanne: The Early Years, 1859–1872,* exh. cat. (London: Royal Academy of Arts, 1988), p. 220.

I. CÉZANNE

Adler, Kathleen. "Camille Pissarro and Paul Cézanne: A Study of Their Artistic Relationship Between 1872 and 1885." *De Arte* 13 (April 1973): 19–25.

Adriani, Götz. *Paul Cézanne: Zeichnungen.* Exh. cat. Tübingen, Kunsthalle. Cologne: Dumont, 1978.

———. *Paul Cézanne, "Der Liebeskampf."* Munich: Piper, 1980.

———. *Paul Cézanne: Aquarelle.* Cologne: Dumont, 1981; English ed., New York: Abrams, 1983.

Andersen, Wayne. "A Cézanne Drawing after Couture." *Master Drawings* 1, no. 4 (Winter 1963): 44–46.

———. "Cézanne's Portrait Drawings from the 1860s." *Master Drawings* 5, no. 3 (Fall 1967): 276–78.

———. *Cézanne's Portrait Drawings.* Cambridge: MIT Press, 1970.

Arrouye, Jean. *La Provence de Cézanne.* Aix-en-Provence: Edisud, 1982.

Badt, Kurt. *The Art of Cézanne.* Translated by Sheila Ann Ogilvie. Berkeley: Univ. of California Press, 1965.

Ballas, Giula. "Paul Cézanne et la revue *L'Artiste.*" *Gazette des beaux-arts* sér. 6, 98 (December 1981): 223–32.

Barnes, Albert and Violette de Mazia. *The Art of Cézanne.* New York: Harcourt Brace, 1939.

Barr, Alfred H., Jr. "Cézanne: In the Letters of Marion to Morstatt, 1865–1868: Chapter III, Cézanne and Wagner." Translated by Margaret Scolari. *Magazine of Art* 31 (May 1938): 288–91.

Barskaia, Anna G. *Cézanne*. Leningrad: Aurora, 1975.

Bernard, Emile. *Souvenirs sur Paul Cézanne, une conversation avec Cézanne*. Paris: Michel, 1926.

Berthold, Gertrude. *Cézanne und die alten Meister*. Stuttgart: W. Kohlhammer, 1958.

Bettendorf, M. Virginia. "Cézanne's Early Realism: *Still Life with Bread and Eggs* Re-examined." *Arts Magazine* 56 (January 1982): 138–41.

Bodelsen, Merete. "Gauguin's Cézannes." *The Burlington Magazine* 104 (May 1962): 204–11.

Borely, J. "Cézanne à Aix (1902)." *L'Art vivant*, 1 July 1926, 491–93.

Burger, Fritz. *Cézanne und Hodler: Eine Einführung in die Probleme der Malerei der Gegenwart*. Munich: Delphin-Verlag, 1913.

Chappuis, Adrien. *The Drawings of Paul Cézanne: A Catalogue Raisonné*. 2 vols. Greenwich, Conn.: New York Graphic Society, 1973.

Cooper, Douglas. "Au Jas de Bouffan." *L'Oeil* 2 (15 February 1955): 13–16, 46.

Coutagne, Denis, et al. *Cézanne; ou la peinture en jeu*. Paris: Criterion, 1982.

———. *Cézanne au Musée d'Aix*. Aix-en-Provence: Musée Granet, 1984.

Doran, P. Michael, ed. *Conversations avec Cézanne*. Translated by Ann Hindry. Paris: Pierre Brochet, 1978.

Edinburgh. The Royal Scottish Academy. *An Exhibition of Paintings by Cézanne*. Exh. cat. 1965.

Faure, Elie. *Cézanne*. Paris: Crès, 1923.

Fry, Roger. "Le Développement de Cézanne." *L'Amour de l'art* 12 (December 1926): 391–418.

———. *Cézanne: A Study of His Development*. London: L. & V. Woolf, 1927.

Gache-Patin, Sylvie. "Douze Oeuvres de Cézanne de l'ancienne collection Pellerin." *La Revue du Louvre et des musées de France* no. 2 (1984): 128–46.

Gasquet, Joachim. *Cézanne*. Paris: Bernheim-Jeune, 1926.

———. "Cézanne, What He Said to Me," *The Leaflet* no. 3. San Francisco: H. Gentry, 1931.

Geist, Sidney. "What Makes *The Black Clock* Run?" *Art International* 22 (February 1978): 8–14.

———. "Cézanne: Metamorphosis of the Self." *Artscribe* (December 1980): 10–17.

Gordon, Donald. "The Expressionist Cézanne." *Artforum* 16 (March 1978): 34–39.

Gowing, Lawrence. "Notes on the Development of Cézanne." *The Burlington Maga-zine* 98 (June 1956): 185–92.

————. *Watercolor and Pencil Drawings by Cézanne.* Exh. cat. London: Arts Council of Great Britain, 1973.

————. *Cézanne: The Basel Sketchbooks.* Exh. cat. New York: The Museum of Modern Art, 1988.

————. *Cézanne: The Early Years, 1859–1872.* Exh. cat. London: Royal Academy of Arts, 1988.

Huyghe, René. *Cézanne.* Paris: Plon, 1936.

Kiefer, Carol S. "Cézanne's *Magdalen:* A New Source in the Musée Granet, Aix-en-Provence." *Gazette des beaux-arts* sér. 6, 103 (February 1984): 91–94.

Kirsch, Bob. "Paul Cézanne: *Jeune Fille au piano* and Some Portraits of His Wife. An Investigation of His Painting of the Late 1870s." *Gazette des beaux-arts* 110 (July–August 1987): 21–26.

Krumrine, Mary Louise. "Cézanne's Bathers: Form and Content." *Arts Magazine* 54 (May 1980): 115–23.

Larguier, Leo. *Cézanne; ou la lutte avec l'ange de la peinture.* Paris: R. Julliard, 1947.

Lewis, Mary Tompkins. "Cézanne's *Harrowing of Hell and the Magdalen.*" *Gazette des beaux-arts* 97 (April 1981): 175–78.

————. "Cézanne's Religious Imagery." Ph.D. diss., Univ. of Pennsylvania, 1981.

————. "A Life Drawing and an Unpublished Sheet of Sketches by Cézanne." *The Picker Art Gallery Annual Report and Bulletin* (1985–1986): 18–27.

Lichtenstein, Sara. "Cézanne and Delacroix." *The Art Bulletin* 46 (March 1964): 55–67.

Lindsay, Jack. *Cézanne: His Life and Art.* Greenwich, Conn.: New York Graphic Soci-ety, 1969.

Loran, Erle. *Cézanne's Composition.* Berkeley: Univ. of California Press, 1943.

Mack, Gerstle. *Paul Cézanne.* New York: Knopf, 1935.

Meier-Graefe, Julius. *Cézanne und sein Kreis.* Munich: R. Piper, 1922.

Monneret, Sophie. *Cézanne, Zola: La Fraternité du génie.* Paris: Denoel, 1978.

Munhall, Edgar. *Paul Cézanne: "Les Environs d'Aix-en-Provence."* New York: Wally Findlay Galleries, 1974.

Niess, Robert J. *Zola, Cézanne, and Manet: A Study of* L'Oeuvre." Ann Arbor: Univ. of Michigan Press, 1968.

Novotny, Fritz. "Zu einer 'Kopie' von Cézanne nach Ostade." *Pantheon* 25, no. 4 (July–August 1967): 276–80.

Orienti, Sandra, and Ian Dunlop. *The Complete Paintings of Cézanne*. New York: Viking, 1985.

Ratcliffe, Robert. "Cézanne's Working Methods and Their Theoretical Background." Ph.D. diss., Univ. of London, 1960.

Reff, Theodore. "Cézanne: The Enigma of the Nude." *Art News* 58 (November 1959): 26–29.

———. "Reproductions and Books in Cézanne's Studio." *Gazette des beaux-arts* sér. 6, 56 (November 1960): 303–9.

———. "Cézanne, Flaubert, St. Anthony, and the Queen of Sheba." *The Art Bulletin* 44 (June 1962): 113–25.

———. "Cézanne's *Dream of Hannibal*." *The Art Bulletin* 45 (June 1963): 148–52.

———. "Copyists in the Louvre, 1850–1870." *The Art Bulletin* 46 (December 1964): 552–59.

———. "Cézanne and Hercules." *The Art Bulletin* 48 (March 1966): 35–44.

———. "Cézanne on Solids and Spaces." *Artforum* 16 (October 1977): 34–37.

———. "The Pictures within Cézanne's Pictures." *Arts Magazine* 53 (June 1979): 90–104.

———. "Cézanne's *Cardplayers* and Their Sources." *Arts Magazine* 55, no. 3 (November 1980): 104–17.

———. "Cézanne: The Severed Head and the Skull." *Arts Magazine* 58, no. 2 (October 1983): 84–100.

Rewald, John. "Sources d'inspiration de Cézanne." *L'Amour de l'art* 17 (May 1936): 189–95.

———. *Cézanne et Zola*. Paris: Sedrowski, 1936.

———. "A propos du catalogue raisonné de l'oeuvre de Paul Cézanne et de la chronologie de cette oeuvre." *La Renaissance* nos. 3–4 (March–April 1937): 53–56.

———. "Paul Cézanne: New Documents for the Years 1870–1871." *The Burlington Magazine* 74 (April 1939): 163–71.

———. *Cézanne: Sa Vie—son oeuvre, son amitié pour Zola*. Paris: A. Michel, 1939.

———. *Paul Cézanne: A Biography*. New York: Simon and Schuster, 1948.

———. "Cézanne and Guillaumin." In *Etudes d'art français offertes à Charles Sterling*. Edited by Albert Chatelet and Nicole Reynaud, 343–53. Paris: Presses universitaires de France, 1975.

———. *Paul Cézanne, The Watercolors: A Catalogue Raisonné*. Boston: Little, Brown, 1983.

———. *Paul Cézanne: A Biography*. New York: Abrams, 1986.

Rewald, John, ed. *Paul Cézanne: Letters*. New York: Hacker Art Books, 1976.

Rewald, John, and Jean Adhémar. "Some Entries for a New Catalogue Raisonné of Cézanne's Paintings." *Gazette des beaux-arts* sér. 6, 86 (November 1975): 157–68.

Rilke, Rainer Maria. *Letters on Cézanne*. Edited by Clara Rilke; translated by Joel Agee. New York: Fromm International, 1985.

Rivière, Georges. *Le Maître Paul Cézanne*. Paris: Floury, 1923.

———. "La Formation de Paul Cézanne." *L'Art vivant* (August 1925): 1–4.

———. *Cézanne, le peintre solitaire*. Paris: Floury, 1933.

Rubin, William, et al. *Cézanne: The Late Years*. Exh. cat. New York: The Museum of Modern Art, 1977.

Schapiro, Meyer. *Cézanne*. New York: Abrams, 1952.

———. "The Apples of Cézanne: An Essay on the Meaning of Still-life." In *Modern Art, 19th & 20th Centuries: Selected Papers*, pp. 1–38. New York: George Braziller, 1979. First printed in *Art News Annual* 34 (1968): 34–53.

Shiff, Richard. "Impressionist Criticism, Impressionist Color, and Cézanne." Ph.D. diss., Yale Univ., 1973.

———. "Seeing Cézanne." *Critical Inquiry* 4 (Summer 1978): 769–808.

———. *Cézanne and the End of Impressionism*. Chicago: Univ. of Chicago Press, 1984.

Steinberg, Leo. "Resisting Cézanne: Picasso's *Three Women*." *Art in America* 66 (November 1978): 114–33.

Sutton, Denys. "The Paradoxes of Cézanne." *Apollo* 100 (August 1974): 98–107.

Thomson, Richard. "Greedy for Images." Review of *Cézanne: The Early Years*. *Times Literary Supplement* (6–12 May 1988): 504.

Venturi, Lionello, *Cézanne, son art—son oeuvre*. 2 vols. Paris: Rosenberg, 1936.

———. *Cézanne*. New York: Rizzoli, 1978.

Vollard, Ambroise. *Paul Cézanne*. Paris: Galerie A. Vollard, 1914.

———. *Paul Cézanne: His Life and Art*. Translated by Harold L. Van Doren. New York: Crown, 1937.

Walter, Rudolphe. "Cézanne à Bennecourt en 1866." *Gazette des beaux-arts* sér. 6, 59 (February 1962): 103–18.

Wechsler, Judith, ed. *Cézanne in Perspective*. Englewood Cliffs, N.J.: Prentice-Hall, 1974.

———. *The Interpretation of Cézanne*. Ann Arbor, Mich.: UMI, 1981.

II. PROVENCE

Agulhon, Maurice. *Pénitents et francs-maçons de l'ancienne Provence*. Nouvelle éd. Paris: Fayard, 1984.

Aix-en-Provence. Musée Granet. *Le Roi René en son temps, 1382–1481*. Exh. cat. 1981.

Alauzen, André M. *La Peinture en Provence*. Nouvelle éd. Marseille: J. Laffitte, 1984.

Ambard, R. *Aix romaine*. Aix-en-Provence: Association archéologique "Entremont," 1984.

Aude, Edouard. *Le Musée d'Aix-en-Provence*. Paris: Henri Laurens, 1921.

———. *Une Enigme historique dans les jeux de la fête-Dieu*. Aix-en-Provence, 1937.

Baille, Franck. *Les Petite Maîtres d'Aix à la belle époque 1870–1914*. Aix-en-Provence: Roubaud, 1981.

Bérenger-Féraud, Laurent-Jean-Baptiste. *Réminiscences populaires de la Provence*. Marseille: Laffitte Reprints, 1971.

Bernos, Marcel, et al. *Histoire d'Aix-en-Provence*. Aix-en-Provence: Edisud, 1977.

Bodart, Didier. *Louis Finson*. Brussels: Académie Royale de Belgique, 1970.

Borricand, René. *Les Hôtels particuliers d'Aix-en-Provence*. Aix-en-Provence: Chez l'auteur, 1971.

Boudignon-Hamon, Michèle, and Jacquelin Demoinet. *Fêtes en France*. Paris: Chêne, 1977.

Boyer, Jean. "La Peinture et la gravure à Aix-en-Provence au XVI–XVIIIème siècles." *Gazette des beaux-arts* sér. 6, 78 (July–September 1971): 3–186.

Carrère, J. "The Renaissance of the Classical Spirit: Frédéric Mistral." *Degeneration in the Great French Masters*. London: T. F. Unwin, 1922.

Chabaneau, Camille. *Sainte Marie Madeleine dans la littérature provençale*. Paris: Maissonneuve Frères et Ch. Leclerc, 1887.

Challet, Martine. "La Fête-Dieu à Aix-en-Provence au XVIIème siècle: 1701–1785." Mémoire de maîtrise, Université de Paris X-Nanterre, 1972–1973.

Charles-Roux, Jules. *Souvenir du passé: Le Cercle artistique de Marseille*. Paris: Lemerre, 1906.

Chaumelin, Marius. *Les Trésors d'art de la Provence exposés à Marseille en 1861*. Paris: Jules Renouard, 1862.

de Chennevières-Pointel, Philippe. *Recherches sur la vie et les ouvrages de quelques peintres provinciaux de l'ancienne France*. Paris: Dumoulin, 1847.

Clébert, Jean-Paul. *Les Fêtes en Provence*. Avignon: Editions Aubanel, 1982.

———. *Histoire et légendes de la Provence mystérieuse*. Paris: G. Kogan, 1968.

Clerc, Michel. *Aquae Sextiae*. Aix-en-Provence: A. Dragon, 1916.

Coste, Numa. "Jean Daret, peintre bruxellois." *Réunion des sociétés des beaux-arts des départements* 25 (1901).

———. "Le Camp d'Entremont." *Le Sémaphore de Marseille*, 1–2 March 1903.

Coulet, Noël, et al. *Le Roi René: Le Prince, le mécène, l'écrivain, le mythe.* Aix-en-Provence: Edisud, 1982.

Desplanches, Fr. P. *Les Pénitents gris d'Aix-en-Provence.* Aix-en-Provence, 1976.

Doré, Robert. *L'Art en Provence.* Paris: Les Beaux-Arts, 1930.

Durand, Henri-André. "Eglise et folklore en Provence." *Provence historique* (April–June 1958).

Edwards, Tudor. *The Lion of Arles: A Portrait of Mistral and His Circle.* New York: Fordham Univ. Press, 1964.

Galtier, Charles and Jean-Maurice Rauquette. *La Provence et Frédéric Mistral en museon arlaten.* Arles: J. Cuenot, 1977.

Gaut, Jan B. *Leis Juéchs de la festo de Diou: Consouns nouvellos.* Aix-en-Provence, 1851.

Gouirand, André. *Les Peintres provençaux.* Paris: Soc. d'éditions littéraires et artistiques, 1901.

———. *La Musique en Provence, et la conservatoire de Marseille.* Marseille: P. Ruat, 1908.

Grégoire, Gaspard. *Explication des cérémonies de la fête-Dieu d'Aix.* Aix-en-Provence: E. David, 1777.

Guiet, J.-B.-S. *Explication nouvelle des jeux de la fête-Dieu d'Aix.* Aix-en-Provence: Makaire et Deleuil, 1851.

de Haitze, Pierre. *Esprit du cérémonial d'Aix en la célébration de la fête-Dieu.* Aix-en-Provence, 1708.

———. *Apologétique de la religion des provençaux au sujet de la Madeleine.* Aix-en-Provence, 1711.

Homet, Marie-Claude. *Michel Serre et la peinture baroque en Provence (1658–1733).* Aix-en-Provence: Edisud, 1987.

Koch, Robert A. "La Sainte-Baume in Flemish Landscape Painting of the Sixteenth Century." *Gazette des beaux-arts* sér. 6, 66 (November 1965): 272–82.

Lantier, Raymond. *Les Origines de l'art français.* Paris: Guy Le Prat, 1947.

Loggins, Vernon. "Frédéric Mistral: Poet of the Soil." *Sewanee Review* (January 1924).

Lyle, Rob. *Mistral.* New Haven: Yale Univ. Press, 1953.

Marseille. Musée des Beaux-Arts. *La Peinture en Provence au XVIIe siècle.* Exh. cat. 1978.

———. *Amours et phobies: Stendhal et les peintures du Musée des Beaux-Arts de Marseille.* Exh. cat. 1983.

Mistral, Frédéric. *Mémoires et récits*. Translated into French from Provençal. Paris, 1936.

———. *The Memoirs of Frédéric Mistral*. Translated by George Wickes. New York: New Directions, 1986.

Parrocel, Etienne. *Annales de la peinture*. Paris: Ch. Albessard et Berard, 1862.

Pluyette, E. "Les Oeuvres d'art qui commémorent le souvenir de la peste de 1720 à Marseille." *Revue de Marseille* 15 (August 1920): 457.

Provence, Marcel. "Art celto-ligure." *France illustration* 2 (15 December 1945): 263–66.

Quigley, Hugh. *The Land of the Rhone: Lyons and Provence*. Boston: Houghton Mifflin, 1927.

de Ribbe, Charles. *Les Embellissements d'Aix le cours Saint-Louis il y a deux siècles*. Aix-en-Provence: A. Makaire, 1861.

Roques, Marguerite. *Les Apports néerlandais dans la peinture du sud-est de la France*. Bordeaux: Union française d'impression, 1963.

Roux, Marius. *Mémorial d'Aix*, 3 December 1865.

Roux-Alpheran, François-Ambroise-Thomas. *Les Rues d'Aix*. Aix-en-Provence: Aubin, 1846–1848; reprint Montpellier: Les Presses du Languedoc, 1985.

Scott, Sir Walter. *Anne of Geierstein*. Edinburgh: A. and C. Black, 1879.

Tchoy, Claude. *Guide de la Provence mystérieuse*. Paris: Les Guides noirs, éditions Tchou Princesse, 1976.

Teissier, Léon. *Mistral chrétien: Le Sentiment Religieux dans la vie et dans l'oeuvre de Mistral*. Montpellier: P. Déhan, 1954.

Thurston, H. "St. Mary Magdalen and the Early Saints of Provence." *The Month* 92 (1899): 75–81.

Toursky, A. *La Reconstitution historique de l'entrée du Roi-René dans la ville et les jeux de la fête-Dieu*. Aix-en-Provence, 1964.

Vaudoyer, Jean-Louis. *Les Peintres provençaux de Nicolas Froment à Paul Cézanne*. Paris: La Jeune Parque, 1947.

Vovelle, Michel. *Les Métamorphoses de la fête en Provence de 1750 à 1820*. Paris: Flammarion, 1976.

Wytenhove, Henri. *Loubon*. Exh. cat. Marseille: Musée des Beaux-Arts, 1974.

III. BACKGROUND AND LITERARY SOURCES

Abbate, Carolyn. "The Parisian *Tannhäuser*." Ph.D. diss., Princeton Univ., 1984.

Adhémar, Jean. *Daumier: Dessins et aquarelles*. Paris: Braun, 1954.

———. *Honoré Daumier*. Paris: Editions Pierre Tisné, 1954.

Alauzen, André, and Pierre Ripert. *Monticelli: Sa Vie et son oeuvre*. Paris: Bibliothèque des Arts, 1969.

Banks, Oliver. *Watteau and the North: Studies in the Dutch and Flemish Baroque Influence on French Rococo Painting*. New York: Garland, 1977.

Bardon, Françoise. "Le Thème de la Madeleine pénitente au XVIIème siècle en France." *Journal of the Warburg and Courtauld Institutes* 31 (1968): 274–306.

Barr, Alfred H., Jr. *Picasso: Fifty Years of His Art*. New York: The Museum of Modern Art, 1946.

Bart, Benjamin F. *Flaubert's Landscape Descriptions*. Ann Arbor: Univ. of Michigan Press, 1957.

Barth, Herbert, et al. *Wagner: A Documentary Study*. New York: Oxford Univ. Press, 1975.

Baudelaire, Charles. *Les Fleurs du mal*. Paris: Poulet-Malassis et de Broise, 1857.

———. *Oeuvres complètes*. Edited by Claude Pichois. 2 vols. Dijon: Gallimard, Bibliothèque de la Pleiade, 1975–1976.

———. *The Painter of Modern Life and Other Essays*. Translated and edited by Jonathan Mayne. London: Phaidon, 1970.

Bauer, Oswald Georg. *Richard Wagner: The Stage Designs and Productions from the Premieres to the Present*. New York: Rizzoli, 1983.

Bergström, Ingvar. *Dutch Still-Life Painting in the Seventeenth Century*. Translated by Christina Hedström and Gerald Taylor. London: Faber and Faber, 1956.

Blanc, Charles. *Histoire des peintres de toutes les écoles*. 14 vols. Paris: Librairie Renouard, 1861–1877.

Boime, Albert. *The Academy and French Painting in the Nineteenth Century*. London: Phaidon, 1971.

———. *Thomas Couture and the Eclectic Vision*. New Haven: Yale Univ. Press, 1980.

Braun, Sidney. *The "Courtisane" in the French Theater from Hugo to Becque (1831–1885)*. Johns Hopkins Studies in Romance Literature and Languages, extra vol. 22. Baltimore: The Johns Hopkins Press, 1947.

Brettell, Richard, et al. *A Day in the Country: Impressionism and the French Landscape*. Exh. cat. Los Angeles: Los Angeles County Museum of Art, 1984.

Brion, Marcel. *La Grande Aventure de la peinture religieuse, le sacré et sa représentation*. Paris: Perrin, 1968.

Brombert, Victor. *The Novels of Flaubert: A Study of Themes and Techniques*. Princeton: Princeton Univ. Press, 1966.

Brooklyn. Brooklyn Museum of Art. *From Courbet to Cézanne, A New Nineteenth Cen-

tury: Preview of the Musée d'Orsay, Paris. Exh. cat. Paris: Editions de la réunion des musées nationaux, 1986.

Brown, Marguerite L. "The Subject Matter of Dürer's *Jabach Altar*." *Marsayas* 1 (1941): 55–68.

Bürger, W. [pseud.]. *See* Thoré, Théophile.

Cachin, Françoise and Charles S. Moffett. *Manet*. Exh. cat. New York: The Metropolitan Museum of Art, 1983.

Castagnary, Jules. *Salons 1857–1870*. 2 vols. Paris: G. Charpentier et E. Fasquelle, 1892.

Chadwick, Owen. *The Secularization of the European Mind in the Nineteenth Century*. Cambridge: Cambridge Univ. Press, 1975.

Charlton, D. G., ed. *The French Romantics*. 2 vols. New York: Cambridge Univ. Press, 1984.

Chartres. Musée des Beaux-Arts. *Exigences de réalisme dans la peinture française entre 1830 et 1870*. Exh. cat. 1983–1984.

Chauvin, Sr. John of Carmel. "The Role of Mary Magdalen in Medieval Drama." Ph.D. diss. Catholic Univ. of America, Washington, D.C., 1951.

Chesneau, Ernest. *Les Nations rivales dans l'art*. Paris: Didier, 1868.

Clark, Timothy J. "Preliminaries to a Possible Treatment of *Olympia* in 1865." *Screen* 21, no. 1 (Spring 1980): 18–41.

————. *The Painting of Modern Life*. New York: Knopf, 1985.

Clayson, Susan Hollis. *Representations of Prostitution in Early Third Republic France*. Ann Arbor, Mich.: UMI, 1984.

Crespelle, Jean-Paul. *La Vie quotidienne des impressionistes: Du Salon des Refusés (1863) à la mort de Manet (1883)*. Paris: Hachette, 1981.

Cuisenier, Jean. *French Folk Art*. Translated by T. W. Lyman. Tokyo: Kodansha, 1977.

Curry, Larry. "Henri Fantin-Latour's *Tannhäuser on Venusberg*." *Los Angeles County Museum of Art Bulletin* 16, no. 1 (1964): 3–19.

Cutler, Maxine G. *Evocations of the Eighteenth Century in French Poetry 1800–1869*. Geneva: Droz, 1970.

Dansette, Adrien. *The Religious History of Modern France*. 2 vols. Translated by John Dingle. New York, 1961.

Daulte, François. *Frédéric Bazille et son temps*. Geneva: Pierre Cailler, 1952.

Dayot, Armand. *Carle Vernet*. Paris: Le Goupy, 1924.

Doesschate-Chu, Petra Ten. *French Realism and the Dutch Masters*. Utrecht: Haentjens Dekker & Gumbert, 1974.

Doolittle, James. *Alfred de Vigny: The Man and the Writer*. New York: Twayne Publishers, 1967.

Druick, Douglas and Michel Hoog. *Fantin-Latour*. Exh. cat. Ottawa: National Gallery of Canada, 1983.

Duncan, Carol. *The Pursuit of Pleasure: The Rococo Revival in French Romantic Art*. New York: Garland, 1976.

Duret, Théodore. *Histoire des peintres impressionistes*. Paris: H. Floury, 1906.

Faris, Alexander. *Jacques Offenbach*. London and Boston: Faber and Faber, 1980.

Farwell, Beatrice. *Manet and the Nude: A Study in Iconography in the Second Empire*. New York: Garland, 1981.

Felton, Craig. *Jusepe de Ribera: A Catalogue Raisonné*. 2 vols. Ann Arbor, Mich.: UMI, 1983.

Fernier, Robert. *La Vie et l'oeuvre de Gustave Courbet*. 2 vols. Lausanne: Bibliothèque des Arts, 1977.

Finke, Ulrich, ed. *French 19th Century Painting and Literature, with Special Reference to the Relevance of Literary Subject Matter to French Painting*. Manchester, Eng.: Manchester Univ. Press, 1972.

Flaubert, Gustave. *Novembre*. Translated by F. Jellinek, with an introduction by Francis Steegmuller. New York: Carroll and Graf, 1987.

———. *The Temptation of Saint Anthony*. Translated and with an introduction by Kitty Mrosovsky. Ithaca: Cornell Univ. Press, 1981.

Fried, Michael. "Manet's Sources: Aspects of His Art, 1859–1865." *Artforum* 7 (March 1969): 28–82.

———. "Painting Memories: On the Containment of the Past in Baudelaire and Manet." *Critical Inquiry* 10 (1984): 510–42.

Fry, Roger. "Art and Religion." *Monthly Review* (May 1902): 126–42.

Gauguin, Paul. *Lettres à sa femme et à ses amis*. Edited by M. Malingue. Paris: Bernard Grasset, 1946.

Gautier, Théophile. *The Complete Works of Théophile Gautier*. 12 vols. Translated and edited by F. C. de Sumichrast. London: Postlethwaite, Taylor and Knowles, 1909.

———. *Souvenirs de théâtre, d'art et de critique*. Paris: G. Charpentier, 1883.

———. *Tableaux à la plume*. Paris: G. Charpentier, 1880.

Gedo, Mary M. "Art as Exorcism: Picasso's *Demoiselles d'Avignon*." *Arts Magazine* 55 (October 1980): 70–83.

de Goncourt, Edmond and Jules. *French Eighteenth-Century Painters*. Translated by Robin Ironside. Ithaca: Cornell Univ. Press, 1981.

Grasselli, Margaret Morgan and Pierre Rosenberg. *Watteau 1684–1721*. Exh. cat. Washington, D.C.: National Gallery of Art, 1984.

Guigou, Paul. *Adolphe Monticelli*. Paris: Boussod, Valadon, et Cie, 1890.

Hadler, Mona. "Manet's *Woman with a Parrot* of 1866." *Metropolitan Museum of Art Journal* 7 (1973): 115–22.

Hanson, Anne Coffin. *Manet and the Modern Tradition*. New Haven: Yale Univ. Press, 1977.

Haskell, Francis. *Past and Present in Art and Taste*. New Haven: Yale Univ. Press, 1987.

Hemmings, Frederic W. *The Life and Times of Emile Zola*. London: Elek, 1977.

Herban, Mathew, III. "The Origin of Paul Gauguin's *Vision after the Sermon*." *The Art Bulletin* 59, no. 3 (September 1977): 415–20.

Herbert, Robert L. "City *vs.* Country: The Rural Image in French Painting from Millet to Gauguin." *Artforum* 8 (February 1970): 44–55.

Honour, Hugh. *Neo-Classicism*. Harmondsworth, Middlesex: Penguin, 1968.

———. *Romanticism*. London: Allen Lane, 1979.

Hopp, Gisela. *Europäische Meisterwerke aus schweizer Sammlungen*. Munich: Bavarian Graphic Collection, 1969.

Horn, Pierre L. and Mary Beth Pringle, eds. *The Image of the Prostitute in Modern Literature*. New York: F. Ungar, 1984.

Houssaye, Arsène. *Histoire de l'art français au dix-huitième siècle*. Paris: Henri Plon, 1860.

Hurel, Abbé. *L'Art religieux contemporain*. Paris: Didier, 1868.

Ireson, J. C. *L'Oeuvre poétique de Gustave Kahn*. Paris: Nizet, 1962.

Isarlo, George. *Caravage et le caravagisme européen*. Aix-en-Provence: Libr. Dragon, 1941.

Johnson, Lee. *The Paintings of Eugène Delacroix*. Oxford: Clarendon Press, 1981–.

de Jongh, E. "Erotica in Vogelperspectief. De dubbel-zinnigheid van een reeks 17de eeuwse genrevoorstellingen." *Simiolus* 3 (1968–1969): 22–74.

Jowell, Frances Suzman. *Thoré-Bürger and the Art of the Past*. New York: Garland, 1977.

Kahn, Gustave. "L'Art français à l'exposition." *La Vogue* (1889): vol. 2.

Kind, Joshua. *The Drunken Lot and His Daughters*. Ph.D. diss., Columbia Univ., 1967.

Kloss, Erich, ed. *Briefwechsel zwischen Wagner und Liszt*. 2 vols. Leipzig: Breitkopf und Hartel, 1910.

Komanecky, Michael. *The Folding Image: Screens by Western Artists of the Nineteenth and Twentieth Centuries*. New Haven: Yale Univ. Art Gallery, 1984.

Lapp, John C. "The Critical Reception of Zola's *Confession de Claude.*" *Modern Language Notes* 68, no. 7 (November 1953): 457–62.

Large, David, and William Weber, eds. *Wagnerism in European Culture and Politics.* Ithaca: Cornell Univ. Press, 1984.

de Leiris, Alan. "Manet's *Christ Scourged* and the Problem of His Religious Painting." *The Art Bulletin* 41 (June 1959): 198–201.

Leroy, Alfred. *Histoire de la peinture religieuse des origines à nos jours.* Paris: Amiot-Dumont, 1954.

Levenson, Jon Douglas. *The Book of Job in Its Time and in the Twentieth Century.* Cambridge: Harvard Univ. Press, 1972.

Levin, Harry. *The Gates of Horn: A Study of Five French Realists.* New York: Oxford Univ. Press, 1963.

Lipschutz, Isle. *Spanish Painting and the French Romantics.* Cambridge: Harvard Univ. Press, 1972.

Livio, Antonio. *Richard Wagner: L'Oeuvre lyrique.* Paris: Editions Le Chemin Vert, 1983.

London. Royal Academy of Arts. *Gustave Courbet 1819–1877.* Exh. cat. 1978.

Lowenthal, Anne. "Lot and His Daughters as Moral Dilemma." *The Age of Rembrandt: Papers in Art History from the Pennsylvania State University* 3 (1988): 14–27.

Mainardi, Patricia. *Art and Politics of the Second Empire: The Universal Expositions of 1855 and 1867.* New Haven: Yale Univ. Press, 1987.

McCoubrey, John. "The Revival of Chardin in French Still-Life Painting, 1850–1870." *The Art Bulletin* 46 (March 1964): 39–53.

Mellinkoff, Ruth. *The Horned Moses in Medieval Art and Thought.* Berkeley: Univ. of California Press, 1970.

Meltzoff, Stanley. "Nineteenth-Century Revivals." Master's thesis. Institute of Fine Arts, New York Univ., 1941.

Moffett, Charles S., et al. *The New Painting: Impressionism 1874–1886.* Exh. cat. San Francisco: The Fine Arts Museums of San Francisco, 1986.

Moir, Alfred. *Caravaggio and His Copyists.* New York: College Art Association, 1976.

de Montalembert, Charles. *Du vandalisme et du catholicisme dans l'art.* Paris: Debécourt, 1839.

Mosby, Dewey. *Alexandre-Gabriel Decamps 1803–1860.* New York: Garland, 1977.

Mosse, Walter Eugen. *Liberal Europe: The Age of Bourgeois Realism, 1848–1875.* London: Thames and Hudson, 1974.

Nadeau, Maurice. *The Greatness of Flaubert.* New York: Library Press, 1972.

New York. Shepherd Gallery. *Ingres and Delacroix through Degas and Puvis de Chavannes: The Figure in French Art 1800–1870.* Exh. cat. 1975.

———. *Christian Imagery in French Nineteenth-Century Art 1789–1906.* Exh. cat. 1980.

Nochlin, Linda. *Impressionism and Post-Impressionism, 1874–1904.* Englewood Cliffs, N.J.: Prentice-Hall, 1966.

———. *Realism.* Harmondsworth, Middlesex: Penguin, 1971.

———. *Gustave Courbet: A Study of Style and Society.* New York: Garland, 1976.

Osborne, Carol. "Impressionists and the Salon." *Arts Magazine* 48 (June 1974): 36–39.

Paris. Musée National des Arts et Traditions Populaires. *Religions et traditions populaires.* Exh. cat. 1979.

Paris. Musée Picasso. *Les Demoiselles d'Avignon.* Exh. cat. 2 vols. 1988.

Perry, Ellwood, III. "*The Gross Clinic* as Anatomy Lesson and Memorial Portrait." *Art Quarterly* 32, no. 4 (Winter 1969): 373–91.

Philadelphia. Philadelphia Museum of Art. *The Second Empire 1852–1870: Art in France under Napoleon III.* Exh. cat. 1978.

Pigler, Andor. *Barockthemen.* Vol. 1. Budapest: Akadémiai Kiadó, 1956.

Posner, Donald, *Antoine Watteau.* London: Weidenfeld & Nicholson, 1984.

Praz, Mario. *The Romantic Agony.* 2d ed. London: Oxford Univ. Press, 1979.

"Quelques Oeuvres théâtrales consacrées au saint homme Job." *Jeux, trétaux, et personnages* 4, no. 31 [Paris] (15 July 1933): 187–89.

Railo, Eino. *The Haunted Castle: A Study of the Elements of English Romanticism.* London: G. Routledge & Sons, 1927.

Réau, Louis. *Iconographie de l'art chrétien.* 3 vols. Paris: Presses universitaires de France, 1955–1959.

Renoir, Jean. *Renoir: My Father.* Translated by Randolph and Dorothy Weaver. Boston: Little, Brown, 1962.

Rewald, John. *The History of Impressionism.* New York: The Museum of Modern Art, 1973.

———. *Studies in Impressionism.* New York: Abrams, 1985.

———. *Studies in Post-Impressionism.* New York: Abrams, 1986.

Richardson, Joanna. *Théophile Gautier: His Life and Times.* London: M. Reinhardt, 1958.

Ritter, William. "Henri Rivière." *Die graphischen Künste* 22 (1899): 112–16.

Rivière, Georges. *L'Impressioniste, journal d'art* (14 April 1877).

Rodin, Auguste. *On Art and Artists.* Translated by Paul Gsell. New York: Philosophical Library, 1957.

Rogers, Maris. "The Batignolles Group: Creators of Impressionism." In *The Sociology of Art and Literature*, edited by M. C. Albrecht et al., pp. 194–222. New York: Praeger, 1970.

Rosen, Charles and Henri Zerner. *Romanticism and Realism*. New York: Viking Press, 1984.

Rosenberg, Pierre. *The Age of Louis XV: French Painting 1710–1744*. Exh. cat. Toledo: Toledo Museum of Art, 1975.

Rosenblum, Robert. *The Past Rediscovered: French Painting 1800–1900*. Exh. cat. Minneapolis: Minneapolis Institute of Arts, 1969.

Rosenthal, Léon. *Du romanticisme au réalisme*. Paris: H. Laurens, 1914.

Roy, Joseph-Antoine. *Histoire du Jockey Club de Paris*. Paris: M. Rivière, 1958.

Salvatoris, Gesta. *The Gospel of Nicodemus*. Edited by H. C. Kim. Toronto: The Pontifical Institute for Medieval Studies, 1973.

Seznec, Jean. "The *Temptation of Saint Anthony* in Art." *Magazine of Art* 40 (1947): 86–93.

Sheon, Aaron. *Monticelli: His Contemporaries, His Influence*. Exh. cat. Pittsburgh: Museum of Art, Carnegie Institute, 1979.

Sheppard, Lancelot C. *Lacordaire: A Biographical Essay*. New York: Macmillan, 1964.

Shiff, Richard. "Art History and the Nineteenth Century: Realism and Resistance." *The Art Bulletin* 70, no. 1 (March 1988): 25–48.

Silberner, Edmund. "Pierre Leroux's Ideas on the Jewish People." *Jewish Social Studies* 12, no. 4 (October 1950): 367–84.

Silvestre, Théophile. *Les Artistes français: Etudes d'après nature*. Leipzig: A. Schnée, 1861.

Spector, Jack. *Delacroix: The Death of Sardanapalus*. New York: Viking Press, 1974.

Starkie, Enid. *Flaubert: The Making of the Master*. Harmondsworth, Middlesex: Penguin, 1971.

Steegmuller, Francis, ed. *The Letters of Gustave Flaubert, 1830–1857*. 2 vols. Cambridge: Harvard Univ. Press, 1980–1982.

Steinberg, Leo. "The Metaphors of Love and Birth in Michelangelo's Pietàs." In *Studies in Erotic Art*, edited by Theodore Bowie and Cornelia V. Christenson, pp. 231–335. New York: Basic Books, 1970.

Sturges, Hollister. *Jules Breton and the French Rural Tradition*. Exh. cat. Omaha, Nebr.: Joslyn Art Museum, 1982.

Suleiman, Susan R. and Inge Crosman, eds. *The Reader in the Text: Essays on Audience and Interpretation*. Princeton: Princeton Univ. Press, 1980.

Sutton, Denys. "Ribot: An Overlooked Master." *Apollo* 81 (March 1965): 234.

Sutton, Peter C. *Pieter de Hooch*. Ithaca: Cornell Univ. Press, 1980.

Thomas, John Wesley. *Tannhäuser: Poet and Legend*. Chapel Hill: Univ. of North Carolina Press, 1974.

Thoré, Théophile. "Etudes sur la sculpture française depuis la renaissance." *Revue de Paris*. Nouvelle sér., 25 (1836): 333.

———. *Salons de W. Bürger, 1861 à 1868, avec une préface par T. Thoré*. 2 vols. Paris: Salon Catalogues, 1870.

———. "Van der Meer de Delft." *Gazette des beaux-arts* 21 (1866): 297–330, 458–70, and 542–75.

"Velazquez's *Dying Seneca*." *Bulletin of the Art Institute of Chicago* 19, no. 6 (October 1925): 83–84.

de Vigny, Alfred. *Oeuvres complètes*. Paris: Editions du Seuil, 1965.

Washington, D.C. National Gallery of Art. *The Age of Correggio and the Carracci: Emilian Painting in the Sixteenth and Seventeenth Centuries*. Exh. cat. 1986.

Weigert, Roger-Armand. *Les Peintres de la Bible en France au XVI–XVII siècles*. Paris, n.p., n.d.

Weisbach, W. "L'Histoire de Job dans les arts." *Gazette des beaux-arts* sér. 6, 16 (September 1936): 102–12.

Weisberg, Gabriel. *Bonvin*. Paris: Editions Geoffroy-Dechaume, 1979.

Weisberg, Gabriel and Petra Ten Doesschate-Chu. *The Realist Tradition: French Painting and Drawing 1830–1900*. Exh. cat. Cleveland: Cleveland Museum of Art, 1980.

Weisberg, Gabriel, with William S. Talbot. *Chardin and the Still-life Tradition in France*. Cleveland: Cleveland Museum of Art, 1979.

White, Barbara E., ed. *Impressionism in Perspective*. Englewood Cliffs, N.J.: Prentice-Hall, 1978.

White, Barbara E. *Renoir: His Life, Art, and Letters*. New York: Abrams, 1984.

Whitfield, Sarah. *The Academic Tradition*. Exh. cat. Bloomington: Indiana Univ. Art Museum, 1968.

Wiedmann, August K. *Romantic Art Theories*. Henley-on-Thames: Gresham Books, 1986.

Wind, Edgar. "Traditional Religion and Modern Art." *Art News* 52, no. 3 (May 1953): 18–22.

Young, Karl. *The Drama of the Medieval Church, I*. Oxford: Clarendon Press, 1933.

Zeldin, Theodore. *France 1848–1945*. Vol. I, *Ambition, Love, and Politics*. Vol. II, *Intellect, Taste, and Anxiety*. Oxford: Clarendon Press, 1973–1977.

Zola, Emile. *Madeleine Férat*. Translated and with an introduction by Alec Brown. London: Elek Books, 1957.

———. *Nana*. Translated by George Holden. Harmondsworth, Middlesex: Penguin, 1972.

———. *L'Oeuvre*. Paris: F. Bernouard, 1928.

———. *Salons*. Edited by F. W. Hemmings and R. J. Niess. Geneva: E. Droz, 1959.

———. *Thérèse Racquin*. Translated and with an introduction by Leonard Tancock. Harmondsworth, Middlesex: Penguin, 1976.

INDEX

All works of art are by Cézanne unless otherwise indicated.

Offenbach, Jacques: *La Belle Hélène*, 219; *Orphée aux enfers*, 175, 214, 255n. 3; *La Vie parisienne*, 221

Oiseau chéri, L' (Bouguereau), 249n. 44

Old master paintings, 4

Old Testament, 60, 74

Oller, Francisco, 115, 218, 220

Olympia (Manet), 201, 220

Opéra, Paris, 186, 216

Ordo paschalis, 55

Orgie, L'. See *Le Festin*

Orgy, theme of, 173–77, 255n. 3

Ouverture du "Tannhäuser," L', 139, 221. See also *Jeune Fille au piano*

Ovid, 162, 163; *Metamorphoses*, 76, 156–59, 161, 169, 252n. 7

Pagan beliefs. *See* Christianity

Paris: surrounding landscape of, 102–3; siege of, 196

Parnassiens, Les, 222

Parrocel, Etienne: *Annales de la peinture*, 17

Parrot. *See* Bird

Parrot Cage, The (Steen), 137

Parrot. *See* Bird

Partie carrée, La (Tissot), 245n. 38

Partie de campagne, La, 91, 92 *fig.*

Partie de pêche, La, 107

Pasdeloup, Jules-Etienne, 216

Passion plays, 55–56, 60–62, 236n. 20

Pastoral themes, 205

Pastorale. See *L'Idylle*

Patenir, Joachim: paintings of Magdalen, 53

Paysage de Sicile (Millet), 159

Pellerin collection, 3, 6, 235n. 3

Pencz, Georg: engraving of Lot, 73

Penitent orders, 119, 221; robe of, 119, 120 *fig.*; significance of skulls in, 40, 41 *fig.*

Pense-t-il aux raisins? (Boucher), 94–97, 96 *fig.*

Pentecost, 27

Pergus, Lake, 159

Persephone, 56, 159. *See also* Proserpina

Perspective, La (Watteau), 91, 93 *fig.*

Petipa, Marius, 187

Petites Filles spartiates provoquant des garçons (Degas), 215

Phryné devant l'aréopage (Gérôme), 216

Piano, Au (Whistler), 143 *fig.*, 144, 214

Picasso, Pablo, 203; *Les Demoiselles d'Avignon*, 260n. 12

Pichoun juéc deis diablés, Lou (Grégoire), 34, 35 *fig.*

Picnic on a River, pl. IV.A, 107, 109

Picnic theme, 91, 99, 100–105. *See also* Fête-galante tradition

Piece from Schumann, A (Fantin-Latour), 141

Pietà after Tiarini's *Deposition* (Géricault), 122–23, 123 *fig.*

Pillar from the *sanctuaire aux crânes*, 42 *fig.*, 43

Piombo, Sebastiano del. *See* Sebastiano del Piombo

Pissarro, Camille, 195, 207, 216, 218, 221, 223, 224, 225; Cézanne influenced by, 5, 203; drawings of peasants, 147; landscapes of, 220; Oller and, 115

Plantation d'un calvaire (Breton), 27, 214

Pleinairism, 97, 109

Pluto, 159, 161, 170

Poets of Provence, The, 13, 14 *fig.*

Pontoise, 203, 207, 225

Portrait d'Achille Emperaire, 224

Portrait de l'artiste, pl. VI, 105

Portrait de l'artiste en guitariste (Daret), 17–19, 18 *fig.*

Portrait de la femme d'un ambassadeur (anonymous), 137

Portrait de M. Emile Zola (Manet), 223

Zola, Emile (*continued*)
letters to Cézanne, 27, 214; literary influence of, on Cézanne, 102–5, 129; marriage of, 224; *Mystères de Marseille*, 222; in Paris, 19; at poetry festival in Aix, 15; and religious festivals, 27, 36–37; student at Collège Bourbon, 15; Wagner admired by, 187; youth in Aix-en-Provence, 15. Works: *Confession de Claude, La*, 217, 220; *Contes à Ninon*, 88, 219; *Débâcle, Le*, 196; *Edouard Manet*, 222; *Madeleine Férat*, 102–5, 221, 223; *Oeuvre, L'*, 3, 105, 122, 187, 197; *Rougon-Macquart, Les*, 224, 225; *Thérèse Racquin*, 102, 121, 222; *Ventre de Paris, Le*, 25

Zurbarán, Francisco de, 124, 220

DESIGNER	*Wilsted & Taylor*
COMPOSITOR	*Wilsted & Taylor*
PRINTER	*Malloy Lithographing, Inc.*
BINDER	*John H. Dekker & Sons*
TEXT	*Meridien*
DISPLAY	*Meridien*